THE COLLECTION OF

JOHN A. AND AUDREY JONES BECK

© 1986 by The Museum of Fine Arts, Houston

1001 Bissonnet

Houston, Texas 77005

All rights reserved

Library of Congress Catalogue Card Number: 86-62754

ISBN: 0-89090-041-8, cloth edition

ISBN: 0-89090-042-6, paper edition

Designer: Peter Layne

Type: Characters, Inc., Houston, Texas

Color Separations: Color Separations Incorporated, Houston, Texas

Printer: W. E. Barnett & Associates, Inc., Houston, Texas

Binder: Universal Bookbindery Inc., San Antonio, Texas

PRINTED IN THE UNITED STATES OF AMERICA

THE COLLECTION OF

JOHN A. AND AUDREY JONES BECK

COMPILED BY

AUDREY JONES BECK

THE MUSEUM OF FINE ARTS, HOUSTON

INTRODUCTION

The John A. and Audrey Jones Beck Collection of European art is a treasure which has enriched the lives of art lovers since it was opened as a permanent exhibition at the Museum of Fine Arts, Houston, in 1974. It is a collection of nineteenth and early twentieth-century art which focuses on the avant-garde movements of Paris and represents the important creators of a new aesthetic with some of the finest paintings available. The collection is the product of Audrey Beck's passion for quality in art and zeal for excellence in education. I know of nothing that pleases her more than to see students and first-time museum goers being drawn into the magical worlds of impressionism, pointillism, and fauvism. Before these paintings were brought to the museum, they adorned Mrs. Beck's home, where students and scholars visited for research, discussion, and reflection on the great masters of early modernism. Her collection is dedicated to firing the viewer's imagination and kindling a desire to know and see more. Helping everyone appreciate fine art is Mrs. Beck's special mission.

The exhibition and explication of art treasures for the enrichment of the entire community has been the stated purpose of American museums since the mid nineteenth century. Only through the extraordinary generosity of private collectors have American museums been able to succeed. In Houston, Audrey Jones Beck is a patron in the tradition of great ladies such as Isabella Stewart Gardner and Ailsa Mellon Bruce. The masterpieces of her collection instruct and inspire.

The collection was selected by Audrey Beck, working with her husband, John. Together they haunted the galleries and auction houses of Europe and America in search of *the* picture that was right for the Beck Collection. What a legacy they created! It is not surprising that so many of the artists in the collection were individualists who refused to be enslaved by tradition. They explored new ideas and techniques, and created new visions of the world. Audrey and John went their own way too, but in building this collection and exhibiting it in the Museum of Fine Arts, Houston, they took us along with them. Sadly, John Beck passed away in 1973, but Audrey has continued to collect, continued the journey she started over twenty years ago. We are profoundly fortunate to travel with this generous friend. She makes our passage exhilarating.

Peter C. Marzio
Director

ACKNOWLEDGMENTS

Compiled by Audrey Jones Beck, this catalogue has been made possible by the efforts of many individuals. They include George T. M. Shackelford, associate curator of European painting and sculpture, who provided important art historical information to the texts; Anne Rosen, curatorial assistant, who researched entries with painstaking care; and Wanda Allison, curatorial secretary, who assisted with manuscript preparation and patiently typed multiple entry drafts. At various stages of the project, numerous other members of the staff have lent counsel and help. Linda Shearouse, museum librarian, assisted Mrs. Beck in assembling research. Edward Mayo, registar, and members of his staff, Bonnye Ray and Elizabeth Lang, arranged for the photography of works in the collection. At the initial stages of the project, Anne W. Tucker and David Warren planned the catalogue with Mrs. Beck. Celeste Adams supervised and coordinated the final editing and design of the publication. Production of the catalogue was carried out by Kathryn Kelley, production manager for museum publications. Additional editorial expertise was rendered by Anne Feltus and Carolyn Vaughan, museum publications editor. The catalogue was designed by Peter Layne; the principal photographer was Jim Olive with additional photography by Allen Mewbourn and Paul Hester.

Mrs. Beck is thankful also to Thomas P. Lee, who wrote the first Beck catalogue in 1974; to Frances Marzio for her continuous interest and hours of personal help; and to a talented group of graduate students in the department of art history at Rice University, who conducted research on the collection under the direction of Professor William A. Camfield and his assistant Mary-Margaret Goggin. They are Jill Kyle, Mary Lentz, Nayla Muntasser, Lauren Sinnott, Kelly Tankersley, Sandra Garcia, Martha Mitchell, Robert Williams, Nancy Allen, and Rita Marsales.

This catalogue is valuable not only for the information about the great artists of the late nineteenth and early twentieth centuries in Europe, but also for the insights into the mind of its author and compiler. Each entry contains the points of interest which attracted Mrs. Beck to that particular work of art. We are fortunate to record here the mind's eye that lies behind the Beck Collection, and fortunate also to have a patron willing to devote her time to research and writing. This catalogue is the product of Mrs. Beck's personal vision and deep love for art.

P. C. M.

PREFACE

The excitement of collecting has continued into the writing of this catalogue. It has been a great joy working with Peter Marzio, whose interest and vitality were a constant source of encouragement. To all of those listed under the acknowledgments, I owe a deep gratitude. Each individual played an important part in making this catalogue possible and my dream come true.

My romance with impressionism began when I first visited Europe at the age of sixteen as a student tourist, complete with camera to record my trip. I paid homage to the *Mona Lisa* and the *Venus de Milo*, but the imaginative and colorful impressionist paintings came as a total surprise. Works by these avant-garde artists, who had rebelled against the academic tradition of the day, were scarce in American museums at that time. For me, they were not only the epitome of artistic freedom, but a visual delight. I returned home with many pictures, but none taken with the camera. My images were museum reproductions.

During World War II, art was forgotten for a navy pilot, John A. Beck, whom I married and followed from assignment to assignment. After the war, we returned to Houston, where John became a successful businessman. Although he had little interest in art, I told him of my dream, to collect a representative group of impressionist works for Houston. Needless to say, John at first thought his wife had gone quite mad, but my enthusiasm must have been contagious. He began to manage the business end of my project and soon became vitally interested in what I was trying to achieve. We worked together to tell the story of impressionism and hope that everyone who views the collection may find in it his or her special painting.

Audrey Jones Beck

CATALOGUE OF THE COLLECTION

CHARLES ANGRAND

Born 1854 Criquetat-sur-Ouville, France

Died 1926 Rouen, France

LES MOISSONEURS (THE HARVESTERS) 1892

The Harvesters reveals the delight that Charles Angrand took in portraying scenes from everyday rural life with sincerity and understanding. Angrand, a quiet man with simple tastes, came from a family who had lived for generations in the province of Normandy. The harvest was a part of the cycle of life in Normandy, and a subject that Angrand painted many times. In the critical press of his day, Angrand's harvest scenes were described as poetic works in the tradition of the great realist painter Jean-François Millet. In this grandly scaled painting, Angrand has employed the pointillist technique developed by his friend Georges Seurat to represent a simple scene of peasant life that evokes the work of Millet and of Angrand's friend Camille Pissarro.

The son of a schoolmaster, Angrand studied to become a teacher, but chose instead the painter's vocation after attending the Ecole des Beaux-Arts of Rouen. There, he took an active part in the rebellion against the strict academic discipline of his teachers. His classmates elected him their leader; his professors called him *l'enfant terrible*. In 1882, Angrand left the provinces and moved to Paris, the capital of the avant-garde. Assured of a steady income by his job as a mathematics teacher at the Collège Chaptal, he took an art studio as well. His neighbors were Claude Monet, Henri de Toulouse-Lautrec, and three young painters who were to become his greatest friends and were to exert a profound influence on his work—Georges Seurat, Paul Signac, and Maximilien Luce. Angrand adopted their pointillist manner of painting with small dots of divided color. He was especially close to Seurat, whom he helped in the preparation of motifs for the *Grand Jatte* of 1886; Seurat was the first to acquire a work by Angrand. Along with Signac, the two were invited to exhibit in Brussels with Les Vingt, a society of avant-garde artists. Angrand later helped to found the Société des Artistes Indépendants in Paris, and exhibited annually with them. Deaths in his family, and the death of Seurat in 1891, prompted Angrand to leave Paris for Rouen, the city of his youth, where he lived in seclusion for the last thirty years of his life. Nonetheless, he maintained an active correspondence with his neo-impressionist colleagues, and continued to paint and to exhibit his works. As a humanitarian and a pacifist he was deeply affected by World War I. Ironically, his peaceful sketching in the open air was twice interrupted by British troops, who mistakenly arrested him as a military spy.

Les Moissoneurs (The Harvesters) 1892
Oil on canvas, 31⅛ x 48⅝ inches, signed lower left: *CH ANGRAND-92*

PROVENANCE:

Mr. Mautouchet, Paris, purchased from the artist; Private collection, U.S.A.; Mrs. Audrey Jones Beck, Houston, 1986.

EXHIBITIONS:

Brussels, *Les Vingt, Eighth Annual Exhibition*, 1891, no. 2.
Paris, Pavillon de la Ville, *Seventh Exhibition of the Société des Artistes Indépendants*, 1891, no. 11.
Paris, Le Barc de Boutteville, *Fourth Exhibition of Expressionist and Symbolist Painters*, 1893, no. 6.
Paris, *Third Exhibition, Groupe des Peintres Neo-Impressionistes*, 1894.

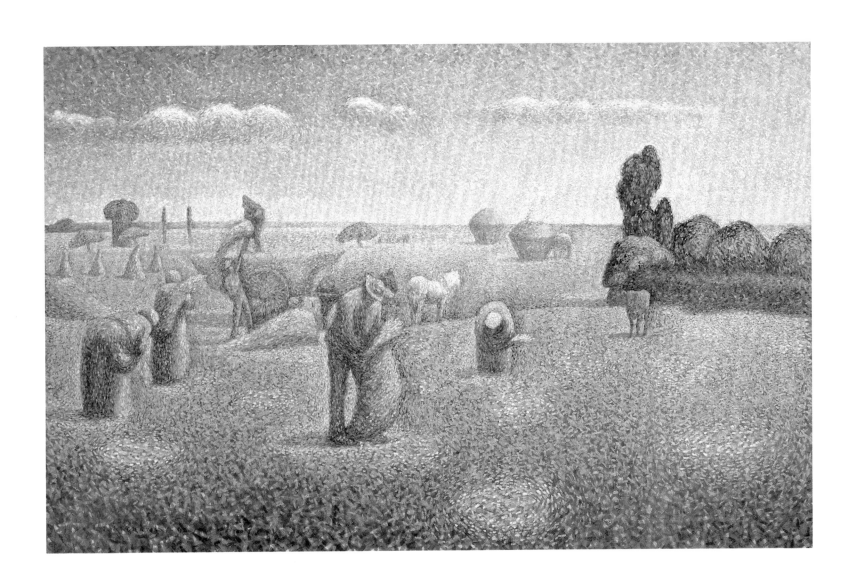

JEAN FRÉDÉRIC BAZILLE

Born 1841 Montpellier, France

Died 1870 Beaune-la-Rolande, France

LE PETIT JARDINIER (THE LITTLE GARDENER) c. 1866-67

The Little Gardener, like many of Jean Frédéric Bazille's works, is only partially finished. A lightly sketched silhouette of a woman is on the left, and the foreground is not complete. Bazille was exploring various compositional ideas in this painting; preparatory drawings in one of his sketchbooks, now in the Louvre, include two preliminary studies of the gardener and one of the landscape. The setting is Bazille's family garden in Méric, a residential area of Montpellier, where he produced many of his paintings during his brief career. Like Claude Monet and Pierre-Auguste Renoir in the 1880s, Bazille was intent on investigating the effects of sunlight on figures in the landscape. *The Little Gardener* reflects this experimental inclination. In its partially finished state, it reveals a rethinking of the overall composition.

Bazille often is referred to as the forgotten impressionist. He was killed in the Franco-Prussian War at the early age of twenty-nine, before the first of the exhibitions of independent artists. However, his brief career influenced the evolution of avant-garde art in the late nineteenth century. Bazille exhibited in the Paris Salon and won critical acclaim. During his life he produced only forty paintings, and most of these remained in his family's estate for decades. A descendant of Montpellier's prominent sixteenth-century Huguenots, Bazille was born into a family of prosperous wine growers. His interest in art was stimulated by a neighbor, Alfred Bruyas, who had assembled a significant collection of modern art. Bazille attended medical school at his father's request and at the same time studied at the Ecole des Beaux-Arts in the studio of Charles Gleyre. After failing his medical examination, Bazille concentrated on his art. He painted in the Forest of Fontainebleau with his friends from Gleyre's studio, Monet, Renoir, and Alfred Sisley. Bazille shared a studio with Monet and aided him financially on numerous occasions, for instance by the purchase of *Femmes Au Jardin,* which had been rejected by the Salon. It was later recognized as an important work of art which became a part of the Musée du Jeu de Paume collection, and is now in the Musée d'Orsay, Paris. At times Bazille served as a model for his friends, and appears, for example, in Monet's version of *Le Dejeuner sur L'Herbe,* painted in 1866, which is now exhibited at the Musée d'Orsay, Paris. He regularly attended the theater, opera, and the weekly salon of Madame Lejosne, his cousin, where poets, writers, and composers con-gregated. Bazille died in the war before realizing his full artistic potential. A major retrospective of his modest output was not assembled until more than a century after his death.

Le Petit Jardinier (The Little Gardener) c. 1866-67
Oil on canvas, 50⅜ x 66½ inches

PROVENANCE:

Family of the artist; Frédéric Bazille; Madame Hérisson, Montpellier; Jacques Fischer, Paris; Sophie Marie Jordan, Paris; Heim Gallery, London; The Museum of Fine Arts, Houston, The John A. and Audrey Jones Beck Collection, 1976

BIBLIOGRAPHY:

Gaston Poulain, *Bazille et ses Amis,* Paris, 1932, no. 22.
François Daulte, *Frédéric Bazille et son Temps,* Geneva, 1952, p. 177 no. 27.
J. Patrice Marandel and François Daulte, *Frédéric Bazille and Early Impressionism,* Chicago, 1978, p. 59, no. 19, ill.
J. Patrice Marandel in William C. Agee, ed., *The Museum of Fine Arts, Houston: A Guide to the Collection,* Houston, 1981, pp. 102-103, no. 178, ill.

EXHIBITIONS:

Montpellier, Exposition Internationale de Montpellier, *Rétrospective Bazille,* 1927, no. 32, as *Parc de Méric.*
Montpellier, Musée Fabre, *Bazille Centenary Exhibition,* 1941, no. 22.
Paris, Galerie Wildenstein, 1950, no. 19.
Montpellier, Musée Fabre, exhibition organized in honor of the XVII Congrès de l'Association des Pédiatres de Langue Française, 1959, no. 11.
Chicago, The Art Institute of Chicago, *Frédéric Bazille and Early Impressionism,* 1978, no. 19.

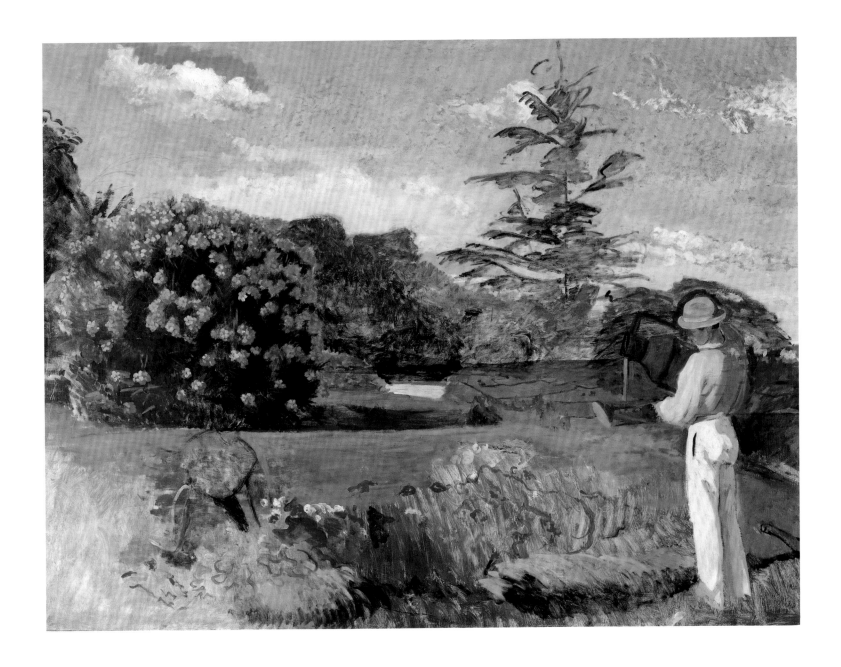

ÉMILE BERNARD

Born 1868 Lille, France

Died 1941 Paris, France

JEUNE FILLE BRÉTONNE (BRETON GIRL WITH A RED UMBRELLA) 1888

Emile Bernard developed a painting style known as cloisonnism, so called for its resemblance to cloissonné enamels. *Breton Girl with a Red Umbrella* demonstrates the component elements of the cloisonnist style, in which areas of flat or unmodulated color are separated by dark outlines. This panel, which has traditionally been called a portrait of Bernard's sister Madeleine, was painted on a wooden door of the old post office in the Brittany village of Pont-Aven. Working directly on the stained panel, Bernard left areas of the dark red wood exposed. In fact, what appears to be the picture frame is part of the same panel.

Although respected in academic circles and by fellow students such as Henri de Toulouse-Lautrec and Louis Anquetin, Bernard was expelled from the Ecole des Beaux-Arts in 1886 for insubordination. Despite the fact that his father vehemently opposed his desire to become a painter, during the next two years his contacts with Vincent van Gogh and Paul Gauguin encouraged him to continue. Bernard knew Paul Signac and experimented with pointillism, but it was the development of cloisonnism which proved to be the painter's great contribution. His early inspiration came from the stained glass windows of his friend Anquetin's home. As Bernard was to recount later, the simplicity of design in Japanese prints was also influential in the creation of cloisonnism. In 1888 he and Gauguin worked together in Pont-Aven. Gauguin's subsequent adoption of the cloisonnist manner and his later fame have until recently overshadowed Bernard's contribution to the development of avant-garde painting in the 1880s and 1890s.

Jeune Fille Brétonne (Breton Girl with a Red Umbrella) 1888
Oil on panel, 25⅛ x 23¼ inches inside, 32⅞ x 30½ inches overall, signed upper right *Bernard 1888*.

PROVENANCE:

Private collection, Pont-Aven; Jean-Marie Lenaour, Pont-Aven; Philippe Perronneau, Dijon, 1969; Mr. and Mrs. John A. Beck, Houston, 1969

BIBLIOGRAPHY:

Bogomila Welsh-Ovcharov, *Vincent van Gogh and the Birth of Cloisonnism*, Toronto, 1981, pp. 264-65, fig. 108.
Jean-Jacques Luthi, *Emile Bernard, Catalogue raisonné de l'oeuvre peint*, Paris, 1982, pp. 28-29, no. 143, ill.
Theodore Reff, *Manet and Modern Paris*, Chicago, 1982, p. 256.

EXHIBITIONS:

Houston, The Museum of Fine Arts, Houston, *The Collection of John A. and Audrey Jones Beck*, 1974, pp. 12-13.

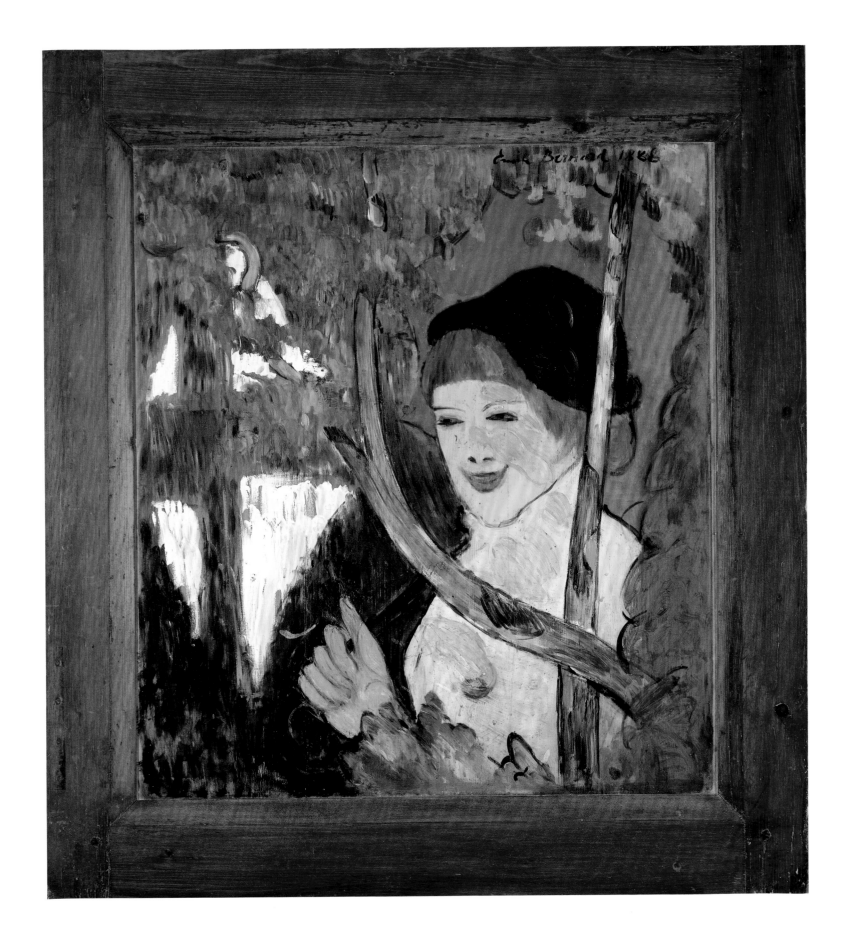

PIERRE BONNARD

Born 1867 Fontenay-aux-Roses, France

Died 1947 Le Cannet, France

DANS L'ATELIER DU PEINTRE (IN THE PAINTER'S STUDIO) 1905

Pierre Bonnard loved to paint scenes of private interiors. *In the Painter's Studio* describes the Hungarian artist Joseph Rippl Ronai and his wife, a cousin of the sculptor Aristide Maillol. The painting shows the artist at work, his wife entering the studio, and their dog running to greet her. This style of painting came to be called intimism, and Bonnard and Edouard Vuillard were its acknowledged masters. Although Bonnard's post-World War I works are noted for vibrancy of color, the somber hues and dim lighting of this early painting recall the tradition of seventeenth-century Dutch domestic scenes; however, it is painted with a broken brushstroke indebted to early impressionist paintings of the 1870s.

Bonnard enjoyed a tranquil childhood. He grew up at Fontenay-aux-Roses near Paris and at the family estate, Le Grand-Lemps, near Côte-Saint-André. His grandmother introduced him to art, but his family urged him to study law. While still in law school, Bonnard attended the Académie Julian, where he met Paul Sérusier in 1887. On completion of his law degree in 1888, Bonnard enrolled at the Ecole des Beaux-Arts, where he befriended Vuillard. In 1888 Bonnard joined Sérusier, Vuillard, Maurice Denis, and Félix Vallotton; this progressive group of painters called themselves "nabis" after an ancient Hebrew word meaning prophet. From this association the strong friendship between Bonnard and Vuillard developed. In his Paris studio in 1891, Bonnard designed a poster, *France-Champagne,* which became widely known and inspired Henri de Toulouse-Lautrec to make his first poster of the Moulin Rouge. When *In the Painter's Studio* was executed, Bonnard was already recognized for his posters, book illustrations, and color prints published by Ambroise Vollard; he had a one-man exhibition at the Galerie Durand-Ruel, made appearances at the Salon des Indépendants and the Galerie Le Barc de Boutteville, and won favorable criticism in Thadée Natanson's influential publication, *La Revue Blanche.*

Dans L'Atelier du Peintre (In the Painter's Studio) 1905
Oil on canvas, 17¾ x 16¾ inches, signed lower right: *Bonnard*

PROVENANCE:

Ambroise Vollard, Paris; Collection Bignou, Paris; M. Kaganovitch, Paris; Mme. Loeb, Paris; Emil Bührle, Zurich, 1954; Marlborough Fine Art Ltd., London, 1962; Mr. and Mrs. John A. Beck, Houston, 1964

BIBLIOGRAPHY:

Jean and Henry Dauberville, *Bonnard: Catalogue Raisonné de l'oeuvre peint,*
 4 vols., Paris, 1965-74, vol. 1, no. 359, p. 315.

EXHIBITIONS:

Zurich, Kunsthaus, *Sammlung Emil G. Bührle,* 1958, no. 260.
London, Marlborough Fine Art, *French Masters,* 1962, no. 1.
Houston, The Museum of Fine Arts, Houston, *The Collection of John A.
 and Audrey Jones Beck,* 1974, pp. 14-15.

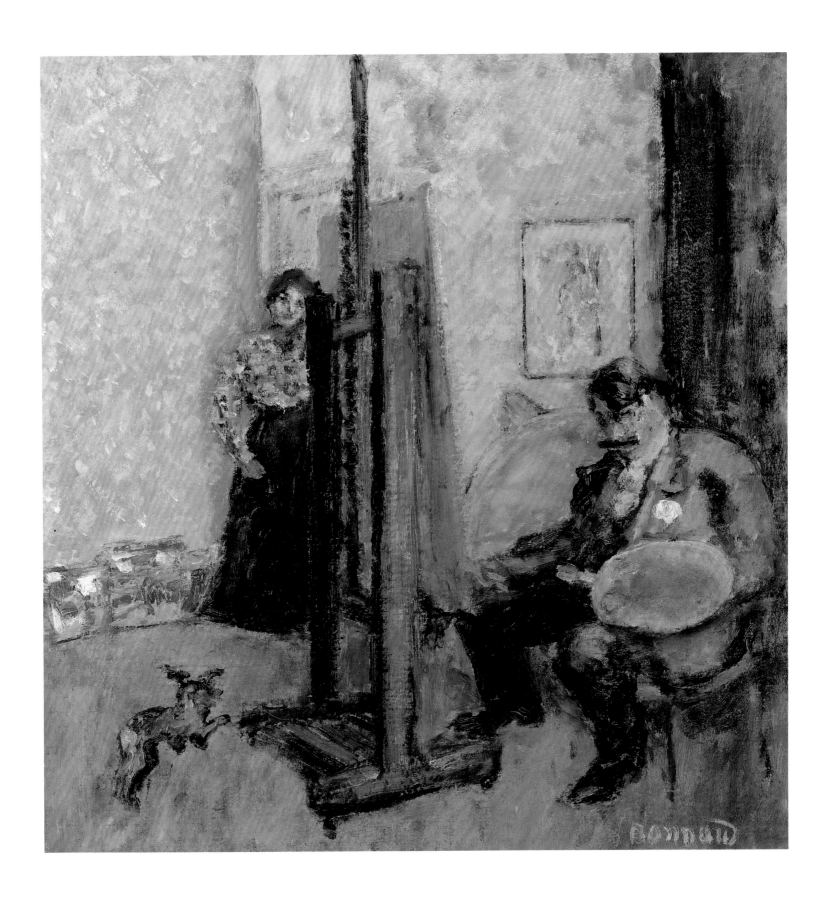

PIERRE BONNARD

Born 1867 Fontenay-aux-Roses, France

Died 1947 Le Cannet, France

TOILETTE AU BOUQUET ROUGE ET JAUNE (DRESSING TABLE AND MIRROR) 1913

Pierre Bonnard, like many artists at the end of the nineteenth century, was influenced by Japanese prints, which were widely known in western Europe from mid century. A famous Japanese exhibition in Paris in 1893 featured scenes of women with mirrors at their toilettes. The figures in these prints were cropped in ways new to western eyes. From 1907, Bonnard, called by his friends "the very Japanese Nabi," was inspired by such images and by the example of Edgar Degas' bathers. He returned repeatedly to the theme of the nude woman bathing or preparing her toilette in the privacy of her bedroom or bath. The mirror appears often in these paintings as a pictorial device. In *Dressing Table and Mirror*, Bonnard creates an intimate environment which proves to be a complex composition. The painting is filled with personal images and meanings. The clutter on the dressing table includes a cherry-decorated vase, won by Bonnard at a fair in Verona, containing wild flowers and poppies from his garden. The reflection in the mirror is the partial image of Bonnard's mistress, Marthe, and one of his dachshunds. There is a tenderness in Bonnard's paintings of Marthe, who was a favorite subject of his work for more than fifty years. Marthe, a habitual bather, often appears at her toilette. This painting is one in a series of depictions of her that Bonnard completed between 1907 and 1914. In 1925 a snide remark about Bonnard and Marthe living together prompted them to marry, a thought which had not occurred to them during their thirty-year relationship.

Although Bonnard trained to become a lawyer, he turned to painting and studied at the Académie Julian and the Ecole des Beaux-Arts. In their youth in Paris, Bonnard and his lifelong friend Edouard Vuillard belonged to a group of painters called the nabis (after the Hebrew word for prophet). Since both artists painted private domestic scenes like *Dressing Table and Mirror*, they became known as intimists. Early in his career Bonnard enjoyed critical acclaim. In 1891 he received favorable reviews for paintings shown in the Salon des Indépendants and in the first group exhibition of the nabis at the Galerie Le Barc de Boutteville. Throughout his life Bonnard was acclaimed, although his patrons remained mostly European. With the exception of paintings in the Phillips Collection in Washington, D.C., his work was not widely collected in the United States until after World War II.

Toilette au Bouquet Rouge et Jaune (Dressing Table and Mirror) 1913
Oil on canvas, 48⅞ x 45¹⁵/₁₆ inches, signed upper right: *Bonnard*

PROVENANCE:

Galerie Bernheim-Jeune, Paris, acquired from the artist in 1913; Elsa Lampe Guaita; Private collection, 1947; Private collection, Lugano, 1948; Galerie Georges Moos, Geneva-Zurich; Sam Salz, Inc., New York; Mr. and Mrs. Gustave M. Berne, Great Neck, New York, 1964; Acquavella Galleries, New York, 1967; Mr. and Mrs. John A. Beck, Houston, 1967; The Museum of Fine Arts, Houston, The John A. and Audrey Jones Beck Collection, 1974

BIBLIOGRAPHY:

François-Joachim Beer, *Pierre Bonnard*, Marseilles, 1947, pl. 10.
John Rewald, *Pierre Bonnard*, New York, 1948, p. 89.
Heinrich Rumpel, *Bonnard*, Berne, 1952, pl. 44.
Michael Benedikt, "The Continuity of Pierre Bonnard," *Art News*, vol. 63, 1964, pp. 20 and 56.
Jean and Henry Dauberville, *Bonnard: Catalogue Raisonné de l'oeuvre peint*, 4 vols., Paris, 1965-1974, vol. 2, no. 773.
Ronald Pickvance, "New Look at Bonnard at Los Angeles County Museum of Art," *Connoisseur*, vol. 158, April 1965, pp. 272-75, ill.
Annette Vaillant, *Bonnard ou le Bonheur de voir*, Neuchâtel, 1965, p. 198.
Judith McCandless Rooney, in William C. Agee, ed., *The Museum of Fine Arts, Houston: A Guide to the Collection*, Houston, 1981, p. 138, no. 231 and pl. 31.
Annie Pérez, "Bonnard, ou le Temps Arrêté," *Beaux Arts Magazine*, no. 11, March 1984, pp. 33-37, ill.
Janet Hobhouse, "Nudes, The Vision of Egon Schiele and Pierre Bonnard," *Connoisseur*, 214, no. 868, June 1984, pp. 100-109, ill.
Diane Kelder, *The Great Book of Post-Impressionism*, New York, 1986, pp. 333-34, no. 363, ill.

EXHIBITIONS:

Paris, Galerie Bernheim-Jeune, *Bonnard: oeuvres récentes (deux panneaux décoratifs et des tableaux)*, 1913, no. 1.
Cleveland/New York, The Cleveland Museum of Art/The Museum of Modern Art, *Pierre Bonnard*, 1948, no. 39, p. 89.
New York, Fine Arts Associates, *Bonnard, an Intimate Selection*, 1954, no. 6.
New York/Chicago/Los Angeles, The Museum of Modern Art/The Art Institute of Chicago/Los Angeles County Museum of Art, *Bonnard and His Environment*, 1964-65, no. 27, p. 74.
Washington, D.C., National Gallery of Art, *U.S. Loan Exhibition*, 1971-73.
Houston, The Museum of Fine Arts, Houston, *The Collection of John A. and Audrey Jones Beck*, 1974, pp. 16-17.
Tokyo/Kobe/Nagoya/Fukuoka, Takashimaya Art Gallary/Hyogo Prefectural Museum of Modern Art/Aichi Prefectural Museum/Fukuoka Museum of Art, *Bonnard in Japan*, 1980-81, no. 33.
Paris/Washington, D.C./Dallas, Centre Georges Pompidou/The Phillips Collection/Dallas Museum of Art, *Bonnard, The Late Paintings*, 1984, no. 7, p. 120.

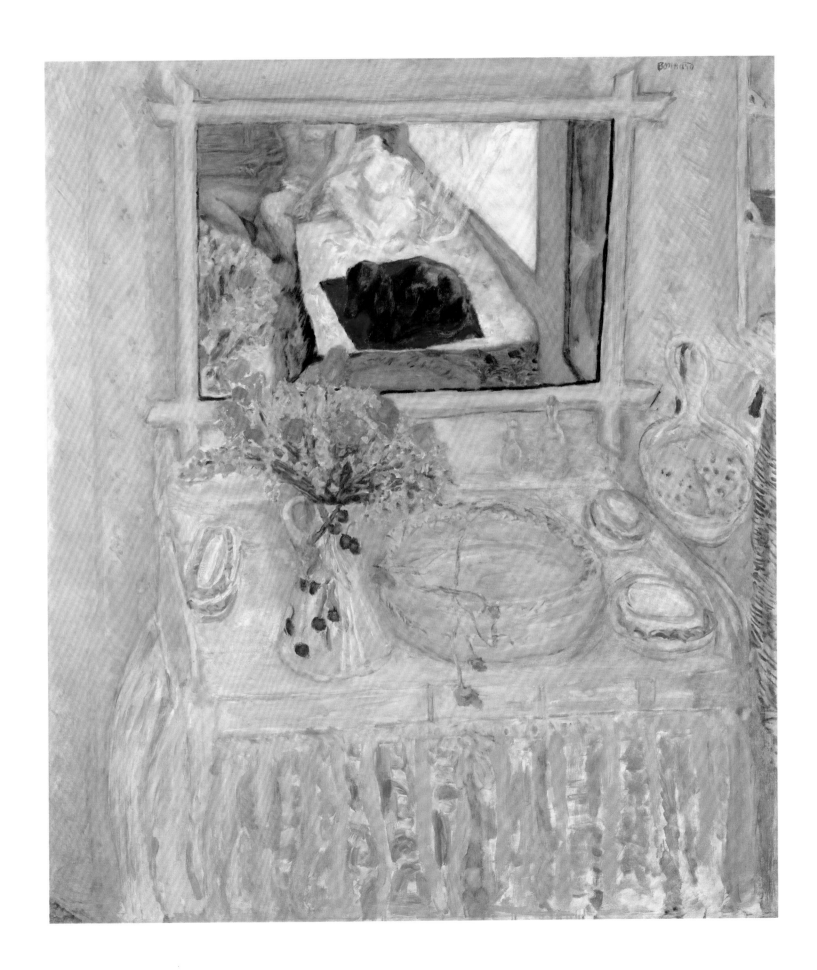

LOUIS-EUGÈNE BOUDIN

Born 1824 Honfleur, France

Died 1898 Deauville, France

FEMMES DE PÊCHEURS AU BORD DE LA MER
(FISHERMEN'S WIVES AT THE SEASIDE) 1872

Although the majority of Eugène Boudin's beach scenes represent the fashionable rich at play, he was equally interested in the life of the more humble inhabitants of the coastal towns in which he preferred to work. *Fishermen's Wives at the Seaside* was painted on the Brittany coast, to which Boudin returned many times to pursue his art. The figures and activity represented, while important for the meaning of the work, serve principally as a foil for the dramatic cloud effects that are the real focus of this picture. Boudin's skies, which typically cover at least half the surface of each canvas, were such a distinctive component in his paintings that his artist friend Camille Corot declared him "king of the skies."

Boudin, the son of a seaman, spent most of his life near the ocean. With no formal training as a painter, he embarked on this career at the age of twenty-three. Encouraged by Jean-François Millet, he first went to Paris in 1847 to study at the Musée du Louvre. Three years later, a fellowship from the city of Le Havre enabled him to study with the marine painter Eugène Isabey. He established a Parisian studio on the Boulevard Montmartre in 1859, but for Boudin, Paris was simply a place to study, to exhibit, and to sell his paintings. In 1858 he introduced the eighteen-year-old Claude Monet to the joys of painting out of doors, and throughout the next decade they often worked together in the summers at the fashionable beach resorts of Normandy or the fishing villages of Brittany. Boudin, the precursor in France of the impressionists, was acknowledged by Monet as an important force in the younger artist's own development. Boudin's popularity grew steadily in his later years. By his death in 1898, he had become a well-known painter in France, besieged with commissions, and he had been awarded the Cross of the Legion of Honor by the State.

Femmes de Pêcheurs au Bord de la Mer (Fishermen's Wives at the Seaside) 1872
Oil on panel, 15¼ x 22 inches, signed and dated lower right: *E. Boudin 72*

PROVENANCE:

Hecquet Family Collection, Grenoble, France; Sale, Paris, Palais Galliéra, *Tableux Modernes,* June 21, 1966, no. 191; Etudes Rheimset et Laurin, Paris, 1966; Mr. and Mrs. John A. Beck, Houston, 1966.

BIBLIOGRAPHY:

Robert Schmit, *Eugène Boudin 1824-1898,* Paris, 1973, vol. 1, p. 283, no. 789.

EXHIBITIONS:

Houston, The Museum of Fine Arts, Houston, *The Collection of John A. and Audrey Jones Beck,* 1974, pp. 18-19.

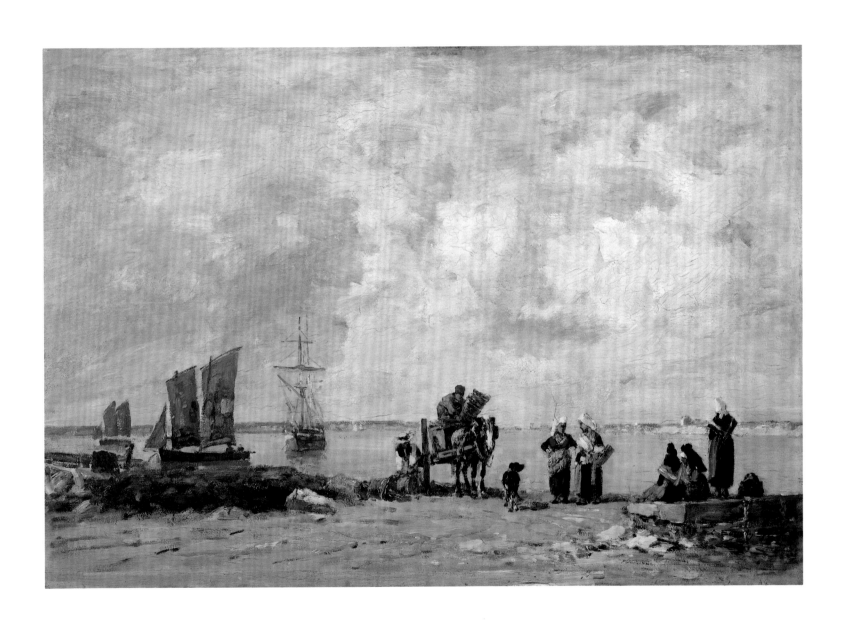

GEORGES BRAQUE

Born 1882 Argenteuil, France

Died 1963 Paris, France

LE CANAL SAINT MARTIN (THE SAINT MARTIN CANAL) 1906

When fauvism shocked the art world in 1905 at the Salon d'Automne, Georges Braque's childhood friend from Le Havre, Emil-Othon Friesz, was among the exhibitors. Impressed by the flamboyant display of color and freedom of composition, Braque began painting in the fauve style while working with Friesz in Antwerp, Belgium, during the summer of 1906. In the autumn of that year, he painted the Saint Martin Canal, a commercial waterway in Paris, transformed on canvas by the use of vivid fauve colors. The composition is based on prototypes from the impressionist generation, but Braque suffuses the cityscape with unexpected colors: the sky and earth are touched with a purple hue, and the water of the canal is flashed with confetti-like strokes of red, white, and green. Boldly conceived and executed, like Braque's other paintings of this period, *The Saint Martin Canal* is a forceful expression of personal temperament.

Eight years after Braque was born, his family moved to Le Havre. There he painted the port and rocky seashore on weekends with his father and grandfather and attended evening classes at the local Ecole des Beaux-Arts. At the age of twenty, Braque seriously took up the study of art and joined his friends Raoul Dufy and Othon Friesz in Paris at the Académie Humbert. He briefly attended the Ecole des Beaux-Arts, and the friends he made at these two academies were to become the leaders of the fauve movement: Henri Matisse, André Derain, Maurice de Vlaminck, Albert Marquet, Kees van Dongen, and Louis Valtat. The work of these artists inspired Braque, and for two years he painted in the fauve manner, producing some forty canvases. At the time Braque painted *The Saint Martin Canal,* his work came to the attention of the art dealer Daniel-Henri Kahnweiler, who purchased his paintings and supported his career. Braque's art, like that of his friend Pablo Picasso, underwent a radical stylistic evolution in the first decades of the twentieth century, but it was his works of the fauve era which marked his decisive break from the conventions of academic realism.

Le Canal Saint Martin (The Saint Martin Canal) 1906
Oil on canvas, 19¾ x 24 inches, signed: *G. Braque* verso

PROVENANCE:

Daniel-Henry Kahnweiler, purchased from the artist, c. 1909; Sale, *Second Kahnweiler Sale,* Paris, Hotel Drouôt, November 17 and 18, 1921, lot 25; Dr. Koch, Frankfurt; Eric A. Alport, Oxford, 1925; Sale, London, Christie's, *Important Impressionist and Modern Drawings, Paintings, and Sculpture,* June 28, 1968, lot 52; Mr. and Mrs. John A. Beck, Houston, 1968

BIBLIOGRAPHY:

Henry R. Hope, *Georges Braque,* New York, 1949, p. 18, ill.

EXHIBITIONS:

London, Institute of Contemporary Arts Gallery, *Braque, paintings and drawings from collections in England with lithographs,* 1954, no. 2.
London/Edinburgh, Tate Gallery/Royal Scottish Academy, *Georges Braque,* 1956, no. 6.
Munich, Haus der Kunst, *Georges Braque,* 1963, no. 6.
Austin, The University of Texas Art Museum, *Fauve-Color,* 1972, no. 1.
Washington, D.C., National Gallery of Art, *U.S. Loan Exhibition,* 1971-73.
Houston, The Museum of Fine Arts, Houston, *The Collection of John A. and Audrey Jones Beck,* 1974, pp. 20-21.

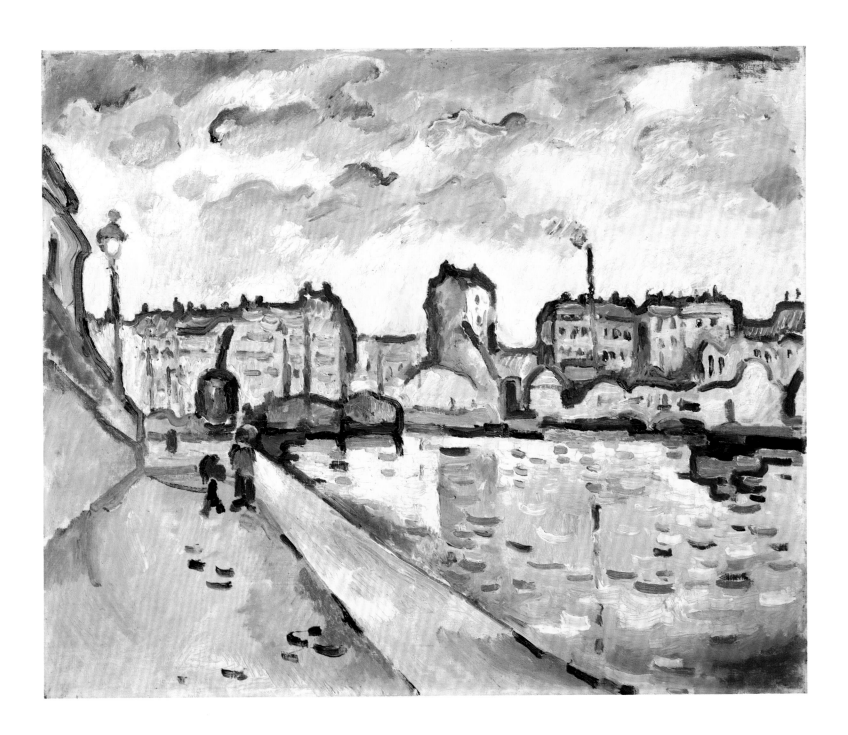

GEORGES BRAQUE

Born 1882 Argenteuil, France

Died 1963 Paris, France

BARQUES DE PÊCHES (FISHING BOATS) 1909

Fishing Boats was painted during the first year of Georges Braque's association with Pablo Picasso. Together the two artists formulated and produced the initial works of analytical cubism, so called because it sought to analyze forms, breaking them down into their component parts. The term cubism came from Louis Vauxcelles, a dedicated enemy of the avant-garde, who described the early works of Braque and Picasso as resembling geometric diagrams or cubes. *Fishing Boats* portrays a typical fishing village on the Normandy coast, but instead of reacting to light or color, Braque restricted his palette to subtle earth tones and concentrated on the geometrical shapes of boats and buildings. His paintings of this period helped to establish one of the significant developments in the history of twentieth-century art.

Braque's interest in art began as a child, painting on weekends beside his father and grandfather and visiting local museums. He attended the Ecole des Beaux-Arts in Le Havre and at age nineteen moved to Paris. He studied for two years at the Académie Humbert, where he met Francis Picabia and Marie Laurencin and was encouraged to pursue his experimental inclinations. He progressed from an impressionist to a fauve style and then began to employ the geometrical elements he adopted from the work of Paul Cézanne. By 1909 he and Picasso had developed analytical cubism and dominated the movement in its early years. Although their works were nearly complete abstractions, in 1911 they introduced more realistic elements. During the cubist era, Braque and Picasso worked closely and produced paintings of amazing similarity. World War I interrupted Braque's career. As a soldier in the French army, he was severely wounded. When he returned to painting, his works were reminiscent of his fauve years, with elements of cubism suggested. He continued painting with characteristic tenacity until his death at the age of eighty-one.

Barques de Pêches (Fishing Boats) 1909
Oil on canvas, 36¼ x 28⅞ inches, signed lower right: *G. Braque*

PROVENANCE:

Galerie Kahnweiler, Paris; Galerie Bernheim-Jeune, Paris, 1930; Walter P. Chrysler, Jr., New York; Mrs. Marius de Zayas, Greenwich, Connecticut, 1965; Perls Galleries, New York; Sale, New York, Parke-Bernet Galleries, *Impressionist and Modern Paintings, Drawings, and Sculptures,* December 8 and 9, 1965, lot 60; Allan Bluestein, Washington, D.C., 1965; Sale, New York, Parke-Bernet Galleries, *Highly Important Impressionist and Modern Paintings, Drawings, and Sculpture: The Property of Allan Bluestein, Washington, D.C.,* April 3, 1968, lot 15; Mr. and Mrs. John A. Beck, Houston, 1968; The Museum of Fine Arts, Houston, The John A. and Audrey Jones Beck Collection, 1974

BIBLIOGRAPHY:

Carl Einstein, "Georges Braque," *XXᵉ Siècle*, Paris, 1934, pl. 5 (as *Leperrey*).
Sele Arte, no. 17, March-April 1955, pl. 51.
Maurice Gieure, *G. Braque,* Paris, 1956, pl. 15.
Stanislas Fumet, *Georges Braque,* Paris, 1965, p. 29.
Raymond Cogniat, "Braque," *Les Maîtres de la Peinture Moderne,* Paris, 1970, p. 11.
Douglas Cooper, *The Cubist Epoch,* 1970, pl. 18.
Christian Brunet, *Braque et l'espace,* Paris, 1971, no. 5.
Charles W. Millard, "Varieties of Cubism," *The Hudson Review,* Autumn 1971, vol. 24, no. 3, p. 447, ill.
Massimo Carra, Pierre Descargues, and M. Valsecchi, *Tout l'oeuvre peint de Braque 1908-1929,* Paris, 1973, no. 39.
Linda Dalrymple Henderson, "*The Fourteenth of July* by Roger de la Fresnaye," *Bulletin,* The Museum of Fine Arts, Houston, vol. 6, nos. 2-4, 1975-76, p. 5, ill.
Judith McCandless Rooney, in William C. Agee, ed., *The Museum of Fine Arts, Houston: A Guide to the Collection,* Houston, p. 125, no. 212 and pl. 30.
Nicole Worms de Romilly and Jean Laude, *Braque: Cubism 1907-1914,* Paris, 1982, no. 51, p. 105 (as *Le Port*).
Diane Kelder, *The Great Book of Post-Impressionism,* New York, 1986, p. 283, no. 305, ill.

EXHIBITIONS:

Basel, Kunsthalle, *G. Braque,* 1933.
London, Alex Reid & Lefevre Ltd., *Georges Braque,* 1934.
Los Angeles/New York, Los Angeles County Museum of Art/The Metropolitan Museum of Art, *The Cubist Epoch,* 1970-71, no. 17, pl. 18, p. 40.
Washington, D.C., National Gallery of Art, *U.S. Loan Exhibition,* 1971-73.
Houston, The Museum of Fine Arts, Houston, *The Collection of John A. and Audrey Jones Beck,* 1974, p. 20.

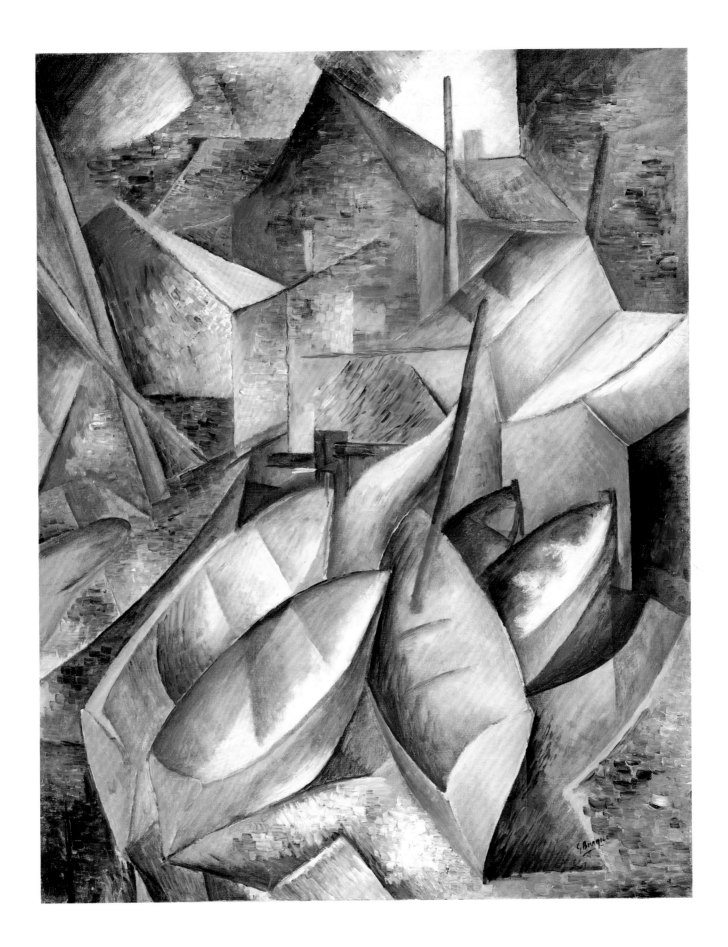

GUSTAVE CAILLEBOTTE

Born 1848 Paris, France

Died 1894 Petit-Gennevilliers, France

MADEMOISELLE BOISSIÈRE TRICOTANT (MADEMOISELLE BOISSIÈRE KNITTING) 1877

Like Edgar Degas and Edouard Manet, Gustave Caillebotte regularly painted domestic scenes of family life, such as this portrait of his father's sister-in-law, *Mlle. Boissière Knitting*. She may be working on one of the patterns that Caillebotte designed for needlework. He sometimes incorporated these doilies, table-cloths, and curtains into his paintings. This painting reveals a tendency to hard-biting realism in portraying the distinct home-liness of Mlle. Boissière. The artist's uncompromising attention to her pouting expression is played off against his delicate, almost facile rendering of the beautiful textures and patterns of mar-quetry, wallpaper, and chintz.

Born into an affluent Parisian family, Caillebotte enjoyed the privileges of wealth, which included a lifelong interest in collecting art. While a student at the Ecole des Beaux-Arts, he met the painter Edgar Degas, who introduced him into the new circle of independent painters later known as impressionists. In 1876 Caillebotte participated in the second of their exhibitions, where his strikingly original compositions, with their unusual perspectives and subject matter, attracted attention. After these felicitous beginnings, however, his name became almost unknown, except as the donor of the greatest collection of impressionist paintings to enter the museums of the French nation. His bequest, only partially accepted at the time of his death, included works by all of the impressionists to whom he was both friend and patron.

Mademoiselle Boissière Tricotant (Mademoiselle Boissière Knitting) 1877
Oil on canvas, 25⅝ x 31½ inches
signed and dated lower right: *G. Caillebotte 1877*

PROVENANCE:

Caillebotte Family Collection, Paris; Bernard Lorenceau, Paris; Feilchenfeldt Galleries, Zurich; Mr. and Mrs. John A. Beck, Houston, 1968

BIBLIOGRAPHY:

J. Kirk T. Varnedoe and Thomas P. Lee, *Gustave Caillebotte, a Retrospective Exhibition*, Houston, 1976, no. 30, p. 118.
Marie Berhaut, *La Vie et l'oeuvre de Gustave Caillebotte*, Paris, 1951, no. 31.
Marie Berhaut, *Caillebotte: sa vie et son oeuvre, catalogue raisonné des peintures et pastels*, Paris, 1978, no. 68, p. 104.

EXHIBITIONS:

Paris, 28, Avenue de l'Opéra, *4me Exposition de Peinture*...(Fourth impressionist exhibition), 1879, no. 21.
Troyes, France, Musée de Troyes, *Renoir et ses Amis*, 1969, p. 36, no. 49 (as *Le Tricot*).
Houston/Brooklyn, The Museum of Fine Arts, Houston/The Brooklyn Museum, *Gustave Caillebotte, a Retrospective Exhibition*, 1976-77, p. 118, no. 30.

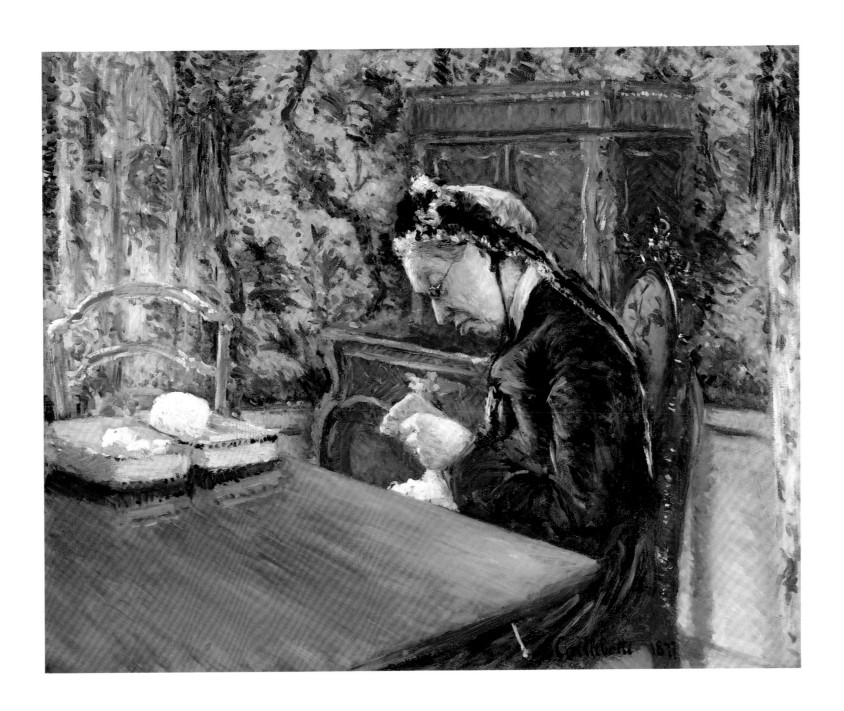

GUSTAVE CAILLEBOTTE

Born 1848 Paris, France

Died 1894 Petit-Gennevilliers, France

LES ORANGERS (THE ORANGE TREES) 1878

In *The Orange Trees* Caillebotte conveys the relaxed mood of his brother Martial, their cousin Zoe, and the family dog. In this delightful scene the artist gives a glimpse of his own lifestyle: comfortable, long years at his parents' villa in Yerres, Seine et Oise, and later at his own villa in Petit-Gennevilliers on the Seine River across from Argenteuil. Both of the properties had spectacular gardens where Caillebotte, an avid gardener, entertained his friends Claude Monet, Pierre-Auguste Renoir, Paul Signac, Edgar Degas, and Paul Cézanne. *The Orange Trees* shows that Caillebotte could transform a simple scene from everyday life into a quiet drama. In his hands, the harmony between man and nature charges the painting with life.

Caillebotte is remembered today principally for his bequest of paintings to France. At the age of twenty-eight he began exhibiting with the impressionists and helped to sponsor many of their exhibitions during the following years. Caillebotte was one of the few painters of his era to have a large fortune which permitted him not only to purchase works by his fellow artists but also to provide them with financial aid. Had he been compelled to live by the sale of his paintings, his work would have passed into galleries and auctions and become better known. Because of his relatively stable resources, Caillebotte gave many of his pictures to relatives and friends in whose collections they remained hidden from the public eye.

Les Orangers (The Orange Trees) 1878
Oil on canvas, 61 x 46 inches, signed and dated lower left: *G. Caillebotte 78*

PROVENANCE:

Caillebotte Family Collection, Paris; Bernard Lorenceau, Paris; Feilchenfeldt Galleries, Zurich, 1968; Mr. and Mrs. John A. Beck, Houston, 1968

BIBLIOGRAPHY:

Marie Berhaut, *Caillebotte: sa vie et son oeuvre, catalogue raisonné des peintures et pastels,* Paris, 1978, pl. 87, p. 111.
J. Kirk T. Varnedoe and Thomas P. Lee, *Gustave Caillebotte, a Retrospective Exhibition,* Houston, 1976, no. 38, p. 128.
George T. M Shackelford and Mary Tavener Holmes, *A Magic Mirror: The Portrait in France 1700–1900,* Houston, 1986, no. 39, pp. 110, 111, 137, ill.

EXHIBITIONS:

Houston, The Museum of Fine Arts, Houston, *The Collection of John A. and Audrey Jones Beck,* 1974, pp. 22-23.
Houston/Brooklyn, The Museum of Fine Arts, Houston/The Brooklyn Museum, *Gustave Caillebotte, a Retrospective Exhibition,* 1976-77, no. 38, p. 128.
Houston, The Museum of Fine Arts, Houston, *A Magic Mirror: The Portrait in France 1700–1900;* 1986-87, no. 39.

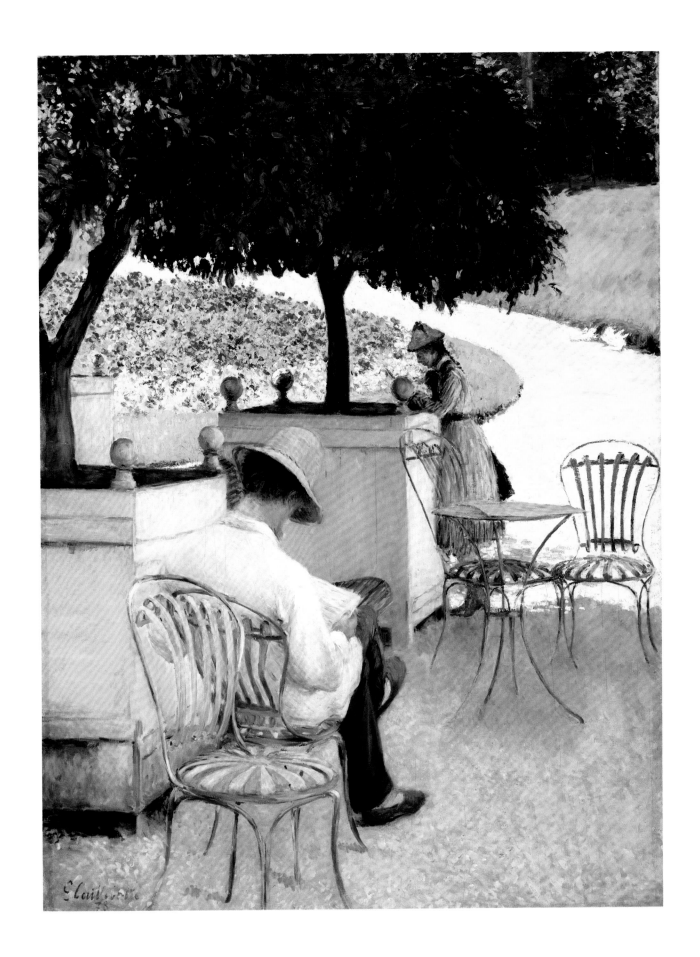

MARY CASSATT

Born 1844 Allegheny City, Pennsylvania

Died 1926 Mesnil-Théribus, France

SUSAN CONSOLANT L'ENFANT (SUSAN COMFORTING THE BABY) c.1881

Mary Cassatt, recognized as the leading American impressionist, painted portraits, genre scenes, and most notably, images of mothers and children. This painting is among her earliest depictions of women with children. In 1880, when her nephews and nieces traveled from America to visit her in France, she was able to study the intimate relationship between mother and child. More and more she directed her art toward domestic scenes, rendering them in a straightforward manner, free from sentimentality. This directness gave her art a power and freedom that is seldom associated with pictures of mothers and children. Susan was a cousin of Mathilde Vallet, Mary Cassatt's loyal companion and maid, to whom the artist left all the works in her studio at the time of her death.

After five years of training at the Pennsylvania Academy of Fine Arts, Mary Cassatt, at the age of twenty-four, moved to Paris to study art independently. Although her family did not take her art seriously, they did encourage her in 1875 to study with the well-known academician Charles Chaplin. She did so only briefly, preferring to copy the works of old masters to discover their secrets. Cassatt spent most of her time in the Louvre and other museums wherever she traveled. Her true mentors were Gustave Courbet, Edouard Manet, and Edgar Degas. She admired Degas' painting long before the two artists met in 1877. In that year, Degas invited her to join the impressionist group, although she did not exhibit with them until 1879. Cassatt and Degas remained close friends for forty years, until his death. Their relationship was punctuated with quarrels triggered by Degas' vitriolic temperament; Cassatt's self-control and tact usually healed the schisms. On his death Cassatt burned all of Degas' letters to her. Although Mary Cassatt spent much of her childhood and almost all her adult life and working career in Europe, she proclaimed herself to the end of her life "thoroughly American."

Susan Consolant L'Enfant (Susan Comforting the Baby) c. 1881
Oil on canvas, 25 x 38½ inches, signed lower left: *Mary Cassatt*

PROVENANCE:

Ambroise Vollard, Paris; Private collection, Paris, 1965; Howard Young Gallery, New York, 1965; Mr. and Mrs. John A. Beck, Houston, 1965; The Museum of Fine Arts, Houston, The John A. and Audrey Jones Beck Collection, 1974

BIBLIOGRAPHY:

"Exposition de l'Art Moderne à l'Hôtel de la Revue," *Les Arts,*
 vol. 2, August 1912, Paris, p. 15.
Arsène Alexandre, "Portraits de Cassatt à Picasso," *La Renaissance
 de l'Art,* July 1928, p. 269.
Apollo, vol. 18, November 1933, p. 340.
London Studio, January 1934, vol. 7, p. 27.
Adelyn Dohme Breeskin, *Mary Cassatt: A Catalogue Raisonné of the
 Oils, Pastels, Watercolors, and Drawings,* Washington, D.C., 1970,
 no. 112, pp. 68-69.
John Minor Wisdom, in William C. Agee, ed., *The Museum of Fine
 Arts, Houston: A Guide to the Collection,* Houston, 1981, p. 112,
 no. 193.

EXHIBITIONS:

Paris, Hôtel de la Revue, *Exposition de l'Art Moderne à l'Hôtel de la
 Revue,* Paris, 1912.
New York, M. Knoedler and Co., *Great Paintings from the Ambroise
 Vollard Collection,* 1933, no. 2.
New York, Wildenstein and Co., *Faces from the World of Impressionism
 and Post-Impressionism,* 1972, no. 10.
Houston, The Museum of Fine Arts, Houston, *The Collection of John
 A. and Audrey Jones Beck,* 1974, pp. 24-25.

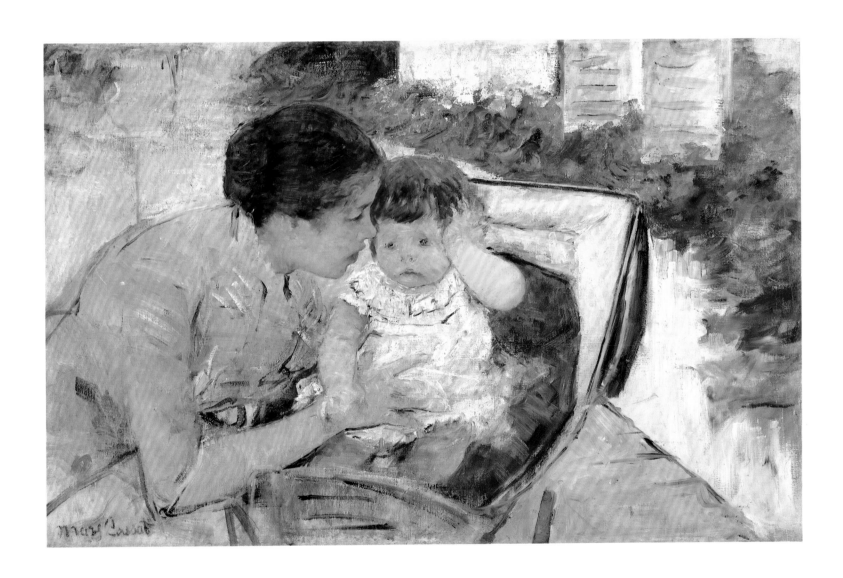

PAUL CÉZANNE

Born 1839 Aix-en-Provence, France

Died 1906 Aix-en-Provence, France

AU FOND DU RAVIN (BOTTOM OF THE RAVINE) c. 1879

Paul Cézanne found the noise and intrigue of Paris distracting, so he spent much of his life painting in the serene countryside near l'Estaque, a village on the Mediterranean near his family's home in Aix-en-Provence. In *Bottom of the Ravine,* painted in the vicinity of l'Estaque, Cézanne exploited the effects of the Mediterranean's strong sunlight illuminating and casting shadows on the craggy cliffs, pines, and olive trees. As *Bottom of the Ravine* demonstrates, Cézanne had begun to deviate from impressionism in the late 1870s, preferring to work in a more structural manner in which each element of the landscape was similarly painted and equally weighted, resulting in an intentionally unbalanced order of perspective.

Cézanne's beginnings as a painter were troubled by opposition from his father and failure to win entry to either the Ecole des Beaux-Arts or the Salon exhibitions. In 1861 Cézanne attended the Académie Suisse, and the following year he met Pierre-Auguste Renoir, Frédéric Bazille, Alfred Sisley, and Claude Monet, whose advanced opinions inspired and encouraged him. Camille Pissarro, in particular, had a profound influence on Cézanne in heightening his awareness of nature as the subject of art. On returning to his native Provence, Cézanne saw the landscape in a new perspective, not just as a background for mountain climbing and hunting. He rented a house at l'Estaque with Hortense Fiquet, who later became his wife. Cézanne's uncompromising, brutally painted early canvases dating from the late 1860s found little favor, but in spite of being routinely rejected, he continued to submit paintings to the official exhibitions well into the 1880s. Although he exhibited twice with the impressionists, in 1874 and 1877, it was only in the later 1880s that Cézanne's genius began to be recognized.

Au Fond du Ravin (Bottom of the Ravine) c. 1879
Oil on canvas, 28¾ x 21¼ inches

PROVENANCE:

Victor Chocquet, Paris; Sale, Mme. Chocquet, July 1–4, 1899, no. 4; Octave Mirabeau, Paris, 1899; Sale, Octave Mirabeau, February 24, 1919, no. 9; Galerie Bernheim-Jeune, Paris, 1919; Joseph Müller, Solothurn, 1920; Galerie Beyeler, Basel; Mrs. John A. Beck, Houston, 1978

BIBLIOGRAPHY:

Julius Meier-Graefe, *Cézanne und sein Kreis,* Munich, 1922, p. 146.
Georges Rivière, *Le Maître Paul Cézanne,* Paris, 1923, p. 209.
Amédée Ozenfant and Charles-Edouard Jeanneret (Le Corbusier), eds., *L'Esprit Nouveau,* no. 2, p. 142.
Elie Faure, *Paul Cézanne,* Paris, 1926, pl. 49.
Lionello Venturi, *Cézanne, son art—son oeuvre,* Paris, 1936, vol. 1, no. 400, p. 152.
Sandra Orienti, *The Complete Paintings of Cézanne,* London, 1972, no. 342, p. 102.
John Rewald, *The History of Impressionism,* New York, 1973, 4th edition, p. 465, ill.
Phyllis Hattis, "Zu den Bildern in der Schanzumühle," *du Europäische Kunstzeit-Schrift,* August, 1978, pp. 47, 49, ill.
Barbara Ehrlich White, *Renoir, His Life, Art, and Letters,* New York, 1984, p. 23, ill.

EXHIBITIONS:

Paris, Galerie Bernheim-Jeune, 1910, no. 33.
Paris, Galerie Bernheim-Jeune, 1914, as *Paysage Rocheux,* pl. 46.

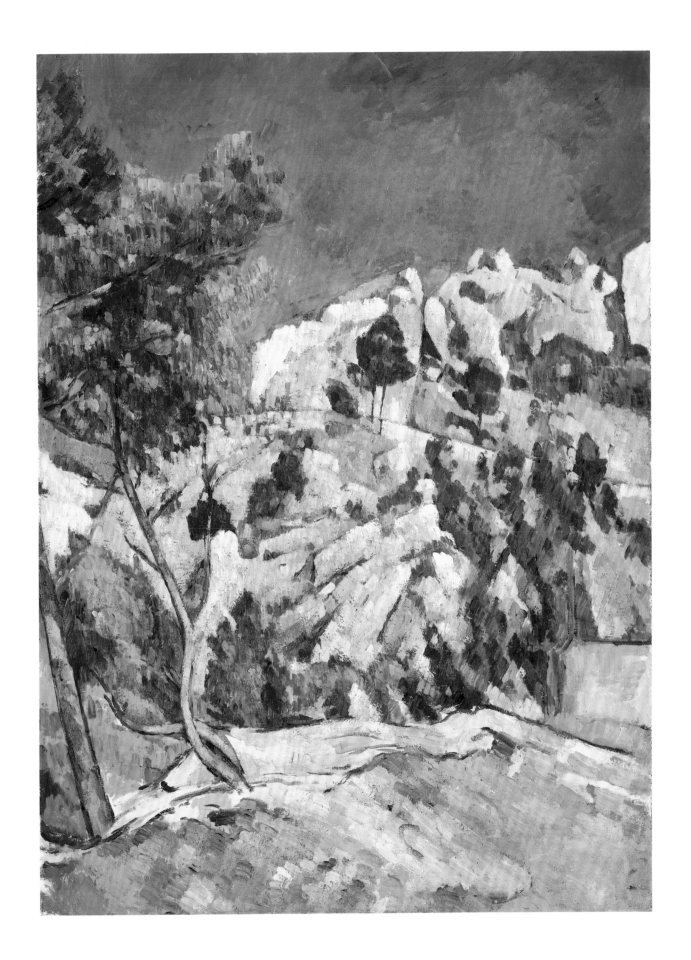

MARC CHAGALL

Born 1887 Vitebsk, Russia

Died 1985 Vence, France

LA FEMME ET LES ROSES (THE WOMAN AND THE ROSES) 1929

The theme of love was often favored by Marc Chagall. *The Woman and the Roses* is a fantasy of romantic love in which Chagall associates the beauty of women with the beauty of flowers, here in the form of an enormous bouquet. The unexpected juxtaposition of an arrangement of roses and lilacs and the reclining form of a nude (floating before a remembered view of Vitebsk, his native town) evokes the mood of a personal dream. Indeed, Chagall's wife Bella, whom he married in 1915, inspired many of his works, as did the fond memories of his boyhood in Russia.

Chagall was born into a religious family of modest means in the Russian town of Vitebsk. He studied at the imperial art school in St. Petersburg, where his teacher, the painter and theater designer Leon Bakst, encouraged his appreciation of French post-impressionist painting. Chagall spent the years 1910-14 in Paris, then returned to Russia, where he became director of the School of Fine Arts in Vitebsk in 1918. He worked prodigiously on paintings and theatrical decor and in 1923 returned to Paris. Chagall's compositions are lyrical variations on a few cherished themes, often touching on the rich history and customs of his Russian Jewish forebearers. Scenes of family and village life painted from memory long after Chagall left Russia often occur in his work. He was also a prolific illustrator, a designer of stage productions and of stained glass, and the painter of monumental decorative projects, including the ceiling of the Paris Opera House. The poet and critic Guillaume Apollinaire called Chagall's paintings "supernatural." A painter of dreams, Chagall himself avowed that "the inner world can be more real than the world of appearance."

La Femme et les Roses (The Woman and the Roses) 1929
Oil on canvas, 32½ x 39⅞ inches
signed and dated lower right: *Marc Chagall 1929*

PROVENANCE:

Felix Guien, Paris; Alex Maguy Galerie, Paris, 1963; Mr. and Mrs. John A. Beck, Houston, 1963

EXHIBITIONS:

Prague, Umelecka Beseda, 1931.
Paris, Galerie Bernheim-Jeune, *Voici des fruits, des fleurs, des feuilles et des branches,* 1957.
Paris, Alex Maguy Galerie de l'Elysée, *7 tableaux majeurs,* 1962, p. 5, ill.
Houston, The Museum of Fine Arts, Houston, *The Collection of John A. and Audrey Jones Beck,* 1974, pp. 26-27.

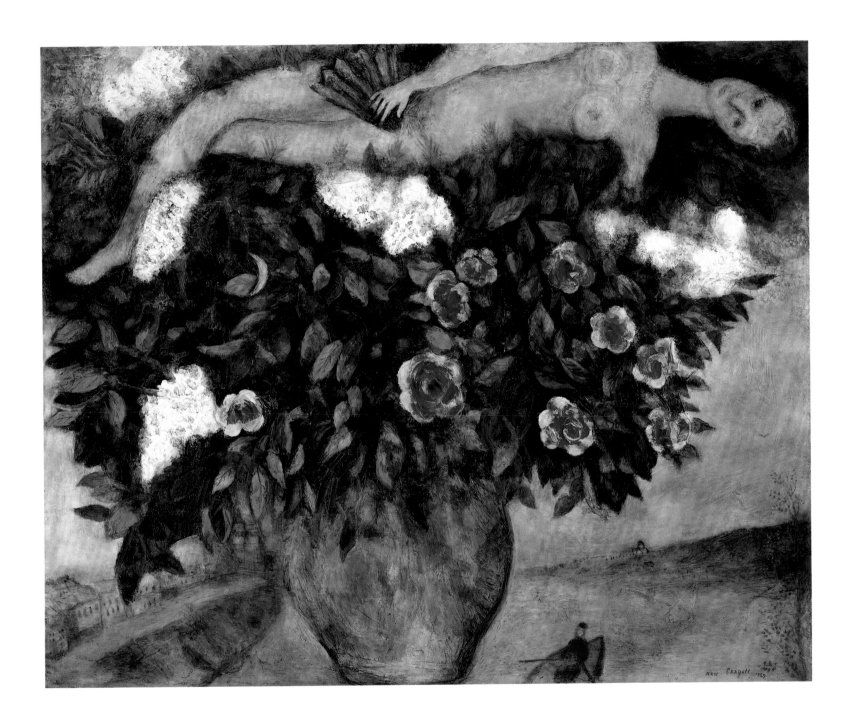

HENRI-EDMOND CROSS

Born 1856 Douai, France

Died 1910 Saint Clair, France

SOLEIL COUCHANT SUR LA LAGUNE (VENICE)
(SUNSET ON THE LAGOON, VENICE) c. 1903-1904

Henri-Edmond Cross wrote, "Venice is like life, the symbol of shining humanity." In 1903 Cross visited Venice, and upon his return to France, he began a series of canvases devoted to Venetian themes. *Sunset on the Lagoon, Venice* was one of six pictures of this subject he exhibited at the Salon des Artistes Indépendants in 1904. This composition is more rectilinear than many of Cross' decorative pictures, recalling, in fact, the "constructed landscapes" Georges Seurat had painted twenty years before. But the wafer-like strokes of white and blue paint reflect Cross's particular appreciation of the atmosphere of Venice. In his travel accounts during his voyage, he wrote of "the far-spread shimmer of the lagoon." Strangely, he found the Venetian sky lacking in vitality; only in this picture does the sky dominate the architecture as it reflects in the canal waters. Here he chose to depict the sky at a moment when sunset charged its blues and whites with tints of rose and yellow, mauve, and even green. The fishing boat, from the nearby island of Chioggia, has a distinctive, colorful sail which is mirrored in the lagoon.

Cross was born Henri-Edmond Delacroix to a French father and an English mother in the town of Douai in 1883; he began to sign his canvases with the anglicized version of his surname in order to avoid confusion with the romantic painter Eugène Delacroix and yet another painter, Henri-Eugène Delacroix. As a youth, he was a pupil of the painter Carolus Duran, and in 1878 he attended the Ecole des Beaux-Arts in the provincial city of Lille. By 1881 Cross had moved to Paris, where he began to exhibit his works. In 1884 he helped establish and participated in the first exhibition of the Indépendants, more formally called the Salon des Artistes Indépendants. This group of progressive artists included Georges Seurat and Paul Signac, with whom Cross became closely associated. The artist, suffering from rheumatism, left Paris in 1891 for the warmer climate of the Riviera, where Signac joined him a year later. There Cross began for the first time to paint in the neo-impressionist, or pointillist, manner. Over the course of the next two decades, he adapted a personalized, mosaic-like brushstroke, broader and more emphatic than that of the first pointillists. Cross favored compositions of lyrical colors and shapes and was largely unconcerned with the complicated color theories that interested Seurat and Signac.

Soleil Couchant Sur La Lagune (Venice)
(Sunset on the Lagoon, Venice) c. 1903-1904
Oil on canvas, 19½ x 25⅝ inches, signed lower left: *Henri Edmond Cross*

PROVENANCE:

Private collection, Paris; Edouard Vuillard; Hervé Galerie, Paris, 1967; Mr. and Mrs. John A. Beck, Houston, 1967

BIBLIOGRAPHY:

Henri Guilbeaux, "Exposition Henri-Edmond Cross," *Les Hommes du Jour,* 29 Octobre 1910.
Henri Guilbeaux, "Peintures et Aquarelles de Cross et Signac," *Les Hommes du Jour,* 5 juillet 1911.
Félix Fénéon, "Les Carnets de Henri-Edmond Cross," *Bulletin de la Vie Artistique,* 1er juillet, 1922, p. 302.
Michael Hoog, "La Direction des Beaux-Arts et Les Fauves: 1903-1905," *Art De France,* no. 3, 1963, p. 365.
Isabelle Compin, *H.E. Cross,* Paris, 1964, no. 117, p. 214.

EXHIBITIONS:

Paris, Salon des Indépendants, Société des Artistes Indépendants, 1904, no. 606.
Paris, Galerie Bernheim-Jeune, *Henri-Edmond Cross,* 1910, no. 4 (as *Soleil sur la Lagune*).
Paris, Salon des Indépendants, Société des Artistes Indépendants, 1911, no. 1586 (as *La Lagune*).
Paris, Galerie Bernheim-Jeune, *Henri-Edmond Cross,* 1937, no. 54 (as *Vue de Venise*).
Washington, D.C., National Gallery of Art, *U.S. Loan Exhibition* 1971-73.
Houston, The Museum of Fine Arts, Houston, *The Collection of John A. and Audrey Jones Beck,* 1974, pp. 28-29.

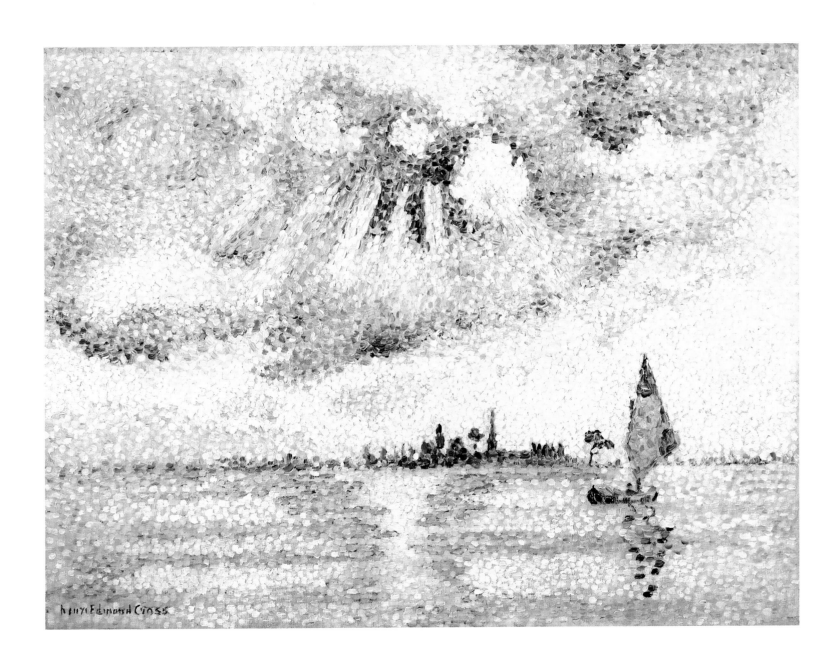

HENRI-EDMOND CROSS

Born 1856 Douai, France

Died 1910 Saint-Clair, France

LA TERRASSE FLEURIE (THE FLOWERED TERRACE) c.1905

Henri-Edmond Cross migrated from Paris to Saint-Clair, a village in southern France between the Mediterranean and the lower slopes of the Alps, in 1891. Here the sun illuminated the sky and colorful landscape in ways that fired Cross' imagination. Working with Paul Signac who lived in Saint-Tropez, Cross developed a painting style of large, mosaic-like brush strokes that eventually influenced both fauve and cubist painters. *The Flowered Terrace,* a tiny painting done in the artist's garden at Saint-Clair, exhibits these broad strokes and vivid colors of the late phase of Cross' divisionism. The artist suggests the natural appearance of brilliant flowers and trees, but the heightened intensity of his color signals the new direction of his painting toward fauvism.

Christened Henri-Edmond Delacroix, the artist changed his name to Cross, the English equivalent, in order to avoid confusion with the romantic painter Eugène Delacroix. After attending the Ecole des Beaux-Arts in Lille, he moved to Paris in 1881 and immediately exhibited in the official Salon. In 1884 he became a founding member of the Salon des Artistes Indépendants and continued exhibiting in that Salon until his death. When Georges Seurat died in 1891, Cross persuaded Seurat's colleague, Paul Signac, to move to the Riviera. Together Cross and Signac continued to develop the pointillist techniques which established a second phase of divisionism. The two artists were close friends, and Signac was at Cross' bedside when he died of cancer at age fifty-four.

La Terrasse Fleurie (The Flowered Terrace) c. 1905
Oil on panel, 9⅛ x 12½ inches, signed lower left: *H.E. Cross*

PROVENANCE:

Sale, Paris, Hôtel Drouot, June 6, 1929, no. 19; Private collection, Paris; Sale, Versailles, Maître Georges Blache, May 13, 1964, no. 5; Mr. and Mrs. John A. Beck, Houston, 1964

BIBLIOGRAPHY:

Isabelle Compin, *H.E. Cross,* Paris, 1964, p. 336, no. 227L.
Réalités, July 1966, p. 13.

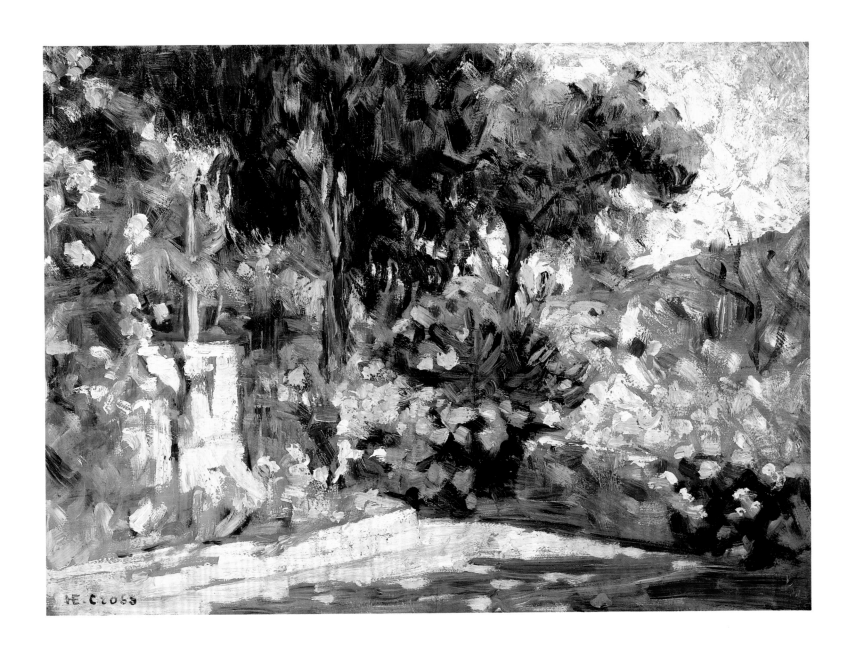

HONORÉ DAUMIER

Born 1808 Marseilles, France

Died 1879 Valmondois, France

RÉUNION D'AVOCATS (LAWYERS' MEETING) c. 1860

Honoré Daumier's biting political caricatures and lively lampoons of social pretensions delighted nineteenth-century Parisians. The greatest caricaturist of his era, Daumier is celebrated today as one of the most brilliant satirists of all time. His early experiences in the courts of law return again and again in his prints and paintings. He portrayed lawyers pleading cases passionately, meeting in the halls of justice, and leaving court bearing the smug expressions of easy victory. Throughout his life Daumier was interested in the science of physiognomy, the study of the face and how it reveals character. In *Lawyers' Meeting,* where the heads of the lawyers are finely delineated and sculpturally modeled, Daumier concentrated on individual expressions, evoking an entire range of emotion from pride to mendacity. His genius allowed him to make satire the subject for painting, showing the same profound understanding and mastery of the medium which characterize his drawings and lithographs.

At the age of twelve, Daumier took a job as bailiff in the Parisian law courts. Later he attended the Académie Suisse and studied the masters in the Louvre, where he was greatly influenced by the works of Goya. Apprenticed in 1825 to an artist who made portraits in the new printing medium of lithography, Daumier soon mastered the technique. From the age of twenty until the end of his life, he made a prosperous living drawing lithographic cartoons published in the Paris newspapers. His prolific career spanned the troubled reigns of two despotic monarchs, Louis-Philippe and Napoleon III, both of whom he caricatured mercilessly. Daumier's cartoon of Louis-Philippe as Gargantua, portraying the King as a gluttonous giant devouring the riches of the country, resulted in the artist's sentence to serve a six-month prison term. Daumier's lithographs were valued by the artists of a later generation— notably Edouard Manet and Edgar Degas— who appreciated many of his works for their wit and their brilliant draftsmanship.

Réunion d'Avocats (Lawyers' Meeting) c. 1860
Oil on panel, 7⁵/₁₆ x 9³/₈ inches, signed upper right: *H. Daumier*

PROVENANCE:

Van der Hoewen Collection, 1878; Sale, Paris, Hubert Debrousse, 1900, no. 111; Sale, Paris, Galerie Georges Petit, May 4, 1906, no. 17; M. Dressoir, Paris; Galerie Bernheim-Jeune, Paris; Dudensing; Valentine Gallery, New York, 1930; James Thrall Soby, New Canaan, Connecticut; Wildenstein and Co., New York; Grace Rainey Rogers, New York, 1943; Sale, New York, Parke-Bernet Galleries, November 18, 1943, lot 48; Billy Rose, New York, 1961; Sale, Parke-Bernet Galleries, December 13, 1961, lot 67; Robert Q. Lewis, Los Angeles; Sale, New York, Parke-Bernet Galleries, *Important Impressionist and Modern Paintings*, April 3, 1968, lot 47; Mr. and Mrs. John A. Beck, Houston, 1968; The Museum of Fine Arts, Houston, The John A. and Audrey Jones Beck Collection, 1974

BIBLIOGRAPHY:

Arsène Alexandre, *Honoré Daumier—L'homme et L'oeuvre,* 1888, p. 375.
Erich Klossowski, *Honoré Daumier,* Munich, 1923, p. 96, no. 110a.
Art News, November 1930, p. 5.
K.E. Maison, *Honoré Daumier: Catalogue Raisonné of the Paintings, Watercolors, and Drawings,* London, 1968, vol. 1, no. I-141, pl. 116.
John Minor Wisdom, in William C. Agee, ed., *The Museum of Fine Arts, Houston: A Guide to the Collection,* Houston, 1981, p. 101, no. 176.

EXHIBITIONS:

Paris, Galerie Durand-Ruel, *Honoré Daumier,* 1878, no. 46.
Houston, The Museum of Fine Arts, Houston, *The Collection of John A. and Audrey Jones Beck,* 1974, pp. 32-33.
Houston, The Museum of Fine Arts, Houston, *Honoré Daumier 1808-1879: The Armand Hammer Daumier Collection* (supplement), 1985.

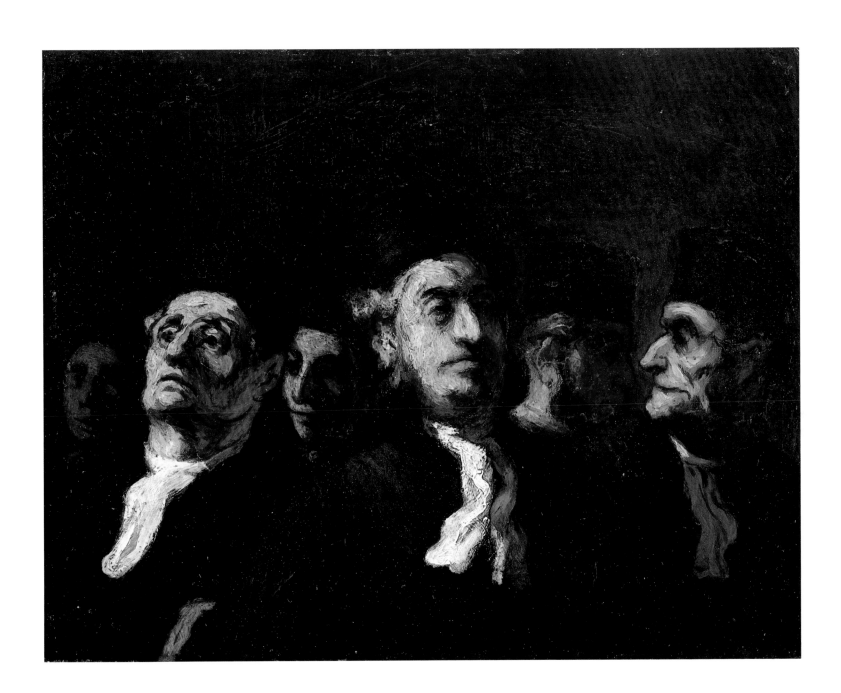

HILAIRE-GERMAIN-EDGAR DEGAS

Born 1834 Paris, France

Died 1917 Paris, France

DANSEUSES RUSSES (RUSSIAN DANCERS) c. 1899

At the end of the nineteenth century, many Russians came to Paris, the new European center for art with a flourishing bohemian subculture. These emigrés left their mark on Parisian culture, particularly the world of dance. Russian ballerinas danced at the Paris Opera House, while performances of colorful native dancers attracted huge café and night-club audiences. Edgar Degas was renowned for painting dance scenes. The lively Ukranian performers intrigued him along with their colorful national costumes, highlighted by the traditional red boots and floral wreaths braided in their hair. Here he painted the decorative silhouettes of three Russian dancers united for a brief moment in the midst of a frenzied and enchanting performance. In transplanting his *Russian Dancers* from stage to landscape, Degas explored the breathless speed and calculated balance of their movements. The pastel began as a charcoal drawing on tracing paper, which he affixed to a stronger support before applying the pastel pigment in broad, superimposed patches so that a shimmering effect of transparency is achieved.

Degas was born to a wealthy banker and his New Orleans-born wife in 1834. The artist spent almost all of his life in Paris and died there, virtually blind, at the age of eighty-three. After a brief attempt at studying law, Degas began his artistic career in the academic system, training to become a painter in the classical tradition. He traveled to Italy to study the great masters and, in Paris, copied paintings in the Louvre and prints in the national library. Degas met and befriended the painter Edouard Manet in the early 1860s, discovering a mutual interest in modern subject matter and a mutual desire to be free from the strictures of official style. In 1874 Degas joined in the first of the impressionist exhibitions. After the last of these, he held only one exhibition, reserving the greatest part of his work for his own study. The most accomplished draftsman of the impressionists, he was also the most urbane: he preferred to paint the life of Paris, its dancers, milliners, and laundresses, or the horse races in the suburbs rather than the countryside of France. His personal art collection included works by masters of the nineteenth century: Camille Corot, Eugène Delacroix, Paul Cézanne, Paul Gauguin, Camille Pissarro, and Jean Auguste Dominique Ingres, whose works influenced Degas' art in its early years. Painstaking, analytical, and sometimes cruel, Degas went about

making art with methodical care. "Nothing in art must seem an accident," he wrote, "not even movement."

Danseuses Russes (Russian Dancers) c. 1899
Pastel on tracing paper mounted on cardboard, 24½ x 24¾ inches
signed lower left: *Degas*

PROVENANCE:

Ambroise Vollard, Paris; Mary S. Higgins, Worcester, Massachusetts; Sale, New York, Parke-Bernet Galleries, *Impressionist and Modern Paintings and Drawings,* March 10, 1971, lot 15; Mr. and Mrs. John A. Beck, Houston, 1971

BIBLIOGRAPHY:

Ambroise Vollard, *98 réproductions signées Degas,* Paris, 1914, no. 5.
Paul-André Lemoisne, *Degas et son oeuvre,* Paris, 1946, no. 1183, vol. 3, p. 687, ill.
Michael Shapiro, "Three Late Works by Edgar Degas," *Bulletin,* The Museum of Fine Arts, Houston, Spring 1982, pp. 9-22.

EXHIBITIONS:

Paris, Orangerie des Tuileries, *Degas,* 1937, no. 181.
Worcester, Massachusetts, Worcester Art Museum, 1946.
Houston, The Museum of Fine Arts, Houston, *The Collection of John A. and Audrey Jones Beck,* 1974, pp. 34-35.

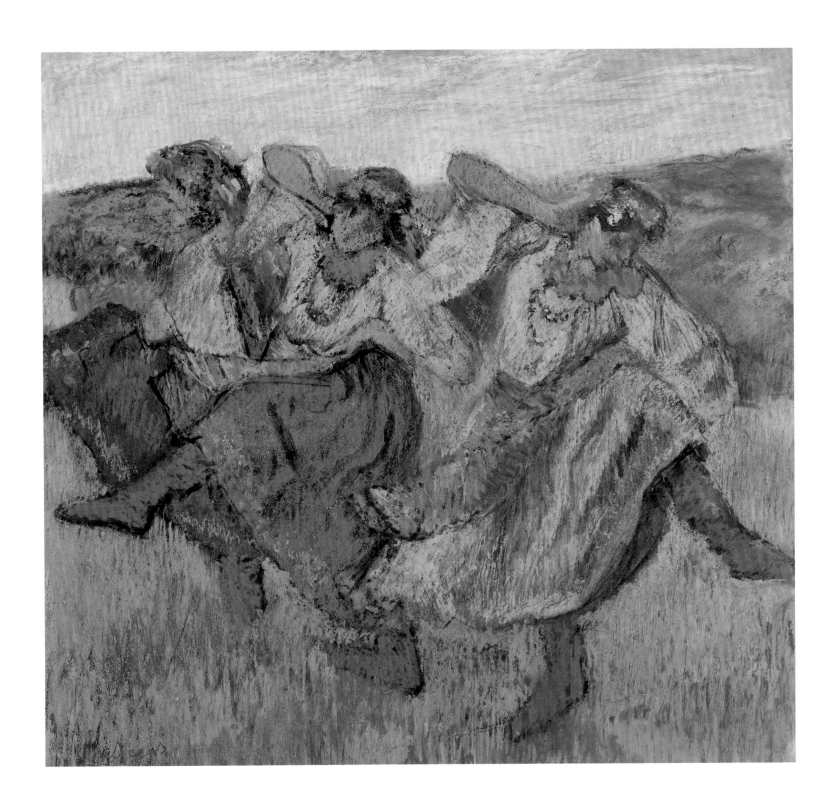

ANDRÉ DERAIN

Born 1880 Chatou, France

Died 1954 Garches, France

LA ROUTE TOURNANT, L'ESTAQUE (THE TURNING ROAD, L'ESTAQUE) 1906

The Turning Road, L'Estaque is considered André Derain's master-piece and a major work of the fauve movement. To the former owner of this painting, Monsieur Robert Blay, Derain wrote, "I had a very affectionate feeling for that large painting of L'Estaque which I painted during a rather difficult moment of my life." The painting, which dates from July of 1906, represents the southern village of L'Estaque, where Cézanne had painted before Derain. The exact site of this painting exists no more: Derain noted that it was destroyed during the construction of a mari-time canal. In Derain's nostalgic recollection of this picture, his reference to the monumental size is significant, as it is most unusual for a fauve canvas. Unlike his earlier fauve works, which were quickly composed, the overall composition of *The Turning Road, L'Estaque* exhibits his determination to combine forms as well as color with meticulous care. Through Derain's imagina-tion, the landscape glows with unnatural colors. Trees burn red, orange, and blue, and everywhere there is yellow, symbolic of sunlight.

Derain's parents, prosperous and conservative, had great ambition for their son to become an officer or an engineer. Although he won a prize for his drawing at the Lycée Chaptal in Paris, his family sent him in 1896 to the Ecole des Mines. Two years later, determined to become a painter, Derain entered the Académie Carrière, where his talents were recognized by an older artist, Henri Matisse. A chance encounter with Maurice de Vlaminck, in a train accident, began a long friendship between the two painters. Derain and Vlaminck shared a studio in an old restaurant on the Seine at Chatou, where Matisse came to visit. He found the two artists painting with pure primary colors, with which he too was experimenting. Shortly afterward, Derain began four years of military duty, during which he illustrated books and designed ballet sets. In 1904 he resumed the study of art at the Académie Julian, and in the following year he joined Matisse on the Riviera in Collioure, painting brilliantly sunlit landscapes. In the fall, Derain exhibited at the Salon des Indépendants and the famous Salon d'Automne, where the shrill colors of the paint-ings scandalized the public. The famous dealer Ambroise Vollard purchased his works and began to represent him. From that time on, Derain exhibited annually at the Paris Salons as well as at galleries throughout the world. The artist enjoyed many friend-ships, but his closest contacts were with Pablo Picasso, Georges Braque, Kees van Dongen, Maurice de Vlaminck, and Henri Matisse. Like many artists, Derain was profoundly affected by the first World War. After the war, his work became more tradition-ally figurative as he abandoned the dashing hues and vibrant rhythms of the fauve style.

La Route Tournant, L'Estaque (The Turning Road, L'Estaque) 1906
Oil on canvas, 51 x 76¾ inches, signed lower right: *Derain*

PROVENANCE:

Robert Blay, Paris, from the artist; Arthur Tooth and Sons, London; Mr. and Mrs. John A. Beck, Houston, 1966; The Museum of Fine Arts, Houston, The John A. and Audrey Jones Beck Collection, 1974

BIBLIOGRAPHY:

John Rewald, *Les Fauves*, 1952, p. 20, ill.
Georges Hilaire, *Derain*, Geneva, 1959, no. 48.
Denys Sutton, *Derain*, London, 1959, no. 16, ill.
John Elderfield, *Fauvism*, 1976, pp. 106, 114, ill.
Amy Goldin, "Forever Wild: A Pride of Fauves," *Art in America,* May-June 1976, pp. 90-95, detail ill. on cover.
Robert Hughes, "Stroking Those Wild Beasts," *Time,* March 29, 1976, p. 50.
John Elderfield, "The Garden and the City: Allegorical Painting and Early Modernism," *Bulletin,* The Museum of Fine Arts, Houston, Summer 1979, pp. 3-21, ill.
Judith McCandless Rooney, in William C. Agee, ed., *The Museum of Fine Arts, Houston: A Guide to the Collection,* Houston, 1981, p. 123, no. 209.
Robert Hughes, *The Shock of the New,* New York, 1981, pp. 132-133, pl. 83.
Diane Kelder, *The Great Book of Post-Impressionism,* New York, 1986, p. 238.

EXHIBITIONS:

New York/Minneapolis/San Francisco/Toronto: The Museum of Modern Art/Minneapolis Institute of Arts/San Francisco Museum of Modern Art/The Art Gallery of Ontario, *Les Fauves,* 1952-53 no. 30.
Paris, Galerie Charpentier, *Derain,* 1955, no. 8.
Paris, Galerie Charpentier, *Les Fauves,* 1962, no. 28.
Marseilles, Musée Cantini, *Derain,* 1964, no. 21.
Paris, Galerie Max Kaganovitch, *Oeuvres choisies de 1900 à nos jours,* 1964.
Austin, The University of Texas Art Museum, *Fauve—Color,* 1972, no. 6.
Washington, D.C., National Gallery of Art, *U.S. Loan Exhibition,* 1971-73.
Houston, The Museum of Fine Arts, Houston, *The Collection of John A. and Audrey Jones Beck,* 1974, pp. 36-37.
New York/San Francisco/Fort Worth, The Museum of Modern Art/San Francisco Museum of Modern Art/Kimbell Art Museum, *Fauvism and its Affinities,* 1976

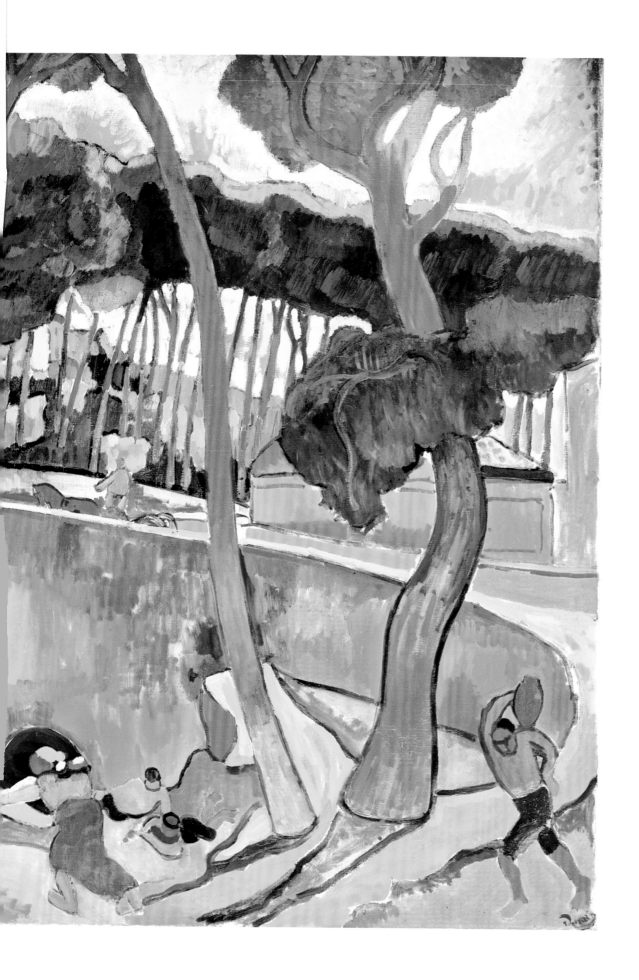

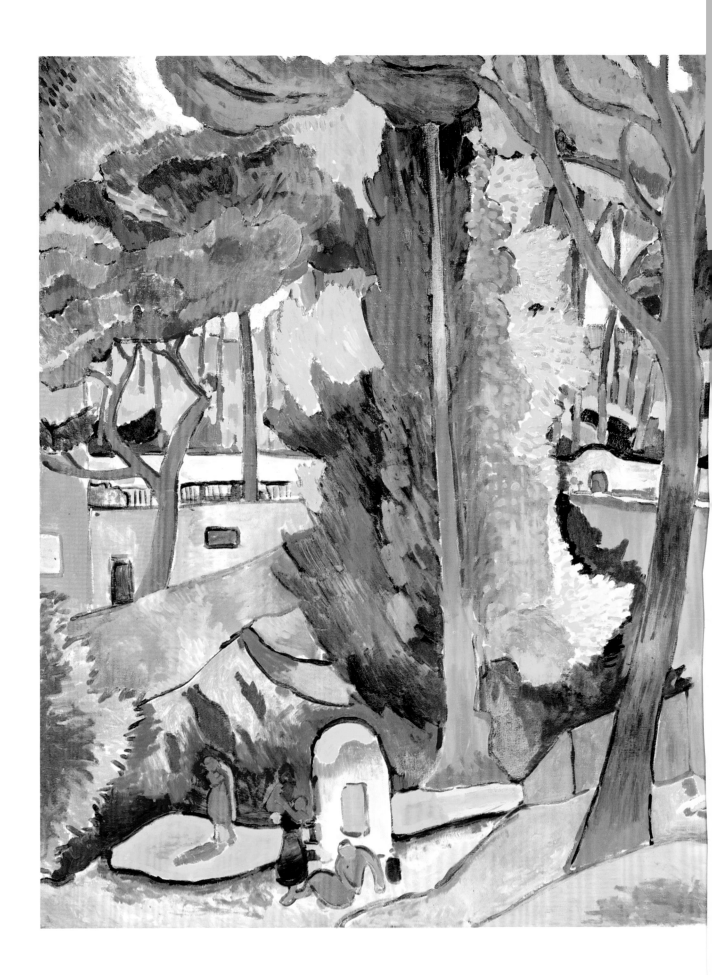

KEES VAN DONGEN

Born 1877 Delfshaven, the Netherlands

Died 1968 Monaco

LE COQUELICOT (THE CORN POPPY) c.1919

The Corn Poppy, named for the sitter's brilliant red hat, was renamed by one French critic *Madame Does Not Want Children.* The sitter is part of the milieu of La Folle Epoque—the flapper days—in Paris. Kees Van Dongen explained the subject's history: "I remember her coming into my studio. She was something of a little simpleton but putting on that red hat was entirely her idea. You might say it was her instinct. The majority of women are painters in their own individual fashion." *The Corn Poppy* was instantly popular and was reproduced in many forms from postcards and magazine covers to posters and prints. Van Dongen's portraits are moody, exotic, and intense. There is a sensuality in his portraits of women, red-lipped, thin, and pallid, that symbolizes the decadent lifestyle of the smart set in the twenties.

Van Dongen left Holland for Paris at the age of twenty; two years later he settled there. To earn a living he worked at a variety of jobs from being a roustabout in a carnival and a porter in the Paris markets to making sidewalk sketches of café clients and satirical drawings for popular newspapers, such as the celebrated *L'Assiette au Beurre.* Living in Montmartre, he first associated with the painters Maurice de Vlaminck and André Derain, who were to join the fauve group, and later with his neighbors at the Bateau Lavoir in Montmartre: Georges Braque, Pablo Picasso, and Juan Gris. Van Dongen was at first interested in impressionism, but in 1905 he participated in the exhibition that gave the fauves their name. After World War I, he became known as a portraitist of European society, working in Paris, Versailles, Venice, and the Côte d'Azur. The artist, once bound by poverty, in later life became an international bon-vivant. His paintings appeared in the principal salons in Paris. He participated in many exhibitions in France and abroad and became a noted book illustrator.

Le Coquelicot (The Corn Poppy) c. 1919
Oil on canvas, 21½ x 18 inches, signed lower left: *Van Dongen*

PROVENANCE:

Dr. A. Roudinesco, Paris; Olivetti Collection, Milan; Mrs. E. Bin, Italy; Sale, London, Sotheby's, *Impressionist and Modern Paintings, Drawings and Sculpture,* March 31, 1965, no. 105; Mr. and Mrs. John A. Beck, Houston, 1965

BIBLIOGRAPHY:

Armand Lanoux, *Paris 1925,* Paris, 1957, p. 13, ill.
Roy McMullen, "Van Dongen Remembers," *Réalités,* June 1960, no. 115. frontis. pp. 64-73.
Réalitiés, June 1965, p. 20.
Louis Chaumeil, *Kees Van Dongen,* Geneva, 1967, pp. 206-208.

EXHIBITIONS:

Albi, Musée Toulouse-Lautrec, *Van Dongen,* 1960, no. 39
Houston, The Museum of Fine Arts, Houston, *The Collection of John A. and Audrey Jones Beck,* 1974, pp. 38-39.

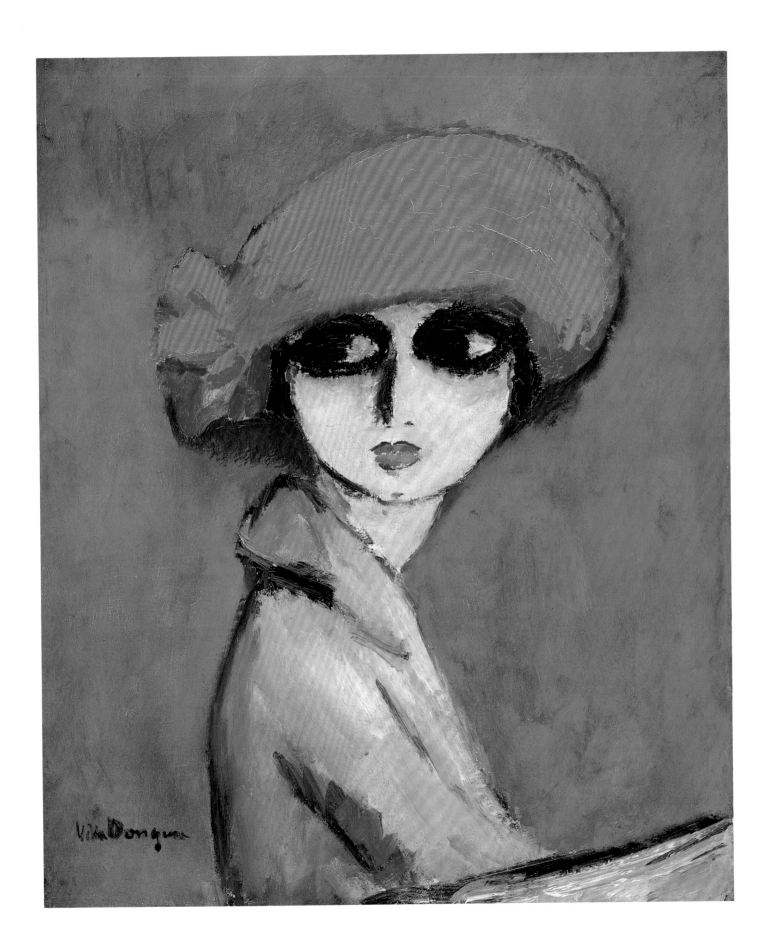

RAOUL DUFY

Born 1877 Le Havre, France

Died 1953 Forcalquier, France

LES TROIS OMBRELLES (THE THREE UMBRELLAS) 1906

Resort areas on the Normandy coast near Raoul Dufy's birthplace were favorite subjects for the artist to paint with his friends Emil-Othon Friesz and Albert Marquet. A superb draftsman and extraordinary colorist, Dufy was also a chronicler of the pleasant and urbane society which he observed with benevolence and painted with skill. He abandoned the impressionist style and in 1905 adopted fauvism. *The Three Umbrellas* is a representative example of the pure, bold colors of his fauve period. Painted on the boardwalk at Sainte-Adresse, the picture represents three girls with umbrellas, who have been identified as Dufy's sisters. Above them the French tricolor flag floats in the breeze, its red, white, and blue echoed in the girls' umbrellas.

Dufy won wide acclaim in his own lifetime. Artistically inclined from his youth, at the age of fifteen he enrolled in evening classes at the Ecole des Beaux-Arts in his native Le Havre. There he met the young artists Georges Braque and Friesz. A grant from the Le Havre municipality enabled Dufy to move to Paris in 1900 and rejoin Friesz and Marquet to study at the Ecole des Beaux-Arts in the atelier of Léon Bonnat. In 1902 the Galerie Berthe Weill began to represent Dufy, and from 1903 until the outbreak of World War I he exhibited regularly at the Salon des Indépendants and occasionally at the Salon d'Automne. When Dufy arrived in Paris, the tenets of impressionism dominated his work, but a painting by Matisse inspired him to join the fauves. Dufy was too poor to meet with his artistic colleagues at the cafés in Montmartre, nor did he care for their bohemian way of life. One colleague noted that Dufy, always neat in his attire, "bore his poverty with carefree airs, but with dignity." His innate love of music often caused him to skip a meal in order to afford a concert ticket. In 1911, Dufy performed a successful woodblock printing experiment on fabric for the fashion designer Paul Poiret and soon after joined the staff of the renowned Bianchini silk firm in Lyons. He also illustrated books, designed tapestries, and conceived sets for stage and ballet productions— but continued to paint. In painting, his preferred medium, Dufy moved away from the fauve style to cubism for a brief period. In his later years he developed a light calligraphic touch, where flecks of pure color recall the bolder experiments of his early fauve paintings.

Les Trois Ombrelles (The Three Umbrellas) 1906
Oil on canvas, 23½ x 29 inches,
signed and dated lower right: *Raoul Dufy 1906*

PROVENANCE:

Dr. A. Roudinesco, Paris, 1932; Sale, New York, Parke-Bernet Galleries, *The Roudinesco Collection of Paintings of the School of Paris*, October 10, 1968, no. 14; Mr. and Mrs. John A. Beck, Houston, 1968

BIBLIOGRAPHY:

Jean Cassou, *Raoul Dufy, poète et artiste*, Geneva, 1946, pl. 3.
Pierre Courthion, *Raoul Dufy*, Geneva, 1951, pl. 35.
René Ben Sussan and Marcel Brion, *Raoul Dufy*, London, 1958, pl. 10.
Jean-Paul Crespelle, *The Fauves*, Greenwich, Connecticut, 1962, pl. 37.
Joseph-Emile Müller, *Fauvism*, New York, 1967, p. 117, no. 116, ill.
Maurice Lafaille, *Raoul Dufy, catalogue raisonné de l'oeuvre peint*, Geneva, 1972, vol. 1, p. 119, no. 130, ill.
John Elderfield, *Fauvism*, New York, 1976, p. 78, ill.
Marcel Giry, *Fauvism: Origins and Development*, New York, 1981, p. 180.
Diane Kelder, *The Great Book of Post-Impressionism*, New York, 1986, pp. 218, 240, no. 227 (detail), and no. 253, ill.

EXHIBITIONS:

Paris, Salon d'Automne, 1906, no. 511.
Paris, Galerie des Beaux-Arts, *L'Atelier de Gustave Moreau*, 1934, no. 55.
Paris, Musée du Petit Palais, *Les maîtres de l'art indépendant: 1895-1937*, 1937, no. 29.
Basel, Kunsthalle, *Vlaminck, Dufy, Rouault*, 1938, no. 20.
Paris, Galerie de France, *Les Fauves*, 1942, no. 12.
Paris, Galerie Charpentier, *Cent chefs-d'oeuvre de peintres de l'école de Paris*, 1946, p. 16.
Paris, Musée d'Art Moderne, *Le Fauvisme*, 1951, no. 51.
Venice, *XXVI Biennale Internationale d'Arte*, 1952, no. 31.
Paris, Musée d'Art Moderne, *Raoul Dufy*, 1953, no. 17, pl. 3.
London, Tate Gallery, *Dufy*, 1954, no. 5, pl. 66.
Basel, Kunsthalle, 1954, no. 14, pl. 3.
Berne, Kunsthalle, 1954, no. 6.
Albi, Musée Toulouse-Lautrec, *Chefs-d'oeuvre de Raoul Dufy*, 1955, no. 5.
Paris, Galerie Bernheim-Jeune, *Chefs-d'oeuvre de Raoul Dufy*, 1959, no. 4.
Paris, Galerie Bernheim-Jeune-Dauberville, 1959, no. 4.
Paris, Galerie Charpentier, *Cent Tableaux de Collections Privées*, 1960, no. 31.
Paris, Galerie Charpentier, *Les Fauves*, 1962, no. 44.
Austin, The University of Texas Art Museum, *Fauve-Color*, 1972, no. 8.
Washington, D.C., National Gallery of Art, *U.S. Loan Exhibition*, 1971-73.
Houston, The Museum of Fine Arts, Houston, *The Collection of John A. and Audrey Jones Beck*, 1974, pp. 40-41.
New York/San Francisco/Fort Worth, The Museum of Modern Art/San Francisco Museum of Modern Art/Kimbell Art Museum, *The "Wild Beasts," Fauvism and its Affinities*, 1976

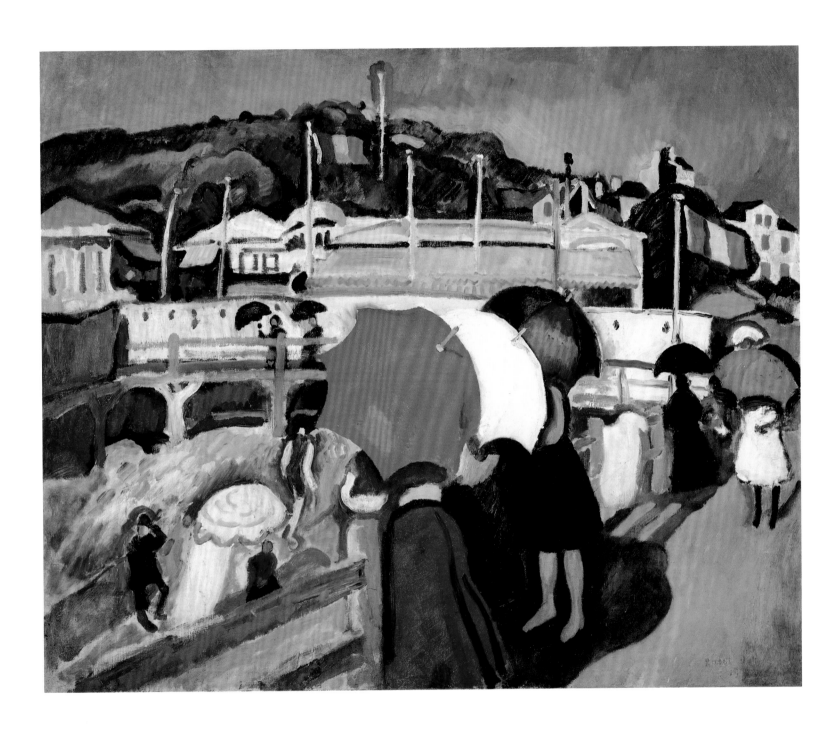

JEAN-LOUIS FORAIN

Born 1852 Reims, France

Died 1931 Paris, France

L'ADMIRATEUR (THE ADMIRER) c. 1877-79

Like Honoré Daumier, who earned a comfortable livelihood as a cartoonist and caricaturist, Jean-Louis Forain was one of the most famous satirical draftsmen in France in the last years of the nineteenth century. His cartoons, which appeared in the Parisian daily *Le Figaro,* lampooned the superficialities of the Paris bourgeoisie and exposed corruption and hypocrisy in the law courts. Public figures were ridiculed daily, and Forain's popularity helped newspaper circulation soar. *The Admirer* is an early and rare example in oil of Forain's satire. This and other works bear a marked influence in both style and subject to those of his friend Edgar Degas. Forain's treatment of the subject matter in *The Admirer* echoes Degas' work during the late 1870s. The scene is typical of the artist's explorations into the mores and decadence of Parisian society. It takes place in the *foyer de la danse,* the hall of the Paris Opera House, where dancers mingled with their friends and entertained their older benefactors. Forain took pleasure in exposing an aging gallant pressing his attentions on a coquettish young girl by offering a bouquet.

Forain was born into a devout middle-class family living close to the cathedral of Reims. To improve their son's education and social standing, his parents moved to Paris. Against their wishes, Forain chose to study at the Ecole des Beaux-Arts. He joined his close friends, the artists Henri de Toulouse-Lautrec, Edgar Degas, Claude Monet, and Paul Cézanne, in four of the impressionist exhibitions, but it was journalistic success that brought Forain great wealth. His friends included the leading intellectuals, poets, novelists, and politicians of the day. Forain became a national figure in France, receiving awards and decorations, including the rosette of the Legion of Honor from the very Republic whose politicians he satirized and disliked until his death.

L'Admirateur (The Admirer) c. 1877-79
Oil on canvas mounted on panel, 8 x 6 inches, signed lower left: *LF*

PROVENANCE:

Private Collection, France, 1972; Adolph Stein, Paris, 1972; Mr. and Mrs. John A. Beck, Houston, 1972

EXHIBITIONS:

Houston, The Museum of Fine Arts, Houston, *The Collection of John A. and Audrey Jones Beck,* 1974, pp. 42-43.

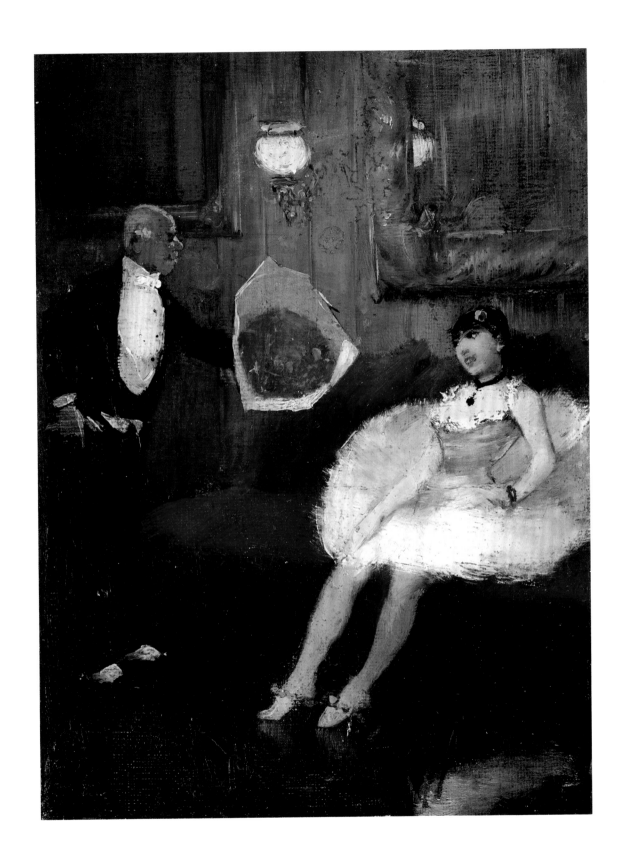

EMIL-OTHON FRIESZ

Born 1879 Le Havre, France

Died 1949 Paris, France

LA REGATE À ANVERS (THE REGATTA AT ANTWERP) 1906

Emil-Othon Friesz spent the summer of 1906 in Antwerp painting with Georges Braque. In a makeshift studio on the river bank, the two painters recorded the activities of the port. Both artists worked in the fauve manner during this period. This composition owes much to Claude Monet's works of the 1870s in its ordered disposition of boats, their sails forming a progression of white triangles and trapezoids across the picture, the masts marking ordered divisions in space. Although it was executed in what seems to be a free and spontaneous style, Friesz painted *The Regatta at Antwerp* with meticulous care. The work reveals Friesz's love for the sea. The painting is enlivened by the impasto strokes on the edges of the sails and the colorful, rippling waves.

Friesz was born in the port city of Le Havre, where his father and uncles worked as sailors and shipbuilders. At the age of fifteen, he tried unsuccessfully to stow away on a Danish ship. Shortly after this episode, Friesz entered the Ecole des Beaux-Arts along with Raoul Dufy and Georges Braque, who were to become his lifelong friends. In 1899 Friesz went to Paris to study under Léon Bonnat and eventually joined Dufy and Braque. He exhibited at the Salon des Artistes until 1903 and then began exhibiting regularly at the Salon des Indépendants and the Salon d'Automne. Friesz had been influenced by the impressionists and particularly by Paul Cézanne. He retained throughout his career a more naturalistic point of view than his colleagues in the fauve movement. His friends numbered among the noted impressionist and fauve artists of the day, but unlike many whose works at that time were rejected, Friesz was popular and received official recognition. The success of his fauve works was a high point in his long career.

La Regate à Anvers (The Regatta at Antwerp) 1906
Oil on canvas, 22¾ x 31¼ inches
signed and dated lower right: *Othon Friesz 06*

PROVENANCE:

Karl Nierendorf Gallery, New York; Sale, New York, Parke-Bernet Galleries, *Important Impressionist and Modern Paintings,* April 6, 1967, lot 50; Private Collection, U. S. A., 1972; Sale, London, Sotheby's, *Impressionist and Modern Paintings and Sculpture,* November 29, 1972, lot 40; Mr. and Mrs. John A. Beck, Houston, 1972

EXHIBITIONS:

Houston, The Museum of Fine Arts, Houston, *The Collection of John A. and Audrey Jones Beck,* 1974, pp. 44-45.

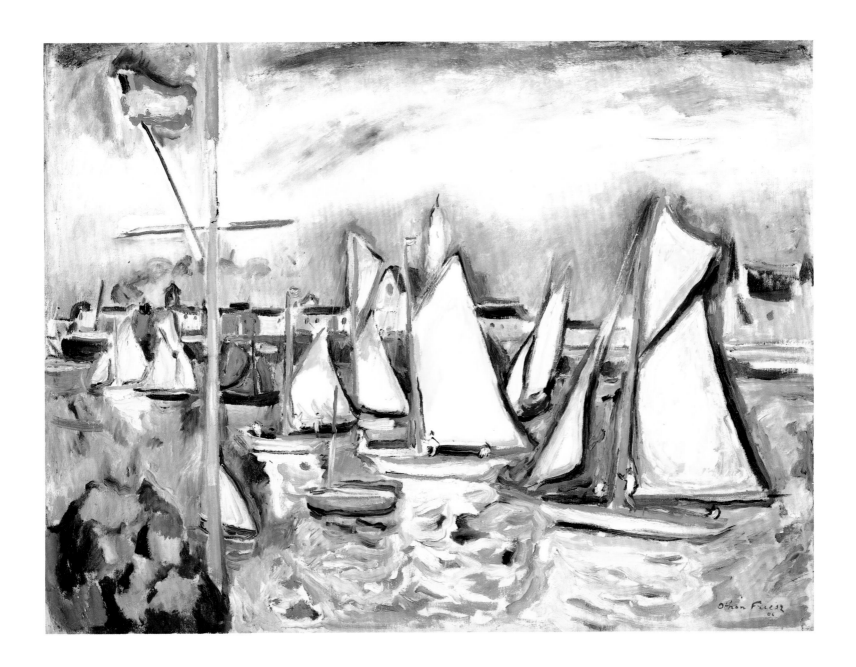

PAUL GAUGUIN

Born 1848 Paris, France

Died 1903 Fatu-Iwa, Marquesas Islands

AREAREA II (JOYOUSNESS) c. 1892-95

Ladies' hand fans were popular in France during the nineteenth century. Artists such as Camille Pissaro and Edgar Degas painted in this highly profitable format. *Arearea,* a Tahitian word meaning joyousness, is the title of a painting by Gauguin in the Musée d'Orsay, Paris, from which *Arearea II* was derived. When Gauguin left Europe for Tahiti in 1891, he expected to find a primitive people who worshiped idols of wood or stone. When he saw that such idols did not exist there, he carved his own. After Gauguin read Moerenhout's *Voyages aux îles du Grand Océan,* he carved Hina, the idol in *Arearea II.* Hina was a minor deity in Polynesian lore, who inspired Gauguin to invent the rites pertaining to her worship. The source for the seated figures on the right is a frieze from the Javanese temple of Borobudur which is depicted in a photograph that Gauguin owned.

Gauguin did not begin to paint seriously until he was twenty-five years old. Already a successful businessman, he had begun to collect impressionist paintings. His own work was first accepted in 1876 at the official Salon, and he exhibited in the fifth exhibition held in 1880. When France experienced a financial crash in 1883, Gauguin left his brokerage firm and family to devote his time to painting. Pissarro gave him great encouragement, and the two artists painted together frequently. In the late 1880s, working first with Emile Bernard in Brittany and later with Vincent van Gogh in the south of France, Gauguin not only adopted Bernard's new painting technique, cloisonnism, but, backed by his own technical insight, evolved a new way of painting in which boldly designed, highly colored figures participate in dramas charged with literary or spiritual meaning. A two-month stay with van Gogh in Arles ended abruptly when van Gogh, in a fit of madness, tried to kill Gauguin. Gauguin returned to Paris and in 1891 left for Tahiti, where he sought, in this native paradise, an inspiration for his art. Although he is remembered best for his painting, Gauguin experimented with printmaking and the decorative arts. In Tahiti, his work in sculpture was equally original, often evoking primitive, totemic forms. He lived among the islanders, absorbing their culture and depicting their pure and, to him, unspoiled spirituality.

Arearea II (Joyousness) c. 1892-95
Gouache and watercolor on linen, 11¼ x 22¹⁵/₁₆ inches
signed lower right: *P. Gauguin*

PROVENANCE:

Ambroise Vollard, Paris; Gaston Brunaud, Paris; Galerie Bernheim-Jeune, Paris, 1913; Max Linder, 1914; Marcel Kapferer, Paris; Wildenstein and Co., New York; Mr. and Mrs. Sidney F. Brody, Los Angeles; Sale, New York, Sotheby Parke-Bernet, *Important 19th and 20th Century Paintings, Drawings, and Sculptures from the Collection of Mrs. Sidney F. Brody,* October 19, 1977, lot 10; The Museum of Fine Arts, Houston, The John A. and Audrey Jones Beck Collection, 1977

BIBLIOGRAPHY:

John Rewald, *Gauguin Drawings,* New York, 1958, no. 54, ill.
Sylvie Béguin, "Arearea," *Revue du Louvre,* vol. 11, 1961, p. 222, ill.
Georges Wildenstein, *Gauguin,* Paris, 1964, no. 469, ill. p. 190.
Ronald Pickvance, *The Drawings of Gauguin,* London, 1970, pl. 13.
G.M Sugana, *L'Opera Completa di Gauguin,* Milan, 1972, no. 312, ill.
Marc S. Gerstein, *Impressionist and Post-Impressionist Fans* (Harvard University Ph.D. thesis), Cambridge, Massachusetts, 1978, pp. 340-43, no. 27, ill.
Marc S. Gerstein, "Paul Gauguin's 'Arearea,'" *Bulletin,* The Museum of Fine Arts, Houston, vol. 7, no. 4, Fall 1981, pp. 2-20, ill.
John Minor Wisdom, in William C. Agee, ed., *The Museum of Fine Arts, Houston, a Guide to the Collection,* Houston, 1981, pp. 118-19, no. 203, ill.
Diane Kelder, *The Great Book of Post-Impressionism,* New York, 1986, p. 170, no. 174, ill.

EXHIBITIONS:

Paris, Salon d'Automne, *Paul Gauguin,* 1906, no. 92.
New York, Wildenstein and Co., *Gauguin,* 1956, no. 36.
Chicago/New York, The Art Institute of Chicago/The Metropolitan Museum of Art, *Gauguin,* 1959, no. 107.
San Francisco, San Francisco Museum of Art, *Twenty-Fifth Anniversary Exhibition,* 1960.

VINCENT VAN GOGH

Born 1853 Zundert, the Netherlands

Died 1890 Auvers-sur-Oise, France

LES ROCHERS (THE ROCKS) 1888

Vincent van Gogh was preoccupied throughout his life with the symbolic qualities of nature. Through expressive colors and intense, obsessive structure, his landscapes convey his belief in the mystical forces present in the natural world. *The Rocks*, painted near Arles in the summer of 1888, depicts a gnarled oak tree, shaped by the mistral winds, standing steadfast and alone. Here we see the spontaneity of van Gogh's calligraphic brushstroke, thick and tactile, giving a sculptural quality to the rocks and tree. Visible layers of rich oil paint build up in relief as evidence of the artist's hand forcibly working the pigment to conform to his personal temperament and vision.

In his brief life of thirty-seven years, van Gogh was called both to religion and to art. He began his life's work as a pastor to the poor in his native Holland, but his identification with their suffering overwhelmed his sensitive spirit. In 1885 van Gogh attended the Royal Academy of Arts in Antwerp. A year later, because of his poverty, he moved to Paris to stay with his brother Theo. Theo had faith in his brother's work and supported him throughout his life, making enormous sacrifices on his behalf. In Paris, where he attended Fernand Cormon's classes at the Ecole des Beaux-Arts, van Gogh discovered the work of the impressionists and became friends with the leaders of that movement. In 1888 van Gogh left Paris for the southern town of Arles. In the light and landscape of Provence, his paintings became brighter and more emphatically painted. Paul Gauguin joined him there to paint, but the two strong-willed eccentrics clashed. Van Gogh, greatly disturbed, tried to kill Gauguin, and later turned his rage against himself, cutting off his own left ear in a moment of despair. During the last three years of van Gogh's life, he committed himself intermittently to psychiatric hospitals for epilepsy and mental disorders. Shortly after an interim release from care in 1890, while painting in a wheat field, van Gogh took his own life.

Les Rochers (The Rocks) 1888
Oil on canvas, 21¼ x 25½ inches

PROVENANCE:

Theo van Gogh, Paris, 1888; Mrs. Johanna van Gogh-Bonger, Amsterdam and Laren, the Netherlands; Paul Cassirer, Berlin; Mrs. Margarette Mauthner, Berlin; Josef Stransky, New York; Wildenstein and Co., New York; Sir A. Chester Beatty, London; Miss Edith Beatty, London; Arthur Tooth & Sons, London, 1962; Mr. and Mrs. John A. Beck, Houston, 1964; The Museum of Fine Arts, Houston, The John A. and Audrey Jones Beck Collection, 1974

BIBLIOGRAPHY:

Jacob-Bart de la Faille, *L'Oeuvre de Vincent van Gogh: catalogue raisonné*, 4 vols., Paris-Brussels, 1928; rev. ed. *The Works of Vincent van Gogh: His Paintings and Drawings*, New York, 1970, no. 466.

Theo van Gogh, *Further Letters of Vincent van Gogh to his Brother*, Boston and New York, 1929, letter no. 535.

Ralph Flint, "The Private Collection of Josef Stransky," *The Art News*, vol. 29, no. 33, May 16, 1931, p. 88, p. 108, ill.

Perry B. Cott, "The Stransky Collection of Modern Art," *Bulletin of the Worcester Art Museum*, Winter 1933, p. 156.

W. Scherjon and W.J. de Gruyter, *Vincent van Gogh's Great Period: Arles, Saint-Remy and Auvers-sur-Oise*, Amsterdam, 1937, no. 85.

Jacob-Bart de la Faille, *Vincent van Gogh*, trans. by P. Montagu-Pollock, Paris-London-New York, 1939, p. 352, no. 494.

Mark W. Roskill, "Van Gogh's Exchanges of Work with Emile Bernard in 1888," *Oud Holland*, vol. 86, no. 2-3, 1971, pp. 156, 159.

Jan Hulsker, *The Complete van Gogh: Paintings, Drawings, Sketches*, New York, 1980, no. 1489, pp. 210, 629-30.

John Minor Wisdom, in William C. Agee, ed, *The Museum of Fine Arts, Houston: A Guide to the Collection*, Houston, 1981, p. 114, pl. 27.

Ronald Pickvance, *Van Gogh in Arles*, New York, 1984, no. 59, pp. 118-20.

EXHIBITIONS:

Cologne, *Internationale Kunstausstellung des sonderbundes west-deutsches Kunstfreunde und Künstler zu Köln*, 1912, no. 44.

Berlin, Paul Cassirer Gallery, *Vincent van Gogh*, 1914, no. 92.

Berlin, Kronprinzenpalais, Nationalgalerie, *Van Gogh-Matisse*, 1921.

Berlin, Paul Cassirer Gallery, *Vincent van Gogh*, 1928, no. 48.

Worcester, Massachusetts, Worcester Art Museum, 1932-34.

London, Wildenstein and Co., *Collection of a Collector from Ingres to Matisse*, 1936, no. 20.

London, National Gallery, on loan from Miss Edith Beatty, 1953-61.

London, Arthur Tooth & Sons, *Recent Acquisitions*, 1962, no. 4.

Washington, D.C., National Gallery of Art, *U.S. Loan Exhibition*, 1971-73.

Houston, The Museum of Fine Arts, Houston, *The Collection of John A. and Audrey Jones Beck*, 1974, pp. 46-47.

New York, The Metropolitan Museum of Art, *Van Gogh in Arles*, 1984, no. 59.

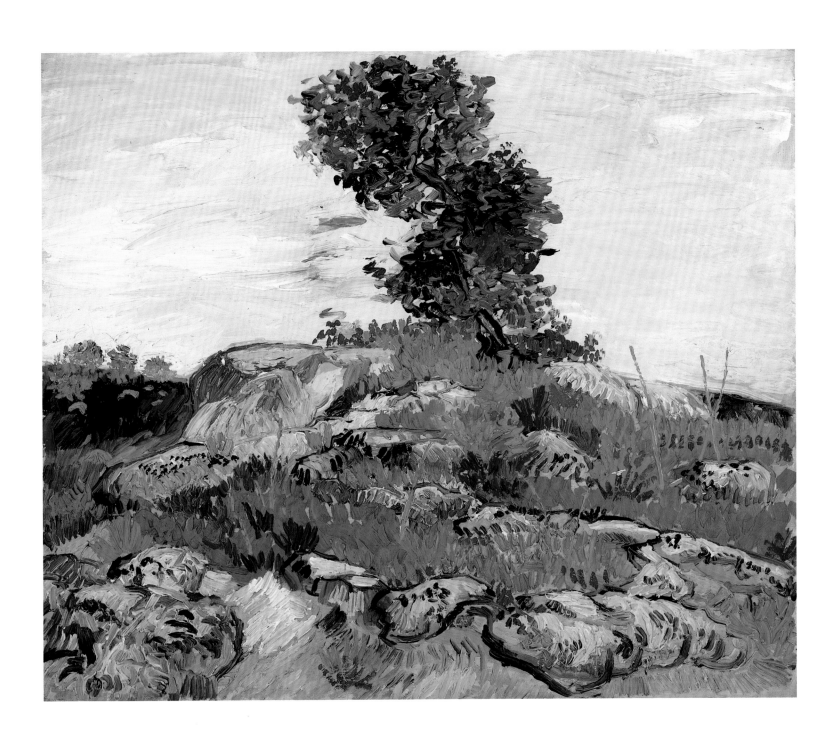

JEAN-BAPTISTE-ARMAND GUILLAUMIN

Born 1841 Paris, France

Died 1927 Paris, France

LA SEINE À PARIS (THE SEINE IN PARIS) 1871

Jean-Baptiste-Armand Guillaumin's monumental canvas of *The Seine in Paris* was one of the pictures he sent to the first exhibition of the impressionists in 1874. The painting, one of the most ambitious and most beautiful among Guillaumin's works, represents a portion of the river seen from just above the Ile St. Louis, perhaps from the present-day Quai Henri IV. In the center of the painting are the towers of the cathedral of Notre Dame, seen across the coal barges on the river and piles of coal stored on the opposite bank. Farther up the river, two bridges, the Pont Sully and the Pont de Tournelle, can be seen. The banks of the Seine were a favorite spot for Guillaumin, who often worked there with Paul Cézanne. In fact, it has been said that Cézanne and Camille Pissarro are among the figures standing on the banks of the river in this picture. This painting appears in the background of one of Guillaumin's portraits and in one of Cézanne's self-portraits painted around 1877.

Although born in Paris, Guillaumin spent most of his childhood in the provinces. He returned to Paris at the age of sixteen to work for several years in various businesses, later taking a night job with the City Department of Roads and Bridges in order to paint during the daylight hours. He attended the municipal art school in Paris and in 1858 the ramshackle Académie Suisse, where he met and became a friend of Cézanne and Pissarro. Years later he befriended the younger artist Vincent van Gogh. Guillaumin participated in six of the eight impressionist group exhibitions and in 1894 held his first one-man show at the Galerie Durand-Ruel. Until 1891, when Guillaumin won 100,000 francs in a lottery, he worked in poverty, often painting window shades and shop interiors to earn a living. In 1870 and 1871, during the seige of Paris and the civil strife of the Commune that followed, many of his early paintings were lost.

La Seine à Paris (The Seine in Paris) 1871
Oil on canvas, 49¾ x 71⅜ inches, signed lower right: *Guilláumin 71*

PROVENANCE:

Private collection, Paris; Sale, Paris, Palais Galliéra, *Collection de M' X,* June 18, 1969, lot 49; Mr. and Mrs. John A. Beck, Houston, 1969; The Museum of Fine Arts, Houston, The John A. and Audrey Jones Beck Collection, 1971

BIBLIOGRAPHY:

Armand Silvestre, "Chronique des beaux-arts: L'exposition des révoltés," *L'Opinion Nationale,* April 22, 1874.

Philippe de Montebello and Thomas P. Lee, "Recent Acquisitions, a French Impressionist View of Paris," *Bulletin,* The Museum of Fine Arts, Houston, vol. 2, no. 5, September 1971, pp. 58-60.

G. Serret and D. Fabiani, *Armand Guillaumin, catalogue raisonné de l'oeuvre peint,* Paris, 1971, no. 10.

Christopher Gray, *Armand Guillaumin 1841-1927,* Chester, Connecticut, 1972, no. 24, pl. 1.

Linda Dalrymple Henderson, "Alfred Sisley's 'The Flood on the Road to St. Germain,'" *Bulletin,* The Museum of Fine Arts, Houston, 1975-76, p. 21.

Theodore Reff, "The Pictures Within Cézanne's Pictures," *Arts,* June 1979, p. 92.

John Minor Wisdom, in William C. Agee, ed., *The Museum of Fine Arts, Houston: A Guide to the Collection,* Houston, 1981, pp. 106-107, no. 184, ill.

John Rewald, *Studies in Impressionism,* New York, 1985, p. 105, ill.

Charles S. Moffett, et al., *The New Painting: Impressionism 1874-1886,* San Francisco, 1986, no. 5, pp. 120, 128.

Katherine E. Silburgh, "The Other Impressionists," *Art and Auction,* April 1986, p. 106, ill.

EXHIBITIONS:

Paris, 35, Boulevard des Capucines, *Société Anonyme des Artistes, Peintres, Sculpteurs, Graveurs, etc., Première Exposition,* (first impressionist exhibition), 1874, no. 65, as *Temps Pluvieux (Rainy Weather).*

Paris, Galerie Raphaël Gerard, *Exposition Guillaumin,* November 1958, no. 5.

New York, Hirschl and Adler Galleries, *Paintings by Jean Baptiste Armand Guillaumin (1841-1927),* 1971, no. 33.

Houston, The Museum of Fine Arts, Houston, *The Collection of John A. and Audrey Jones Beck,* 1974, pp. 48-49.

Washington, D.C./San Francisco, National Gallery of Art/The Fine Arts Museums of San Francisco, *The New Painting: Impressionism 1874-1886,* 1986, no. 5, pp. 120, 128, as *Temps Pluvieux (Rainy Weather).*

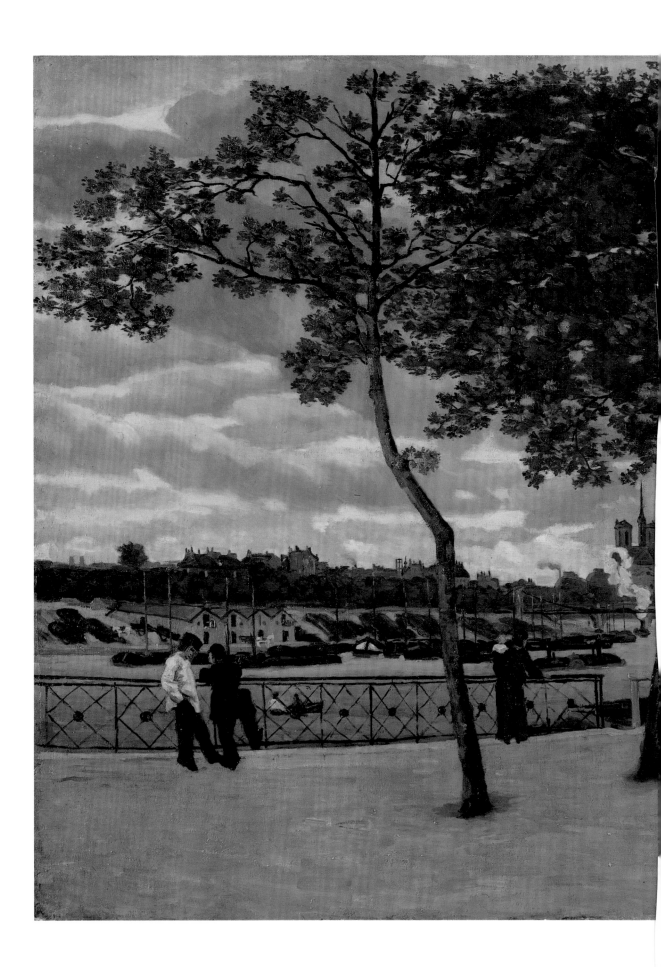

ALEXEI VON JAWLENSKY

Born 1864 Torzhok, Russia

Died 1941 Wiesbaden, Germany

WEIBLICHER KOPF (PORTRAIT OF A WOMAN) 1910

Alexei von Jawlensky's intense feelings toward women are vividly expressed in his portraits, forceful works using fauve colors and expressionistic vigor. *Portrait of a Woman* dates from the Russian-born painter's formative years in Munich, when he and other progressive artists founded the New Association of Munich Artists, a German version of the Salon des Indépendants, dedicated to exhibiting the avant-garde works that the Munich Secession refused to hang. This portrait is one of many large-scale heads, each filling the entire canvas, that Jawlensky painted at this time. He began to experiment with this subject and format in series. This idea was carried through to the end of Jawlensky's career, when he created almost completely abstract variations of the same theme. In his memoirs, Jawlensky referred to his prewar portraits as his "most powerful works."

Jawlensky, born of Russian nobility, was a military cadet when he first saw a large collection of paintings at the Palace of Art at the Moscow World's Fair of 1880. "Ever since then art has been my ideal," he later wrote, "that for which my entire self yearns." At the age of twenty-five, he joined a regiment in St. Petersburg, and although it was difficult for a cadet to do so, he attended the Imperial Art Academy. Jawlensky resigned his commission as captain in 1896 and moved to Munich, where he entered the studio of Anton Azbé. There he met a fellow Russian, Wassily Kandinsky, and the Swiss painter Ferdinand Hodler, initiating a lifelong friendship. In 1905 the Russian art critic and ballet impressario Sergei Diaghilev was instrumental in having ten of Jawlensky's expressionist works accepted at the Salon d'Automne's notorious fauve exhibition. While in Paris, Jawlensky associated with the fauve painters and worked in Henri Matisse's studio. Returning to Germany four years later, Jawlensky exhibited regularly at the New Association of Munich Artists. At the outbreak of World War I, he immigrated to Switzerland and settled in Zurich, which had become a meeting place for European artists and writers fleeing the war. In 1924, along with Lionel Feininger, Kandinsky, and Paul Klee, he formed the group known as the Blauen Vier (Blue Four), promoting their artistic ideas abroad through lectures and exhibitions. Stricken by arthritis in 1929, he tried many cures; but in the last years of his life, he was forced to abandon painting entirely.

Weiblicher Kopf (Portrait of a Woman) 1910
Oil on board, 20⅞ x 19½ inches, signed upper left: *A Jawlensky*

PROVENANCE:

Echem Nichaus, Munich; Roman N. Ketterer, Lugano, 1968; Mr. and Mrs. John A. Beck, Houston, 1968

EXHIBITIONS:

Washington, D.C., National Gallery of Art, *U. S. Loan Exhibition,* 1971-73. Houston, The Museum of Fine Arts, Houston, *The Collection of John A. and Audrey Jones Beck,* 1974, pp. 50-51.

JOHAN BARTHOLD JONGKIND

Born 1819 Latrop, the Netherlands

Died 1891 Grenoble, France

PAYSAGE HOLLANDAISE (DUTCH LANDSCAPE) 1862

Johan Barthold Jongkind's *Dutch Landscape* reveals the qualities of painting that established this artist as an important forerunner of impressionism. The impressionists' debt to Jongkind was stated clearly by Camille Pissarro: "Had he not been, we would not have been." *Dutch Landscape* reveals complex sources of inspiration deriving partly from French art, notably the paintings of Barbizon artists Jean-François Millet and Camille Corot but more obviously from the great tradition of Dutch landscape painting. Throughout his career, Jongkind produced works such as *Dutch Landscape,* which captured the fleeting qualities of nature despite being painted in his studio.

Jongkind, a generation older than the impressionists, received his first artistic training in Holland while studying at the Hague Drawing Academy. An excellent pupil, he won a government grant to continue his studies there. Under the patronage of the Prince of Orange, he studied in Paris with the French marine painter Eugène Isabey from 1846 until the early 1850s. Isabey influenced the development of Jongkind's work, encouraging and directing him for many years. In 1852 he won a third-class medal, his first success at the Paris Salon. Born in Holland, Jongkind spent most of his adult life in France, where his landscape paintings inspired the work of his friends Eugène Boudin and Claude Monet.

Paysage Hollandaise (Dutch Landscape) 1862
Oil on canvas, 13¼ x 22¼ inches, signed lower left: *Jongkind 1862*

PROVENANCE:

Galerie Durand-Ruel, Paris, no. 4835; F.H. Sherwood, Montreal; Mrs. James Bradlee, Boston; Hirschl & Adler Gallery, New York, 1967; Mr. and Mrs. John A. Beck, Houston, 1967

BIBLIOGRAPHY:

Victorine Hefting, *Jongkind, sa vie, son oeuvre, son époque,* Paris, 1975, no. 228, p. 126.
Linda Dalrymple Henderson, "Alfred Sisley's 'The Flood on the Road to St. Germain,'" *Bulletin,* The Museum of Fine Arts, Houston, 1975-76, p. 27, ill.

EXHIBITIONS:

Houston, The Museum of Fine Arts, Houston, *The Collection of John A. and Audrey Jones Beck,* 1974, pp. 52-53.

WASSILY KANDINSKY

Born 1866 Moscow, Russia

Died 1944 Neuilly-sur-Seine, France

SKIZZE 160 A (SKETCH 160 A) 1912

Wassily Kandinsky's *Sketch 160 A* was painted in Murnau in 1912. The evocative color and line of *Sketch 160 A*, together with half-hidden images of nature, birds, fish, a triumphant figure of a mounted horseman, and other subjects, convey the artist's spiritual message, an allegory of the struggle of good and evil. The apparently haphazard structure of *Sketch 160 A* belies the care with which Kandinsky placed each element of the composition, using contrasting pictorial elements and moods to create an intricate balance. The recognizable images bring the viewer into the painting and help to interpret its mystery.

Kandinsky was born in Moscow, where his imagination was fired by the magic of Russian myth, the pageantry of the Orthodox church, and the bright colors of Russian folk art. A gifted artist and musician, Kandinsky pursued the correspondence that he perceived between color and sound. Abandoning a successful legal career, Kandinsky traveled extensively and eventually moved to Munich, where he devoted himself entirely to abstract painting. Along with Franz Marc and Paul Klee, Kandinsky became a major generating force of the Blue Rider movement, a group of avant-garde Munich artists who believed in a spontaneous and expressive approach to painting subject matter drawn from myth and the use of intense colors. They organized exhibitions that included works by August Macke, Henri Rousseau, Robert Delaunay, and Georges Braque. Kandinsky also exhibited with the fauve painters in Paris at the Salon d' Automne from 1904 to 1910. In 1910 he wrote "On the Spiritual in Art," a treatise which argued that abstract shapes and colors in the proper configuration revealed spiritual truth. "Color is the keyboard, the eyes are the hammer, the soul is the piano with many strings," he wrote. "The artist is the hand that plays, touching one key or another purposively, to cause vibrations in the soul." In 1922 Kandinsky became a teacher at the newly organized Bauhaus School and remained there until its dissolution by Adolph Hitler in 1933. Kandinsky's works and those of many of his colleagues were labeled degenerate by the Nazis. They confiscated approximately 16,500 items, some of which were sold and others burned in Berlin in 1939.

Skizze 160 A (Sketch 160 A) 1912
Oil on canvas, 37½ x 42 inches,
signed and dated lower left: *Kandinsky 1912*

PROVENANCE:

Heer Collection, Zurich; Galerie Maeght, Paris; Mrs. Bertram Smith, New York; Mr. and Mrs. David E. Bright, Beverly Hills; Galerie Heinz Berggruen, Paris; Mr. and Mrs John A. Beck, Houston, 1969; The Museum of Fine Arts, Houston, The John A. and Audrey Jones Beck Collection, 1974

BIBLIOGRAPHY:

Will Grohmann, *Wassily Kandinsky, Life and Work*, New York, 1958, p. 275.
Ellen H. Johnson, *Modern Art and the Object, A Century of Changing Attitudes*, London, 1976, pl. 4.
Hans K. Roethel and Jean K. Benjamin, *Kandinsky: Catalogue Raisonné of the Oil Paintings 1900-1915*, Ithaca, 1982, vol. 1, no. 442.
Judith McCandless Rooney, in William C. Agee, ed., *The Museum of Fine Arts, Houston: A Guide to the Collection*, Houston, 1981, pp. 128-29, no. 216.

EXHIBITIONS:

Bern, Kunsthalle, 1955, no. 32.
London, Marlborough Fine Art, Ltd., *Kandinsky: the Road to Abstraction*, April-May 1961, no. 36.
New York/Paris/The Hague/Basel, The Solomon R. Guggenheim Museum, Musée National d'Art Moderne, Gemeente-museum, Kunsthalle, *Vasily Kandinsky, 1866-1944: A Retrospective Exhibition*, 1963, no. 20.
Washington, D.C., National Gallery of Art, *U. S. Loan Exhibition*, 1971-73, no. 20.
Houston, The Museum of Fine Arts, Houston, *The Collection of John A. and Audrey Jones Beck*, 1974, pp. 54-55.

ERNST LUDWIG KIRCHNER

Born 1880 Aschaffenburg, Germany

Died 1938 Frauenkirch, Switzerland

MONDAUFGANG: SOLDAT UND MÄDCHEN (MOONRISE: SOLDIER AND MAIDEN) 1905

Ernst Ludwig Kirchner's *Moonrise: Soldier and Maiden* was probably painted at the end of 1905 in direct response to the exhibition of Vincent van Gogh's art held in Dresden at that time. Kirchner adopted van Gogh's heightened palette and broad, thick brushstroke, as well as borrowing the compositional idea from one of the artist's earlier works of the Arles period, *The Lovers*, 1888. Kirchner did not fully give up a naturalist reference in the colors of objects, but he strengthened the intensity of each hue and retained romantic subject matter in the two lovers set in a natural environment.

Obeying his parents' wishes, Kirchner attended architectural school in Dresden, but he abandoned the promise of this career after graduating with honors in 1905. He had decided to concentrate on painting. His early interest in scientific theories of color led him to the work of the neo-impressionists, but he was equally attracted to the art of the Middle Ages and to tribal arts. Kirchner was one of four founders of the avant-garde group of expressionists *Die Brücke* (The Bridge) established in Dresden. There he pursued an intense period of self-instruction in drawing. His earlier academic lessons had taught him proportion and perspective, but increasingly he began to draw from contemporary life. He had to sketch rapidly to capture the essence of what he saw, and this led to a new definition of "exact representation" for Kirchner. In his own words, "I drew in the streets and squares, in inns and cafés. Through the speed of the work...abbreviations took place in the sketches—abbreviations which still rendered the intended image most accurately...often better than did...precise execution." On the whole he avoided what Henri Matisse called "unpleasant subject matter" and followed van Gogh's lead in liberating color from its descriptive role in painting. During World War I, Kirchner was a volunteer in an artillery regiment, but in 1915 he suffered a physical breakdown and nervous collapse. He continued to paint and exhibit throughout his life, but in 1938, branded as degenerate by the totalitarian government, Kirchner fled Germany. He worked in Switzerland for a brief period, and then—like his early idol van Gogh—tragically took his own life.

Mondaufgang: Soldat und Mädchen (Moonrise: Soldier and Maiden) 1905
Oil on cardboard, 27½ x 19½ inches, signed and dated lower right:
EL Kirchner 03

PROVENANCE:

Kirchner Estate, Dresden; Norman R. Ketterer, Lugano; Mr. and Mrs. John A. Beck, Houston, 1968

BIBLIOGRAPHY:

Donald E. Gordon, "Kirchner in Dresden," *The Art Bulletin*, vol. 47, September-December 1966, p. 339, pl. 11.
Donald E. Gordon, *Ernst Ludwig Kirchner*, Cambridge, Massachusetts, 1968, p. 48, ill. p. 266, pl. 7.
Anton Henze, *Ernst Ludwig Kirchner, Leben und Werk*, Stuttgart, Zurich, 1980, p. 16, ill. p. 11.

EXHIBITIONS:

Washington, D.C., National Gallery of Art, *U.S. Loan Exhibition*, 1971-73.
Houston, The Museum of Fine Arts, Houston, *The Collection of John A. and Audrey Jones Beck*, 1974, pp. 56-57.

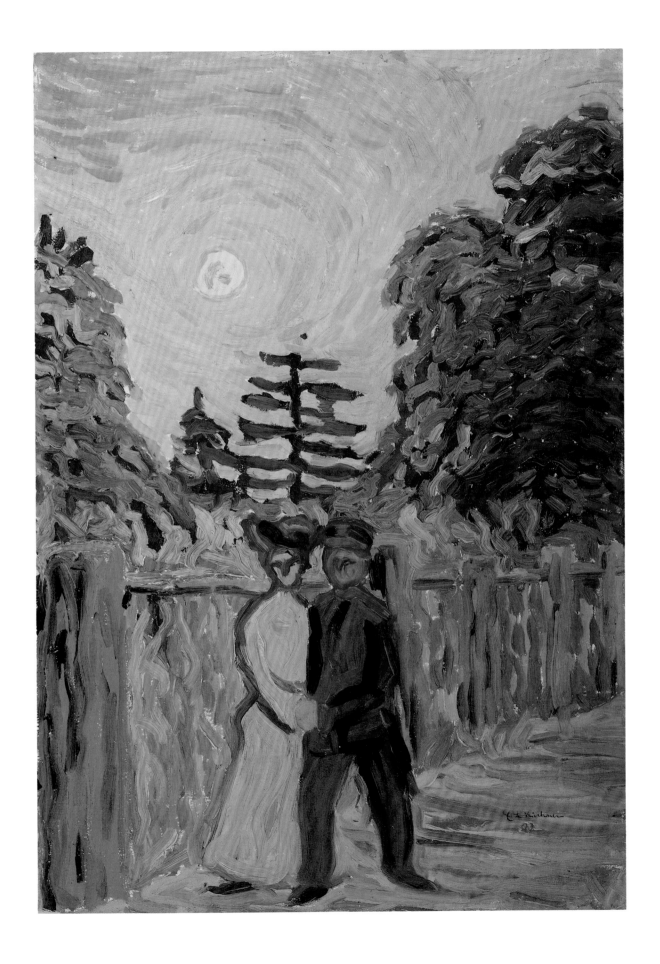

ROGER-NOËL-FRANÇOIS DE LA FRESNAYE

Born 1885 Le Mans, France

Died 1925 Grasse, France

LE QUATORZE JUILLET (THE FOURTEENTH OF JULY) 1914

Painted with patriotic pride, *The Fourteenth of July* celebrates Bastille Day, which commemorates French independence from the monarchy. This painting in oil is a small-scale version of a monumental canvas which Roger-Noël-François de La Fresnaye never completed. Planning for the grand-scale work, he made line drawings and sketches of the entire composition and details in pencil, charcoal, and watercolor. His broad planes of fresh color and his deft brushwork evoke an exuberant holiday spirit. La Fresnaye developed his own style of cubism, structuring his compositions with pure, luminous colors. *The Fourteenth of July* was the artist's last important work.

La Fresnaye was born in Le Mans, France, into a Norman family of scholars, soldiers, and landed aristocrats. His grandeur of conception and intricate working methods owe a debt to his classical education, which instilled in him a deep interest in and respect for the history of art. In La Fresnaye's words, "The continuity of art through the ages is the indispensable element without which it could not live and develop." Trained at the Académie Julian and the Ecole des Beaux-Arts, La Fresnaye left the traditional academic system in 1908 to enroll at the more progressive Académie Ranson. There he came under the influence of the Nabi painter Maurice Denis and worked briefly in a decorative style derived from that of Paul Gauguin. Having been inspired by the innovative paintings of Pablo Picasso and Georges Braque, La Fresnaye began producing cubist style compositions in 1910. He rejected the monochromism and formal concerns of the pioneering cubists in favor of a more colorful and even philosophical approach to painting, retaining his personal style of flat, rectangular planes of pure color. His career ended when he entered the French infantry at the beginning of World War I. La Fresnaye suffered a hemorrhage in the trenches. Though he lived seven more years, his condition weakened until his death in 1925.

Le Quatorze Juillet (The Fourteenth of July) 1914
Oil on canvas, 28¼ x 38¼ inches

PROVENANCE:

Marcel Kapferer, Paris; Charles Girard, Paris; Jacques Seligmann & Co., New York; Jerome Hill, California; Sale, *Modern Paintings from the Collection of Jerome Hill*, Christie's, London, December 2, 1974, no. 21; Fourcade, Droll, Inc., New York, 1975; The Museum of Fine Arts, Houston, The John A. and Audrey Jones Beck Collection, 1975.

BIBLIOGRAPHY:

E. Nebelthau, *Roger de la Fresnaye,* Paris, 1935, ill.
Germain Seligman, *Roger de la Fresnaye,* New York, 1945, p. 41.
Raymond Cogniat and Waldemar George, *Oeuvre Complète de Roger de la Fresnaye,* Paris, 1950, no. 14, ill. (mistakenly given measurements and location of larger *Fourteenth of July* in Musée National d'Art Moderne, Paris).
Germain Seligman, *Merchants of Art: 1880-1960, Eighty Years of Professional Collecting,* New York, 1961, plate 97.
Germain Seligman, *Roger de la Fresnaye (catalogue raisonné),* Greenwich, Conn., 1969, no. 145, p. 51, ill.
Linda Dalrymple Henderson, "'The Fourteenth of July' by Roger de la Fresnaye," *Bulletin,* The Museum of Fine Arts, Houston, vol. 6, nos. 2-4, 1975-76, pp. 2-19.
Judith McCandless Rooney, in William C. Agee, ed., *The Museum of Fine Arts, Houston: A Guide to the Collection,* Houston, 1981, p. 131, no. 220.

EXHIBITIONS:

London, Alex Reid & Lefevre, Ltd., *Paintings and Drawings by Roger de la Fresnaye,* 1931, no. 16.
Paris, Galerie Charpentier, *Cents Chefs-d'Oeuvres de l'Art Contemporain,* 1945.
Rome and Rio de Janeiro, *Art Français,* 1946.
The Hague, Gemeentemuseum, *Fransche Kunst,* 1947, no. 65.
Minneapolis, The Minneapolis Institute of Arts, *Fiftieth Anniversary Exhibition,* 1965-66.

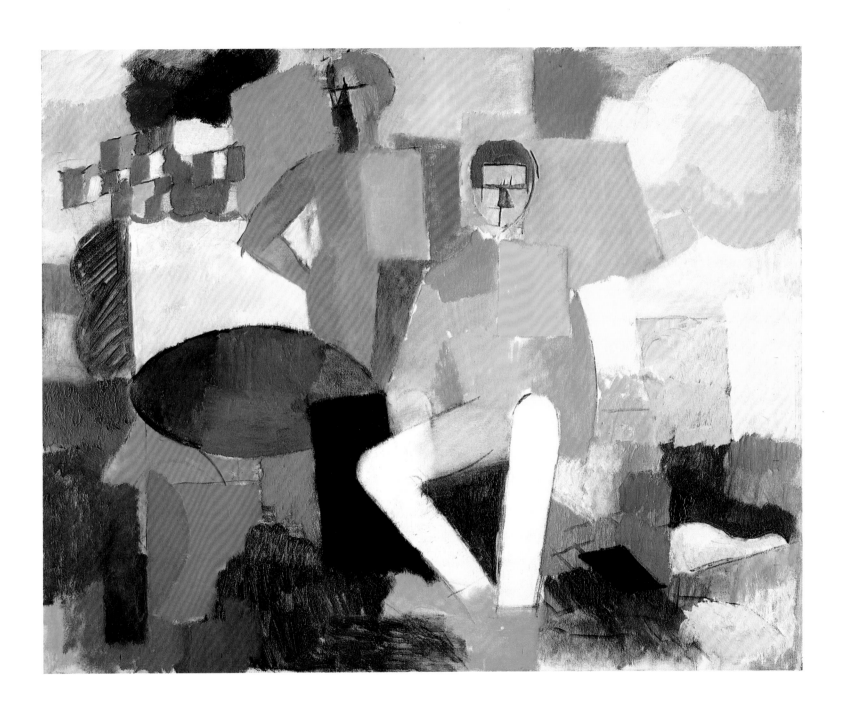

MARIE LAURENCIN

Born 1883 Paris, France

Died 1956 Paris, France

FEMME AU CHAPEAU (WOMAN WITH A HAT) 1911

Woman with a Hat reveals the influence of Pablo Picasso and Georges Braque on Marie Laurencin's style in the broken and shifted planes of the figure's face and costume. She began to paint in this style at the age of twenty-six, and although she pursued it for only a brief period, such works as *Woman with a Hat* elicited the praise of cubism's outspoken critic, Guillaume Apollinaire. The picture's oval format relates to several canvases Laurencin painted in 1912 for wall panels in the Maison Cubiste, a collaborative project for the application of cubist paintings in interior decoration; it evokes, furthermore, a conscious reference to the decorative panels of the eighteenth century, a reference underscored by the picture's rococo charm. Laurencin preferred to use pastel colors, and the figure here, on a gray tonal background, as in many of Laurencin's portraits, bears a strong resemblance to her own image.

Like Pierre-Auguste Renoir, Laurencin first worked as a porcelain painter. In 1904 at the Académie Humbert she met Georges Braque, who introduced her to the circle of cubist painters. She became a close friend of Picasso and his mistress Fernande Olivier. Laurencin became the mistress of the poet Guillaume Apollinaire and through this relationship was accepted into the small group of artists and writers who gathered frequently at the home of Gertrude Stein. Laurencin exhibited at the 1910 Salon des Indépendants, the cubist room of the 1911 Salon des Indépendants and at the Salon d'Automne's Maison Cubiste in 1912. She designed theatrical scenery and costumes for the Ballets Russes and for the Comédie Française. Brought up solely by her mother, the artist wrote in her book of poems and remembrances, "But if the genius of men intimidates me, I feel perfectly at ease with all that is feminine." Laurencin's early work in the cubist manner gave way in later years to a more lyrical style; her best-known subjects are doe-eyed young girls painted in pastel tones.

Femme au Chapeau (Woman with a Hat) 1911
Oil on panel, 13¾ x 10¼ inches (oval)
signed lower right: *Marie Laurencin*

PROVENANCE:

Dr. Le Masle, Paris; Palais Galliéra, Paris, 1968; Mr. and Mrs. John A. Beck, Houston, 1968

EXHIBITIONS:

Lille, Palais des Beaux-Arts, *Apollinaire et le cubisme,* 1965, no. 30.
Houston, The Museum of Fine Arts, Houston, *The Collection of John A. and Audrey Jones Beck,* 1974, pp. 58-59.

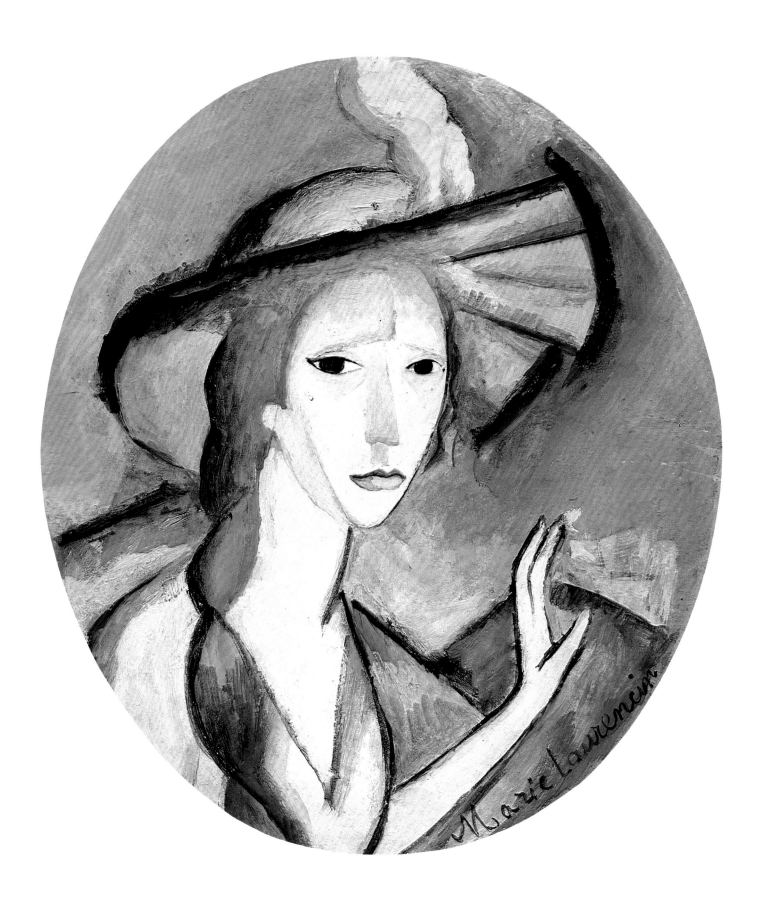

HENRI-CHARLES MANGUIN

Born 1874 Paris, France

Died 1949 Saint-Tropez, France

PORT SAINT-TROPEZ, LE 14 JUILLET (PORT OF SAINT-TROPEZ, JULY 14TH) 1905

In 1905, on the advice of Henri Matisse and Paul Signac, Henri-Charles Manguin and Albert Marquet spent the summer in the small village of Saint-Tropez. The bright light of the Midi and colorful landscapes made Saint-Tropez a paradise for fauve artists. Marquet's balcony at the Hôtel Subes overlooked the harbor, and it was there on July 14 that Manguin witnessed a *fête pavoisée*, a festival of boats decorated with flags in celebration of the anniversary of the French Revolution. He painted at least three pictures of the fête that day, including this canvas. The other works comprise a two-part panorama of the entire port. The painting in this collection is meticulously organized, consisting of repeated horizontal shapes, vertical lines, and parallel diagonals. The sails of the boats, shining orange, blue, and white, are broken by the red lines of masts and flagpoles. At the left, larger than the sails, hangs the French tricolor flag, symbol of independence.

Manguin, the son of conservative upper-class Parisians, lost his father at the age of six. At fifteen Manguin was able to persuade his mother to permit him to leave school and devote his life to painting. In 1894 he became a student along with Matisse and Marquet in Gustave Moreau's atelier at the Ecole des Beaux-Arts; they remained lifelong friends. Moreau was an influential teacher as well as an important artist. When a group of his students joined the Salon d'Automne (1905), the explosive colors of their work earned the avant-garde artists the title of fauves (wild beasts). Manguin was part of this group, and like most of his colleagues, his work soon gained broad recognition. Important collectors such as Gertrude Stein became patrons, and influential critics including Guillaume Apollinaire who praised Manguin's canvases. He exhibited annually at the Salons throughout his life. After 1905 he lived mainly in Saint-Tropez. It was a tranquil existence with his wife Jeanne, who was his secretary, model, and friend.

Port Saint-Tropez, le 14 Juillet (Port of Saint-Tropez, July 14th) 1905
Oil on canvas, 24⅛ x 19¾ inches, signed lower left: *Manguin*

PROVENANCE:

Ambroise Vollard, Paris, purchased from the artist, 1906; Private collection, Le Vesinet, France; Sale, Geneva, Galerie Motte, March 6, 1975, no. 274; Galleries Maurice Sternberg, Chicago, 1977; Mrs. John A. Beck, Houston, 1977

BIBLIOGRAPHY:

Lucile and Claude Manguin, *Henri Manguin, l'oeuvre peint*, Neuchâtel, 1980, no. 149.

EXHIBITIONS:

Paris, Galerie Berthe Weill, *Exposition de peintures*, 1905, no. 25, 26, or 27 (as *Saint-Tropez, fête nautique*).

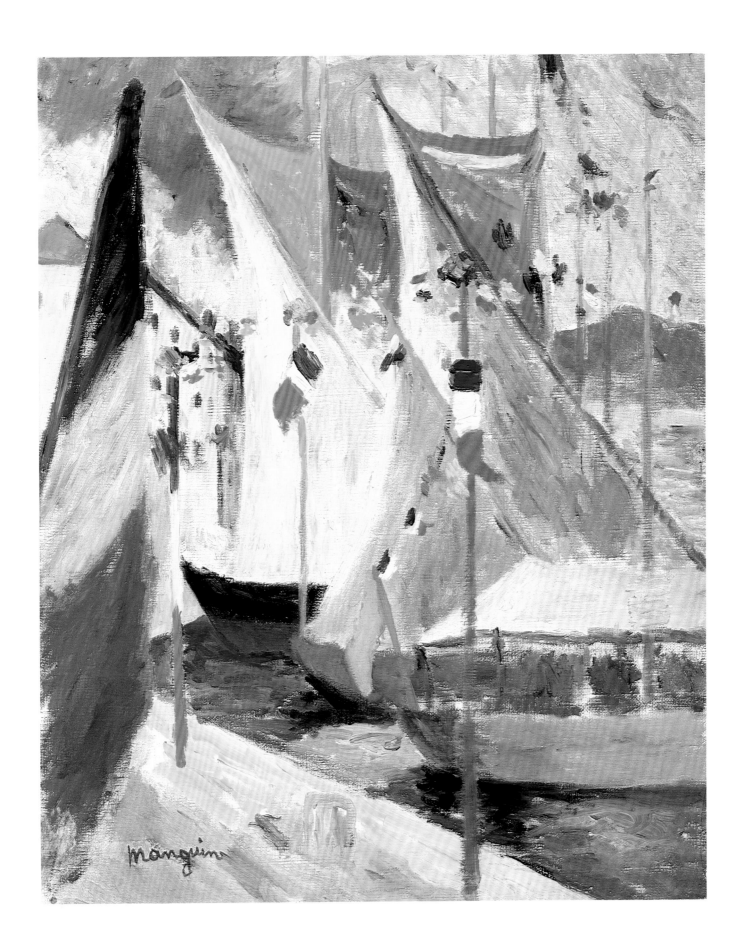

ALBERT MARQUET

Born 1875 Bordeaux, France

Died 1947 Paris, France

LA PASARELLE DE SAINTE-ADRESSE (THE BOARDWALK AT SAINTE-ADRESSE) 1906

The Boardwalk at Sainte-Adresse, painted on the Normandy coast in 1906, is characteristic of Albert Marquet's calm, uncluttered style. The painting describes people casually enjoying a summer day on the boardwalk and beach in front of the popular Casino Marie-Christine. Marquet visited Sainte-Adresse with Raoul Dufy, who often painted this picturesque site. The beach area seemed to have unlimited visual possibilities, and Marquet's response was to capture the fleeting movement of water and people. Painting side by side, Marquet and Dufy repeated this particular scene from many different vantage points.

Marquet came from humble origins. His father was opposed to his pursuit of a career in painting; his mother, however, moved to Paris and worked to support her son's art lessons. He first entered the Ecole des Arts Décoratifs and later the Ecole des Beaux-Arts in the studio of Gustave Moreau. His classmates were Henri Matisse, Georges Rouault, and Henri Maguin. These future fauves were influenced by Paul Signac's color theories, and began to simplify their painting techniques by using bold if unnatural colors. Gradually Marquet developed a style of realism reminiscent of early impressionism. His excellent draftsmanship led Matisse to compare Marquet to a Japanese master: "He is our Hokusai." Marquet painted the harbors and ports of western Europe, northern Africa, and Russia. Chosen as the principal French artist in the Venice Biennale of 1936, Marquet enjoyed a successful career. A modest man, unconcerned with critics or dealers, shunning publicity, this anonymous chronicler of daily life even refused prestigious honors such as the Legion of Honor and membership in the Institut de France. At the outbreak of World War II, he and his wife Marcelle fled to her family home in Algiers. Marquet's anti-Nazi posters, which greeted the German occupation troops in Paris, made the departure mandatory. The Marquets returned to Paris in 1945, and the artist spent his final two years painting scenes from windows, a practice he had followed for more than forty years.

La Pasarelle de Sainte-Adresse (The Boardwalk at Sainte-Adresse) 1906
Oil on canvas, 15 x 24 inches, signed lower right: *Marquet*

PROVENANCE:

Madame Marcelle Marquet, Paris; Mrs. Beverly Kean, New York; Sale, New York, Sotheby Parke-Bernet, *Important 19th and 20th Century Paintings, Drawings and Sculpture,* May 3, 1973, lot 66; Acquavella Galleries, New York, 1973; Mr. and Mrs. John A. Beck, Houston, 1973

BIBLIOGRAPHY:

Florent Fels, *L'Art vivant de 1900 à nos jours,* Paris 1950, p. 201, ill.
Francis Jourdain, *Albert Marquet,* Paris 1959, p. 66, ill.

EXHIBITIONS:

Berne, Kunsthalle, *Les Fauves und die Zeitgenossen,* 1950, no. 82.
Venice, *25th Biennale: I "Fauves,"* 1950, p. 49, no. 37.
Paris, Musée National d'Art Moderne, *Le Fauvisme,* 1951, no. 86.
Belgrade, *Exposition d'art français en Yugoslavie,* 1952.
New York, Wildenstein Galleries, *Loan Exhibition of Marquet,* 1953, no. 17.
Toulouse, Musée des Augustins, *Marquet,* 1954, no. 11, ill.
Rotterdam/Arnhem, Museum Boymans-van-Beuningen/Gemeente Museum, *Marquet,* 1955-56, no. 19, ill.
Lyons, Musée de Lyon, *Marquet,* 1962, no. 22.
Paris, Galerie Charpentier, *Les Fauves,* 1962, no. 82.
Rotterdam, Museum Boymans-van-Beuningen, *Franse Landscappen can Cézanne tot Leden,* 1963, no. 64, pl. 21.
New York, M. Knoedler and Co., *Marquet,* 1964, no. 12.
Houston, The Museum of Fine Arts, Houston, *The Collection of John A. and Audrey Jones Beck,* 1974, pp. 60-61.

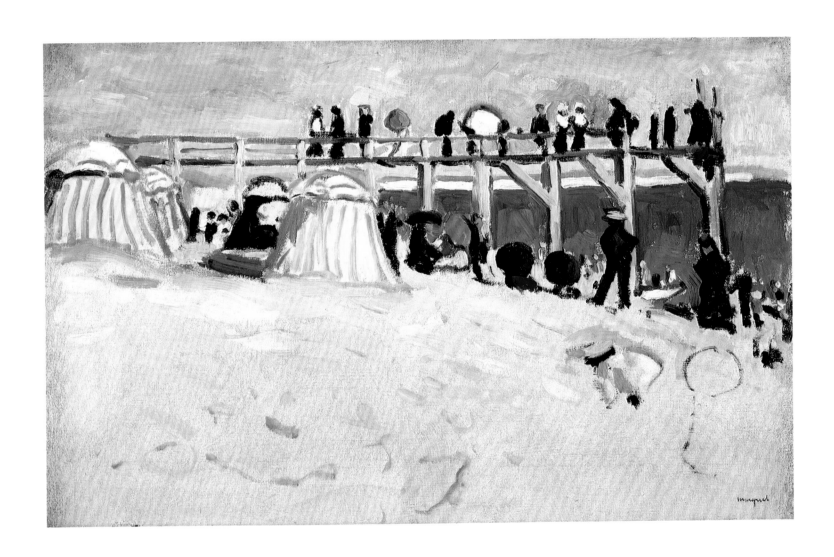

HENRI-EMILE-BENOÎT MATISSE

Born 1869 Cateau-Cambrésis, France

Died 1954 Nice, France

FEMME AU MANTEAU VIOLET (WOMAN IN A PURPLE COAT) 1937

Henri Matisse, a master of restraint and simplicity, paradoxically surrounded himself with luxurious furnishings and elegant models. *Woman in a Purple Coat* is a portrait of Lydia Delectorskaya, a beautiful Russian girl who was his secretary, companion, and model for more than twenty years. This painting was one among many that Matisse painted depicting costumed women in complex exotic settings. These works were executed in Matisse's new style of painting, relying on line and the opposition of warm and cool colors to give the picture relief. The arabesque line and pure color in *Woman in a Purple Coat* suggest the influence of Matisse's earlier days spent in Morocco. As Matisse worked toward a simplification of form, he often distorted details, such as his sitter's hands and feet, for the sake of the picture's overall design.

Coming late to the craft of painting, Matisse studied first with the academic artists William-Adolphe Bouguereau and Gustave Moreau. After meeting the impressionist painter Camille Pissarro, he abandoned academic training altogether. Like Paul Cézanne and Paul Signac, Matisse sought out the light of southern France in Saint-Tropez, where in 1904 he joined Signac and Henri-Edmond Cross. Both Signac and Cross were developing the divisionist style; their technique influenced the work of Matisse. As the color in his paintings became increasingly brilliant and removed from the colors of the natural world, he emerged as the leader of the fauves. In the succeeding decades, he strove to make, as he said, "an art of balance, of purity and serenity devoid of troubling or depressing subject matter." Painting large, simplified forms enlivened by pattern and brilliant color, Matisse preferred above all the female figure. He continued to work up to the time of his death, exploring new and more simplified modes of expression.

Femme au Manteau Violet (Woman in a Purple Coat) 1937
Oil on canvas, 37⅞ x 25¹¹/₁₆ inches, signed lower left: *Henri Matisse 37*

PROVENANCE:

Madame Méric Callery, Paris; Frederic R. Mann, Philadelphia; M. Knoedler & Co., New York, 1965; Mr. and Mrs. John A. Beck, Houston, 1965; The Museum of Fine Arts, Houston, The John A. and Audrey Jones Beck Collection, 1974

BIBLIOGRAPHY:

Cahiers d'Art, Paris, 1937, No. 6-7, p. 207, ill.
"Les Grandes Expositions," *Cahiers d'Art,* Paris, February 25, 1938, ill.
Martha Davidson, "Recent Matisse Anthology," *Art News,* November 19, 1938, page 12, ill.
R.H. Wilenski, *Modern French Painters,* New York, 1954, p. 323.
John Jacobus, "Reassessing the Middle Matisse, an Art of Chamber-music Proportions," *Artnews,* vol. 72, no. 9, November 1973, pp. 74-76, ill.
Judith McCandless Rooney, in William C. Agee, ed., *The Museum of Fine Arts, Houston: A Guide to the Collection,* Houston, 1981, p. 151, no. 251.

EXHIBITIONS:

Paris/London, Galerie Paul Rosenberg/Rosenberg and Helft, *Recent Works of Henri Matisse,* 1937, no. 10.
New York, Pierre Matisse Gallery, *Henri Matisse Exhibition, Paintings and Drawings of 1918 to 1938,* 1938, no. 9.
Philadelphia, The Philadelphia Museum of Art, *Masterpieces of Philadelphia Private Collections,* 1947, no. 93.
Philadelphia, The Philadelphia Museum of Art, *Philadelphia Collects Twentieth-Century Art,* 1963, p. 24.
Washington, D.C., National Gallery of Art, *U.S. Loan Exhibition,* 1971-73.
New York, Acquavella Gallery, *Henry Matisse,* 1973.
Houston, The Museum of Fine Arts, Houston, *The Collection of John A. and Audrey Jones Beck,* Houston, 1974, pp. 64-65.
Fort Worth, Kimbell Art Museum, *Henri Matisse: Sculptor/Painter,* 1984, no. 53.

AMEDEO MODIGLIANI

Born 1884 Livourne, Italy

Died 1920 Paris, France

PORTRAIT DE LÉOPOLD ZBOROWSKI (PORTRAIT OF LÉOPOLD ZBOROWSKI) c. 1916

Amedeo Modigliani painted many portraits of Léopold Zborowski, one of the artist's greatest friends during his last years. Zborowski, a Polish poet, came to Paris in 1914 during the first World War. He began dealing in old books, but in 1916, upon seeing the work of Modigliani and becoming the artist's friend, he devoted himself to being Modigliani's dealer. Convinced of the young Italian's talent, Zborowski made many personal sacrifices in order to provide Modigliani with a regular allowance, canvases, paints, models, a studio, and even alcohol. When Zborowski died in 1932, he was so deeply in debt that his widow was forced to sell her entire collection, which included this painting.

Modigliani was plagued by illness from the age of eleven. He left art school at sixteen after a typhoid attack, and in 1901, after a second attack of pleurisy, he went to Italy for convalescence. There he continued academic studies in Florence. In the winter of 1906 he moved to Paris, a handsome, intellectual young bourgeois who in one year changed to a romantically inclined bohemian. Sensitive and generous, he made friends easily with avant-garde artists such as Maurice de Vlaminck and Chaim Soutine. In 1907 he joined the Société des Artistes Indépendants and became one of the key figures in the group of artists known as the School of Paris. His meeting with Constantin Brancusi in 1909 developed into a close relationship, and Modigliani began devoting his attention to sculpture rather than painting. After 1915, because of poor health and difficulty in obtaining materials, he returned to painting, rendering the human figure with the pupil-less eyes that characterized his sculpture. Although he exhibited at the Salon des Artistes Indépendants and the Salon d'Automne and had a one-man show at the Galerie Berthe Weill, it was not until 1919 at a group exhibition in Heal's Gallery, London, that he finally gained recognition. Modigliani died on January 24, 1920, of tubercular meningitis. Zborowski arranged a memorial exhibition for Modigliani in 1921. His importance in the development of twentieth-century art is recognized everywhere today, but the artist himself knew neither fame nor fortune.

Portrait de Léopold Zborowski (Portrait of Léopold Zborowski) c. 1916
Oil on canvas 45¾ x 28¾ inches, signed upper right: *Modigliani*

PROVENANCE:

Léopold Zborowski, Paris; Renou and Colle, Paris; Jacques Guerin, Paris; Sale, *Impressionist and Modern Painting and Sculpture*, Sotheby's, London, July 1, 1970, lot 49; Mr. and Mrs. John A. Beck, Houston, 1970

BIBLIOGRAPHY:

Deutsche Kunst und Dekoration, vol. 28, July 1925, ill. p. 206.
Arthur Pfannstiel, *Modigliani, l'art et la vie,* Paris, 1929, p. 43.
Arthur Pfannstiel, *Modigliani et son Oeuvre,* Paris, 1956, no. 266.
Ambrogio Ceroni, *Amedeo Modigliani,* Milan, 1965, no. 186.
Lon Piccioni, *I dipinti di Modigliani,* Milan, 1970, no. 158.
Apollo, vol. 92, 1970, p. 322.
Pierre Courthion, *Soutine, Peintre du Déchirant,* Lausanne, 1972, p. 151, ill.

EXHIBITIONS:

Venice, 17th Biennale Internazionale de Arte, *Modigliani,* 1930.
New York, Acquavella Galleries, Inc., *Amedeo Modigliani,* 1971, no. 20.
Houston, The Museum of Fine Arts, Houston, *The Collection of John A. and Audrey Jones Beck,* 1974, pp. 66-67.

CLAUDE-OSCAR MONET

Born 1840 Paris, France

Died 1926 Giverny, France

LE MOULIN DE L'ONBEKENDE GRACHT, AMSTERDAM
(THE WINDMILL ON THE ONBEKENDE CANAL, AMSTERDAM) 1871

In the summer of 1870, at the outbreak of the Franco-Prussian war, Claude Monet fled to England; there he remained until the following year, returning to France by way of Holland. He was attracted by the landscape of the low countries and the picturesque Dutch windmills, which appear frequently in the paintings made during his stay in Holland. It was in Amsterdam that he painted the Rozenboom mill on the Onbekende Canal. Intrigued by the reflections of light on water, a recurrent theme in early impressionist paintings, Monet painted the shimmering surface with the same substantial brushstrokes he employed in the gabled buildings.

Monet, a native of the Normandy seaport Le Havre, began to paint at the insistence of Eugène Boudin, who had seen some of Monet's youthful caricatures. By 1859, at the age of nineteen, Monet had settled in Paris, where he began to paint in earnest. He became a close friend of and worked with Pierre-Auguste Renoir, Alfred Sisley, and Frédéric Bazille throughout the 1860s and was influenced both by the realism of Gustave Courbet and by the new style of painting that he saw in the works of Edouard Manet. In 1874, he sent *Impression: Sunrise* to an exhibition of independent artists, and it was from the title of his painting that the term "impressionism" was coined. While continuing to exhibit at the salons, Monet also began an important series of exhibitions in 1883 with the influential dealer Paul Durand-Ruel. Monet's manner of painting, characterized by vibrant color and dappled brushstrokes, is the style most commonly associated with impressionist landscapes. Although his manner can appear quick and improvisational, it is, in fact, based on a deliberate application of brushstrokes, subsequently retouched and reworked to perfection.

Le Moulin de l'Onbekende Gracht, Amsterdam
(The Windmill on the Onbekende Canal, Amsterdam) 1871
Oil on canvas, 21¼ x 25½ inches, signed lower right: *Claude Monet*

PROVENANCE:

Galerie Rosenberg, Paris; Galerie Durand-Ruel, Paris, 1902; Paul Cassirer, Berlin, 1912; Bodenheimer Collection, Switzerland; Wildenstein and Co., 1966; Alex Reid and Lefevre Ltd., London; Mr. and Mrs. Thomas S. Neelands, Jr., New York, 1968; Sale, New York, Sotheby Parke-Bernet, *Important 19th and 20th Century Paintings, Drawings and Sculpture*, April 26, 1972, lot 9; Acquavella Galleries, New York, 1972; Mr. and Mrs. John A. Beck, Houston, 1972

BIBLIOGRAPHY:

Daniel Wildenstein, *Monet, Impressions*, Lausanne, 1967, p. 19, ill.
Daniel Wildenstein, *Claude Monet: biographie et catalogue raisonné*, vol. 1, Paris, 1974, no. 302, ill.
Linda Dalrymple Henderson, "Alfred Sisley's 'The Flood on the Road to Saint-Germain,'" *Bulletin*, The Museum of Fine Arts, Houston, 1975-76, p. 23, ill.

EXHIBITIONS:

Berlin, *Grosse berliner Kunstausstellung*, 1903, no. 622.
London, Grafton Galleries, *Pictures by Boudin, Manet, and Monet*, 1905, no. 104.
Paris, Galerie Durand-Ruel, *Paysages par Monet et Renoir*, 1908, no. 4.
Brussels, La Libre Esthétique, *L'Evolution du paysage*, 1910, no. 146.
London, Lefevre Gallery, *Nineteenth and Twentieth Century French Paintings*, 1967, no. 13.
New York, Wildenstein and Co., *One Hundred Years of Impressionism: A Tribute to Durand-Ruel*, 1970, no. 17.
Houston, The Museum of Fine Arts, Houston, *The Collection of John A. and Audrey Jones Beck*, 1974, pp. 68-69.
Amsterdam, Rijksmuseum Vincent van Gogh, *Monet in Holland*, 1986-87.

CLAUDE-OSCAR MONET

Born 1840 Paris, France

Died 1926 Giverny, France

LE PONT JAPONAIS À GIVERNY (THE JAPANESE FOOTBRIDGE AT GIVERNY) c.1922

Claude Monet was devoted to his garden at Giverny with its lily pond and Japanese footbridge, and he produced many paintings there. In this work, tangled brushstrokes and thickly applied pigment in the area of the vine-covered footbridge serve as evidence of Monet's fading eyesight. The method of applying the paint in superimposed layers of different, often opposing hues, however, is identical to Monet's practice in the 1880s. His late works are often fiery and dark evocations of sunset and twilight. They are wrought by an artist whose hand remains sure though his eyes are dim. His first paintings of the Japanese footbridge date to 1899; this canvas, probably one of the last pictures he painted, dates to 1922-23.

Giverny, a tiny tributary on the River Seine northwest of Paris, was an impressionist painter's delight—a natural setting with hills, meadows, and waters laced with light. In 1883 Monet moved his household to this small village and wrote his dealer Paul Durand-Ruel, "Once settled, I hope to produce masterpieces." This he did over the next forty years. Giverny and its environs became the principal subject of his art. In 1888 he began his first series of paintings on the theme *Haystacks*. His concept of works in series became increasingly important. In 1981 he produced the series *Poplars*, and in 1897, *Morning on the Seine*. As he grew older, his own garden and the water lily pond with its Japanese footbridge became the main subject for his late series of paintings. Commissioned by the State, he painted a great mural cycle of water lilies for the Musée de l'Orangerie, Paris. Even before then, his fame had spread and a steady flow of artists visited the small village of Giverny to work in his shadow. Although Monet's paintings of Giverny bring his impressionist style to maturity, late works such as *The Japanese Footbridge* show his interest in compositions which became the forerunners of abstraction.

Le pont japonais à Giverny (The Japanese Footbridge at Giverny) c. 1922
Oil on canvas, 35 x 36¾ inches, studio stamp upper left: *Claude Monet*

PROVENANCE:

Estate of the artist; Katia Granoff, Paris; M. Knoedler and Co., Inc., New York; Mr. and Mrs. Walter Bareiss, Greenwich, Connecticut; Fourcade, Droll, Inc., New York; The Museum of Fine Arts, Houston, The John A. and Audrey Jones Beck Collection, 1976.

BIBLIOGRAPHY:

William C. Seitz, *Claude Monet*, New York, 1960, p. 158, ill.
B. Von Grunigen, *Vom Impressionismus zum Tachismus*, Basel, 1964, p. 33, ill.
Neue Pinakothek und Staatsgalerie München, Französische Meister des 19. Jahrhunderts...Augestellte Werke I, Munich, 1966, pp. 72,73, pl.9.
Phoebe Pool, *Impressionism*, New York, 1967, p. 63, no. 43, ill.
M. Kuroe, *L'art moderne du monde. Claude Monet*, Japan, 1970, p. 141, no. 54, pl. 69.
Daniel Wildenstein, *Claude Monet*, Milan, 1971, p. 81, ill.
Denis Rouart and Jean-Dominique Rey, *Monet Nymphéas ou les miroirs du temps, suivi d'un catalogue raisonné par Robert Maillard*, Paris, 1972, p. 181.
René Huyghe and the editors of *Réalités, Impressionism*, Paris, 1973, p. 140.
Jerome Klein, "The Strange Posthumous Career of Claude Monet," *The Atlantic*, March 1981, vol. 247, no. 3, pp. 46-51, ill. p. 51
John Minor Wisdom, in William C. Agee, ed., *The Museum of Fine Arts, Houston: A Guide to the Collection*, Houston, 1981, p. 140, no. 234.
Roger Shattuck, "Approaching the Abyss: Monet's Era," *Artforum*, New York, vol. 20, no. 7, March 1982, p. 36, ill.
Robert Gordon and Andrew Forge, *Monet*, New York, 1983, no. 287.
George Heard Hamilton, "The dying of the light: the late work of Degas, Monet, and Cézanne," in *Aspects of Monet, a symposium on the artist's life and times*, John Rewald and Frances Weitzenhoffer, eds., New York, 1984, p. 226.
Daniel Wildenstein, *Claude Monet, Biographie et catalogue raisonné*, vol. 4, Paris, 1985, p. 300, no. 1925, ill.

EXHIBITIONS:

New York/Los Angeles, The Museum of Modern Art/Los Angeles County Museum of Art, *Claude Monet—Seasons and Moments*, 1960, no. 103.
Munich, Bayerische Staatsgemaldesammlungen, *Sammlung Walter Bareiss*, 1965, no 17.
New York, Acquavella Galleries, *Four Masters of Impressionism*, 1968, no. 69.
New York, Richard L. Feigen & Co., *Claude Monet*, 1969, no. 48.
New York/St. Louis, The Metropolitan Museum of Art/St. Louis Art Museum, *Monet's Years at Giverny: Beyond Impressionism*, 1978, no. 55.

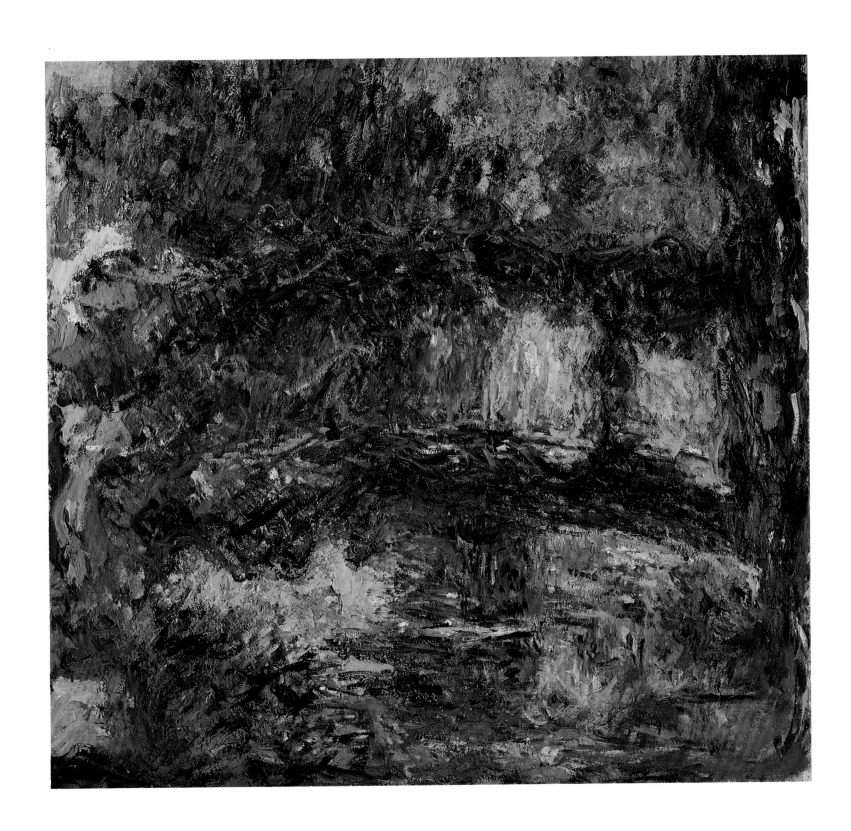

BERTHE MORISOT

Born 1841 Bourges, France

Died 1895 Paris, France

LA HOTTE (THE BASKET-CHAIR) 1885

In the garden of her Paris home, surrounded by a large basket-chair, a watering can, a child's hoop, and a doll, Berthe Morisot's young daughter, Julie Manet, is portrayed peering on tiptoe over the garden fence, while the artist's favorite niece, Jeannie Gobillard, is at play nearby. *The Basket-Chair* is a freely worked painting with large areas of the canvas remaining exposed, creating an unfinished appearance. This freedom of execution evokes the playful naïveté of childhood. Morisot's paintings describe a world of polite, comfortable domesticity, a world populated by family and friends. She painted her daughter, to whom she was devoted, and niece from their infancy through adolescence with an ingenuous charm free from sentimentality.

A distant relative of the eighteenth-century artist Jean-Honoré Fragonard, Morisot was born into a prosperous family that encouraged her artistic inclinations. Although it was somewhat unusual in nineteenth-century France for a woman to pursue an independent career, Morisot's natural artistic ability destined her to a painter's life. As a young girl she admired the work of Camille Corot and at the age of twenty became his pupil. Her first entries in the Salon exhibitions were landscapes in the tradition of Corot and Charles Daubigny. As a student she met Edouard Manet while both were copying old master paintings in the Louvre. Later, she posed for Manet, and her own work began to reflect the influence of his painting style. In return, Morisot encouraged Manet to paint out of doors. She married Manet's younger brother, Eugène, in 1874 and gave birth to their only child Julie four years later. Morisot had numerous exhibitions and showed at the Paris Salon over the course of eight years. Against Edouard Manet's protest, she exhibited in several of the eight impressionist exhibitions. Organized in defiance of the official Salon, the now-famous impressionist exhibitions included the works of Claude Monet, Alfred Sisley, Pierre-Auguste Renoir, Camille Pissarro, Edgar Degas, and Paul Cézanne. Morisot's popularity as an artist is demonstrated by the fact that in the Hotel Drouot sale in 1875, twelve of her canvases brought higher prices than did those of Monet, Renoir, and Sisley. In 1894 one of her paintings was purchased by the Musée de Luxembourg, her first official recognition.

La Hotte (The Basket-Chair) 1885
Oil on canvas, 24⅛ x 29¾ inches

PROVENANCE:

Madame Ernest Rouart, Paris; Gabriel Thomas, Paris; E. and A. Silberman Galleries, New York; David Daniels, Minneapolis and New York; Sale, *Impressionist and Modern Paintings, Drawings, and Sculpture,* Sotheby's, London, June 23, 1965, lot 95; Mr. and Mrs. John A. Beck, Houston, 1965.

BIBLIOGRAPHY:

Louis Rouart, *Berthe Morisot,* Paris, 1941, p. 28.
Louis Rouart, *Berthe Morisot,* Paris, 1949, pl. 44.
Elizabeth Mongan, et. al., *Berthe Morisot, Drawings/Pastels/Watercolors,* New York, 1960, pl. 13.
M.-L. Bataille and G. Wildenstein, *Berthe Morisot, Catalogue Des Peintures, Pastels et Aquarelles,* Paris, 1961, no. 181, pl. 64.

EXHIBITIONS:

Paris, Galerie Durand-Ruel, *Berthe Morisot,* 1902, no. 35.
Paris, Salon d'Automne, 1907, no. 16.
Paris, Galerie Marcel Bernheim, *Réunion d'oeuvres par Berthe Morisot,* 1922, no. 38
Paris, Galerie Bernheim-Jeune, *Exposition d'oeuvres de Berthe Morisot,* 1929, no. 82.
New York, M. Knoedler & Co., *Berthe Morisot,* 1936, no. 8.
Paris, Musée de L'Orangerie, *Exposition Berthe Morisot,* 1941, no. 62.
Minneapolis, Minneapolis Institute of Art, *Paintings and Drawings from Three Private Collections,* 1960, no. 42.
New York, Wildenstein Co., 1960.
San Francisco, Palace of the Legion of Honor, 1960.
Baltimore, The Baltimore Museum of Art, *Manet, Degas, Berthe Morisot, and Mary Cassatt,* 1962, no. 90.
Houston, The Museum of Fine Arts, Houston, *The Collection of John A. and Audrey Jones Beck,* 1974, pp. 70-71.

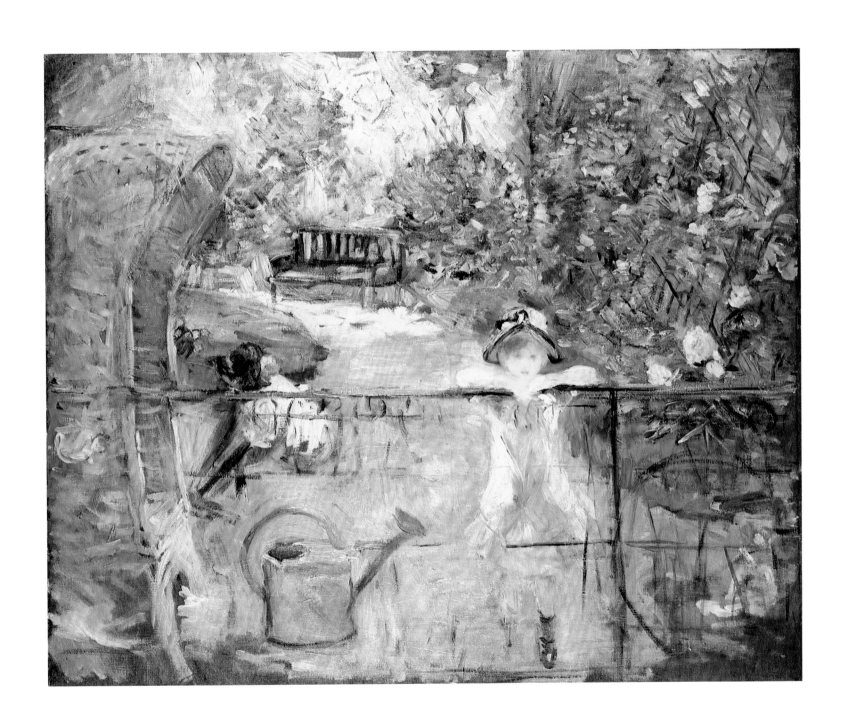

CAMILLE PISSARRO

Born 1830 St. Thomas, Virgin Islands

Died 1903 Paris, France

LA GARDEUSE D'OIES À MONTFOUCAULT, GELÉE BLANCHE
(THE GOOSE GIRL AT MONTFOUCAULT, WHITE FROST) 1875

Camille Pissarro, the oldest member of the impressionist group, painted peasants at work, village scenes, and suburban landscapes. Pissarro occasionally relied upon his wealthy friend, the painter Ludovic Piette, for room and board. During an extended stay at Piette's Montfoucault farm in the autumn of 1875, Pissarro painted *The Goose Girl,* also known as *White Frost.* Like his predecessor, Jean-François Millet, Camille Pissarro gives a quiet dignity to the simple subject of a goose girl guiding her flock, a dignity enhanced by the beautiful colors of nature.

Pissarro received his formal education in Paris and then returned home briefly to work for his father in the Virgin Islands. Back in Paris in 1855, he attended the Ecole des Beaux-Arts for a short time before leaving for the surrounding countryside to paint in the tradition of the Barbizon school. During the years that followed, he met Claude Monet, Pierre-Auguste Renoir, and Alfred Sisley, with whom he was to formulate a new landscape style. Pissarro's works were presented without recognition in the Salons, but in 1874 he was instrumental in organizing the first of the impressionist exhibitions and showed in seven others. Although these exhibitions of avant-garde painting attracted attention, the public denounced impressionism; consequently Pissarro spent years in poverty. His painting career during the second half of the century embraced several of the developing new styles, including a brief attempt at the pointillist technique of Georges Seurat and Paul Signac. Pissarro's role as a teacher was indicated emphatically in Mary Cassatt's statement that "he was so much a teacher that he could have taught stones how to draw correctly." Three years after Pissarro's death, Cézanne paid homage to his friend in an Aix-en-Provence exhibition catalogue where he described himself as, *"Paul Cézanne, Pupil of Pissarro."*

La gardeuse d'oies à Montfoucault, Gelée Blanche
(The Goose Girl at Montfoucault, White Frost) 1875
Oil on canvas, 22¾ x 28¾ inches
signed and dated lower left: *C. Pissarro 75*

PROVENANCE:

Maurice Barret-Décap, Paris; Galerie Durand-Ruel, Paris, 1929; M. Knoedler and Co., New York; Mr. and Mrs. W.J. Dickey, Ellicott City, Maryland; Sale, New York, Parke-Bernet Galleries, *Modern Paintings, Drawings, Sculptures,* December 11, 1963, lot 60; Mr. and Mrs. John A. Beck, Houston, 1963

BIBLIOGRAPHY:

Ludovic Rodo Pissarro and Lionello Venturi, *Camille Pissarro, son art—son oeuvre,* Paris, 1939, no. 324.
George Heard Hamilton, "The Philosophical Implications of Impressionist Landscape Painting," *Bulletin,* The Museum of Fine Arts, Houston, vol. 6, no. 1, Spring 1975, pp. 10-11, fig. 5.

EXHIBITIONS:

Paris, Galerie Marcel Bernheim, *Premières époques de Camille Pissarro,* 1936, no. 18.
Houston, The Museum of Fine Arts, Houston, *The Collection of John A. and Audrey Jones Beck,* 1974, pp. 74-75.
London/Paris/Boston, Hayward Gallery/Grand Palais/Museum of Fine Arts, *Pissarro,* 1980-1981, no. 43.

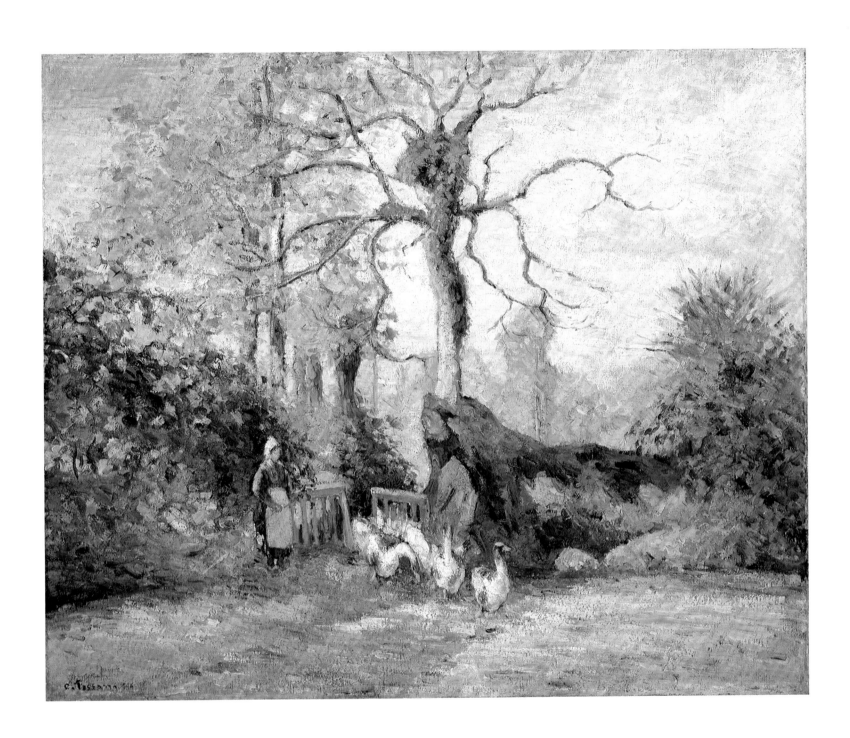

ODILON REDON

Born 1840 Bordeaux, France

Died 1916 Paris, France

VASE DE FLEURS (VASE OF FLOWERS) 1909-10

In addition to his vivid re-creations of myth and poetry, Odilon Redon drew and painted extraordinary still lifes of flowers, especially in the last decades of his career. Mme. Redon planted a variety of flowers in the garden of their country house and often made floral arrangements for Redon to use as models. These still lifes were executed in a realistic manner following faithfully the colors, shapes, and textures of nature. *Vase of Flowers* is an unusual example of Redon's flower paintings in its use of plain, textured rag paper as a background for colorful flowers and a vase which stand out jewellike against a neutral ground. The majority of his still-life pastels have colorful backgrounds, including a similar subject of anemones with the same blue vase in the Musée du Petit Palais, Paris.

Redon was virtually unknown as an artist until he was nearly forty years old. In 1860 he exhibited at the Salon des Amis des Arts de Bordeaux, where his works were shown intermittently for years afterward. He published his first album of lithographs in 1879, and two years later he had his first one-man exhibition in the offices of the weekly newspaper *La Vie Moderne.* The majority of these early works until 1897-98 were lithographs and charcoal drawings which were predominantly dark and somber, mysterious images drawn from childhood impressions. In his illustrations for works by Edgar Allen Poe, Gustave Flaubert, and the poet Stéphane Mallarmé, he created lithographic interpretations of the writers' atmospheric thoughts. The loss of the family country estate, Peyrelebade, was a tragedy for Redon, and yet this painful event coincided with his growing tendency to use a more colorful palette in both oil and pastel. Redon mastered numerous media— charcoal, lithography, and oil painting—but his pastels, such as *Vase of Flowers,* have a special beauty which carry the almost spiritual approach to subjects that marks his work.

Vase de fleurs (Vase of Flowers) 1909-10
Pastel, 23½ x 18¼ inches, signed lower right: *Odilon Redon*

PROVENANCE:

Rogier Collection, Paris; M. Knoedler and Co., New York, 1966; Mr. and Mrs. John A. Beck, Houston, 1966

BIBLIOGRAPHY:

George Heard Hamilton, "The Philosophical Implications of Impressionist Landscape Painting," *Bulletin,* The Museum of Fine Arts, Houston, vol. 6, no. 1, Spring 1975, p. 12, fig. 8.

EXHIBITIONS:

Houston, The Museum of Fine Arts, Houston, *The Collection of John A. and Audrey Jones Beck,* 1974, pp. 76-77.

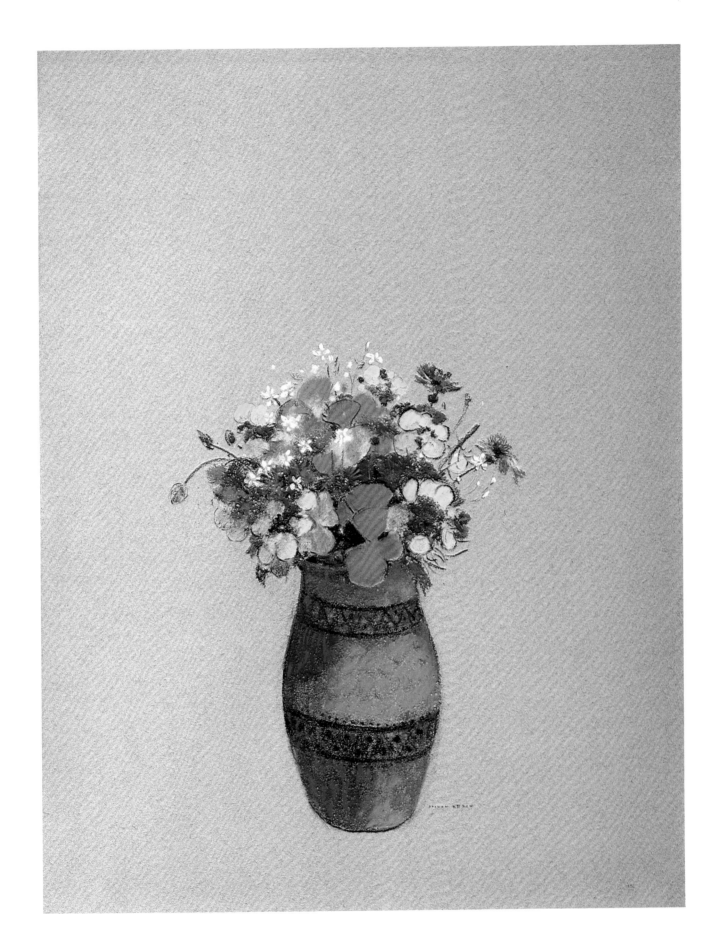

ODILON REDON

Born 1840 Bordeaux, France

Died 1916 Paris, France

DEUX JEUNES FILLES EN FLEURS (TWO YOUNG GIRLS AMONG FLOWERS) c.1905-12

In the 1890s Odilon Redon made a major change in his painting style. From his earlier works which were dark and somber with imaginary subjects taken from childhood fantasies and gruesome nightmares, his canvases became composed of more peaceful images and the colorful palette used by the impressionists. Biblical or mythological subjects often appear, and his careful study of the minutiae in the natural world became a regular theme. *Two Young Girls Among Flowers,* from this latter period, is a dreamy vision where bees and flowers float through space and Madonna-like figures appear in profile; it is unlike many of Redon's early works, which have an eerie bone-chilling power.

Redon was raised at Peyrelebade, the family estate in Medoc, France. Isolated in this remote region, Redon turned to music, reading, and drawing. Throughout his career the mental images he conjured in childhood became his subject matter. He studied art at the age of fifteen with an inspirational instructor, Stanislas Gorin, and attended architectural school for a brief period. Art, however, had become his passion. He learned lithography from the bohemian artist Rodolphe Bresdin in Bordeaux, and later studied under Jean Léon Gérôme at the Ecole dex Beaux-Arts. When albums of Redon's lithographs were first published in 1879, they showed an understanding of the medium which placed his work at the highest aesthetic and technical levels. Redon was knowledgeable about many areas of the fine arts, and enjoyed the weekly salons of Madame de Rayce where artists, composers, writers, and philosophers met. Although Redon's work was not well known until the 1880s, his symbolic imagery with its inexplicable juxtapositions like flowers with human heads, became an important source for symbolism and surrealism in literature, painting, and photography.

Deux Jeunes Filles en Fleurs (Two Young Girls Among Flowers) c. 1905-12
Oil on canvas, 24½ x 20¼ inches, signed lower right: *Odilon Redon*

PROVENANCE:

Marcel Kapferer, Paris; Galerie Beyeler, Basel; Stephen Higgins, Paris; Laurence K. Marshall, Cambridge, Massachusetts; Sale, *Impressionist and Modern Paintings and Sculpture (Part I)*, Christie's, New York, November 12, 1985, lot 53; The Museum of Fine Arts, Houston, The John A. and Audrey Jones Beck Collection, 1985

BIBLIOGRAPHY:

Claude Roger-Marx, *Odilon Redon*, Paris, 1925, p. 41, ill.
Terence Mullaly, "Odilon Redon and the Symbolists," *Apollo,* December 1957, vol. 66, no. 394, pp. 181-85, ill. p. 183.
Klaus Berger, *Odilon Redon, Pfantasie und Farbe,* Cologne, 1964, p. 196, no. 205. English translation under the title *Odilon Redon, Fantasy and Color,* New York, 1965.

EXHIBITIONS:

Paris, Galerie Druet, *Odilon Redon,* 1923, no. 45.
Paris, Stephen Higgins, *Odilon Redon, Magicien du Noir et Blanc,* 1958, no. 77.
Bern, Kunsthalle, *Odilon Redon,* 1958, no. 194.
New York and Chicago, The Museum of Modern Art and the Art Institute of Chicago, *Odilon Redon, Gustave Moreau, Rodolphe Bresdin,* 1961-62, p. 174, no. 38, ill. p. 71.
Boston, Museum of Fine Arts, 1966.
New York, Acquavella Galleries, Inc., *Redon,* 1970, no. 56.

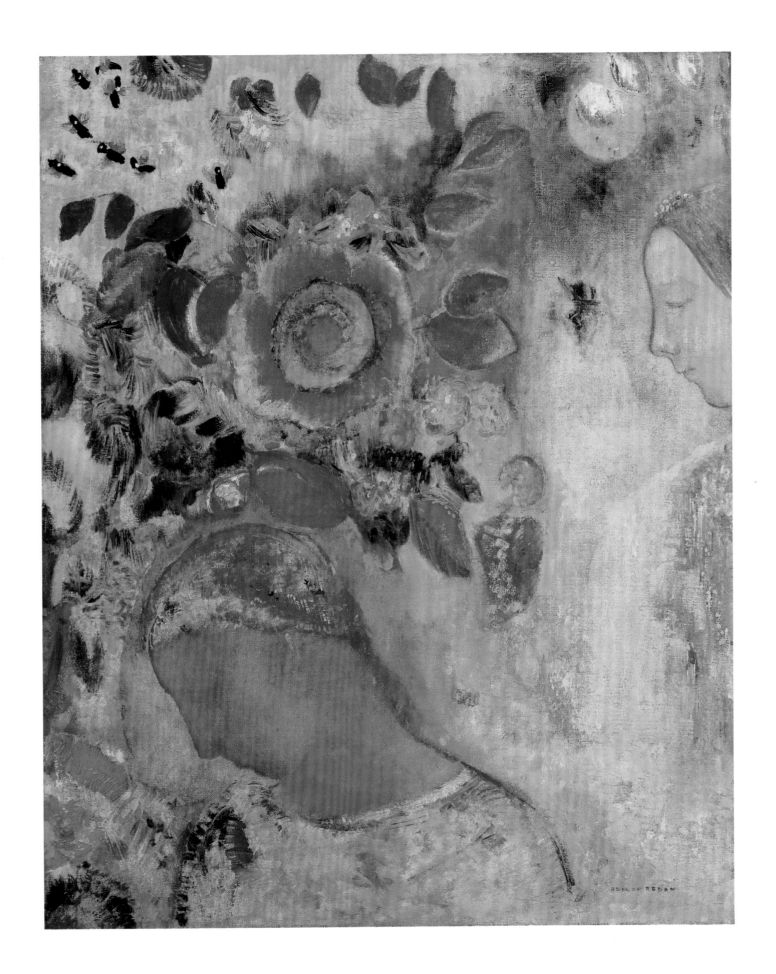

PIERRE-AUGUSTE RENOIR

Born 1841 Limoges, France

Died 1919 Cagnes, France

LA LECTURE (A GIRL READING) c. 1890

Famous for his radiant paintings of voluptuous women, Pierre-Auguste Renoir was also known for his portraits of children. The innocence of childhood fascinated him. He captured their rose-cheeked freshness and animation with a subtle delicacy that brought him countless portrait commissions. *A Girl Reading* demonstrates the careful balance of controlled composition and lively color that marked his work of the 1890s. The young girl's dress of vibrant red trimmed in black is an element that Renoir repeated with some variations in several pictures of this period. The subject is described with a tenderness and warmth that characterizes Renoir's best work.

Renoir's career in art began inauspiciously. At an early age he was apprenticed to the Levy Brothers porcelain firm in Paris where he hoped to become a fine artisan in the Limoges tradition. When a process was developed to paint porcelain mechanically, Renoir saw his profession threatened and began to paint fans and decorative blinds. From this venture he saved enough money to study in the atelier of Charles Gleyre at the Ecole des Beaux-Arts along with Claude Monet, Alfred Sisley, and Jean Frédéric Bazille. These four artists frequently painted together in the Forest of Fontainbleau, and it was there Renoir met the Barbizon painter, Narcisse Diaz who took an interest in his work. Diaz encouraged the younger artist to use a more colorful palette and opened an account for Renoir with his art supplier. He even went so far as to sell some of Renoir's paintings, stating that they were done by Henri Rousseau. At this time Renoir was greatly influenced by Gustave Courbet and the paintings of Edouard Manet which had scandalized the public in 1863 at the Salon des Réfusés. Renoir shared a studio with Bazille until 1870, at which time he was called to serve in the light cavalry regiment during the Franco-Prussian War. After the war he became one of the founding members of the impressionist group. Although Renoir's style continued to reflect elements of eighteenth-century art, color and light changes began to appear. His pictures described the subject most commonly associated with impressionism: bright, light-filled images of happy Parisians, beautiful women, and children. On the subject of paintings he stated, "To my mind a picture should be something agreeable, cheerful—and yes!—nice to look at." In his last years Renoir enjoyed financial and popular success. Though severely crippled by arthritis,

he continued to paint until the end of his life, striving to achieve a monumental classical style.

La Lecture (A Girl Reading) c. 1890
Oil on canvas, 13¼ x 16¼ inches, signed lower left: *Renoir*

PROVENANCE:

Etude Chevallier, Paris; Galerie Durand-Ruel, Paris, 1896; Sam Salz, New York; R.A. Peto, London; Arthur Tooth & Sons, Ltd., London; J.K. Thannhauser, New York; Hurland Collection, New York; Sale, New York, Parke-Bernet Galleries, *Impressionist and Modern Paintings and Drawings,* October 28, 1970, lot 10; Mr. and Mrs. John A. Beck, Houston, 1970

EXHIBITIONS:

Houston, The Museum of Fine Arts, Houston, *The Collection of John A. and Audrey Jones Beck,* 1974, pp. 78-79.

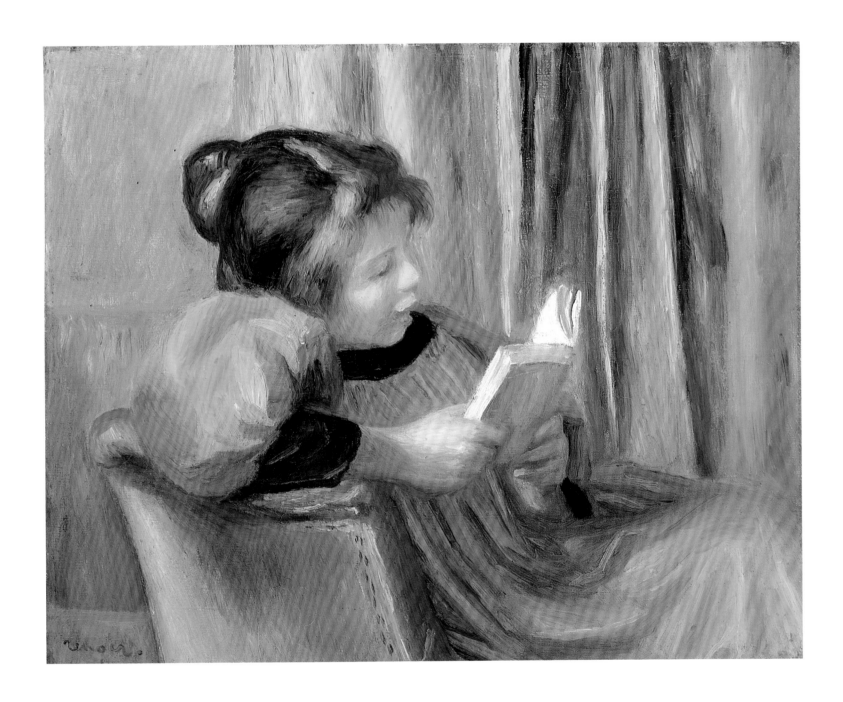

GEORGES ROUAULT

Born 1871 Paris, France

Died 1958 Paris, France

LES TROIS JUGES (THE THREE JUDGES) 1925

Like Honoré Daumier, Georges Rouault was preoccupied with the French law courts, where the everyday dramas of justice were played out. In defense of his interpretation of the subject, Rouault wrote, "If I have made the judges such lamentable figures, it was no doubt because I was translating the anguish I felt at the sight of a human being who is to judge other men." *The Three Judges* is an image of worldly pretensions which summons up recollections of biblical judges, kings, and prophets. The figure on the left may be a self-portrait, and the judge on the right, Ambroise Vollard, Rouault's dealer. Rouault's forms are placed frontally so that the picture is divided like a triptych into three parts. His monumental conception of the human figure owed much to Cézanne's example, as did his habit of painting in multiple layers of pigment to build up effects of thickness on the picture surface. The brightly colored shapes outlined by a network of heavy black lines can be compared to the stained glass in medieval cathedrals.

Rouault was born in a Paris cellar soon after his family home had been shelled during the civil strife following the Franco-Prussian War. At the age of fourteen, he was apprenticed to a maker and restorer of stained glass. Later in life he wrote, "If there had been fine stained glass as there used to be in the Middle Ages, perhaps I should never have become a painter." He enrolled in the Ecole des Beaux-Arts and in 1892 began to study under the symbolist painter Gustave Moreau. Several of Moreau's students became leaders of important artistic movements of the early twentieth century. Unlike his fellow students and friends, Henri Matisse, Albert Marquet, and Henri-Charles Manguin, Rouault continued an association with Moreau's works, serving as the first curator of the Musée Moreau in Paris. He was one of the founders of the Salon d'Automne in 1903. Exhibiting regularly, he held retrospectives of his works and won several awards, including the Legion of Honor from the State and the Order of the Italian Republic. Throughout his life he committed himself to subjects of religious or moral significance. A man of deep religious convictions and personal humility, Rouault wrote, "As time goes by the work alone remains and has to fend for itself."

Les Trois Juges (The Three Judges) 1925
Oil on paper transferred to canvas, 25 x 38½ inches
signed lower right: *G. Rouault*

PROVENANCE:

Ambroise Vollard, Paris; Robert de Galea, Paris; Sam Salz, New York; Mr. and Mrs. Leigh B. Block, Chicago, until 1960; Sale, London, Sotheby's, July 6, 1960, lot 146; Marlborough Fine Art Ltd., London; Sale, London, Sotheby's, December 5, 1973, lot 53; Gustav Zumsteg, Zurich, 1973; Sale, Galerie Koller, Zurich, May 19–June 4, 1976; Sale, London, Sotheby's, *Impressionist and Modern Paintings and Sculpture*, Part 1, 1984, lot 29; Mrs. John A. Beck, Houston, 1984

EXHIBITIONS:

Lausanne, Palais de Beaulieu, *Chefs-d'oeuvres des collections suisses de Manet à Picasso*, 1964, no. 300.
Paris, Orangerie des Tuileries, *Chefs-d'oeuvres des collections suisses de Manet à Picasso*, 1967, no. 204.
Vence, Fondation Maeght, *Rouault*, 1971, no. 135.

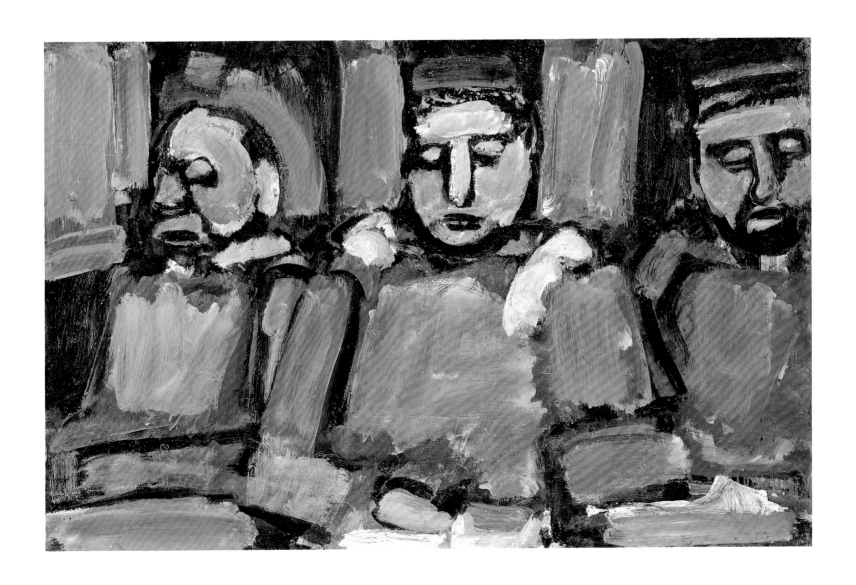

JULIEN-FÉLIX-HENRI ROUSSEAU

Born 1844 Laval, France

Died 1910 Paris, France

LA TOUR EIFFEL (THE EIFFEL TOWER) c.1898

Julien-Félix-Henri Rousseau was a self-taught artist whose subjects ranged from exotic and mysterious allegories to humble portraits and city views. *The Eiffel Tower* is an imaginary scene, for there is no point in Paris where the Eiffel Tower can be aligned with the river Seine. Still, this painting was probably loosely based on the configuration of the river banks in the vicinity of Passy, downstream from the tower, where Rousseau painted frequently. The picture is most remarkable for the sophisticated color harmonies, particularly the subtle effects of the clouds, tinged with the light of the sunset, which are reflected in the calm surface of the river.

Le Douanier, "the customs official," a nickname given to Rousseau by Pablo Picasso and other artist friends, was considered a joke because Rousseau was merely a *gabelou,* a minor inspector stationed at a toll house in the outskirts of Paris. He did not paint to any degree until he was over thirty years old and did not exhibit his works until he was over forty. Encouraged by painters such as Paul Signac, Rousseau ignored the ridicule of critics and regularly participated in the exhibitions of the Salon des Indépendants, organized by the impressionists and neo-impressionists in the 1880s and 1890s. He also exhibited at the fauve Salon d'Automne in 1905. Rousseau's paintings were admired for their naïve draftsmanship and composition, which recalled the best qualities of the so-called primitive artists of the early Renaissance. Although the poet Guillaume Apollinaire as well as the painters Edgar Degas, Pierre-Auguste Renoir, Paul Gauguin, and Pablo Picasso lauded his achievements, they tended to regard Rousseau as a prodigious curiosity rather than an equal. The Douanier himself, happily supported by his colleagues' praise, remained unaware of the fact that their compliments were somewhat qualified. Equally unaware of the indifference of the lady he was courting, he caught a cold one rainy evening while standing outside the home of his reluctant lover and later died of complications.

La Tour Eiffel (The Eiffel Tower) c. 1898
Oil on canvas, 20⅝ x 30⅜ inches, signed lower left: *Henri Rousseau*

PROVENANCE:

Private collection, Paris; Wildenstein and Co., New York, 1968; Mr. and Mrs. John A. Beck, Houston, 1968

EXHIBITIONS:

Houston, The Museum of Fine Arts, Houston, *The Collection of John A. and Audrey Jones Beck,* 1974, pp. 82-83.

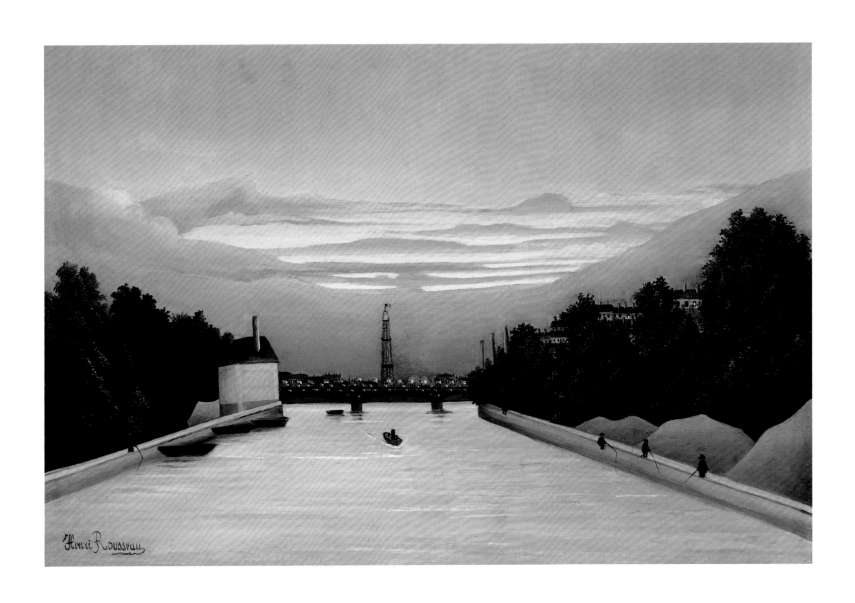

THEOPHILE VAN RYSSELBERGHE

Born 1862 Ghent, Belgium

Died 1926 Saint Clair, France

JEUNE FEMME BLONDE AU CHIGNON
(YOUNG BLONDE GIRL WITH A CHIGNON) c. 1888

As a pointillist painter, Theophile van Rysselberghe was the only artist who placed great importance on portraiture. His portraits were highly regarded for maintaining the human qualities of his models in spite of his use of Georges Seurat's pointillist technique. Concentrating on this type of brushstroke and employing traditional compositional themes, van Rysselberghe portrays in *Young Blonde Girl with a Chignon* an atmosphere of charm and sensitivity. The painting's vibrant color reflects van Rysselberghe's continuing admiration for the highly charged color schemes of impressionist painting.

Van Rysselberghe, Belgium's principal neo-impressionist painter, first studied at the Académie des Beaux-Arts in Ghent, and later at the Académie in Brussels. At the age of nineteen, he won a travel fellowship from the Brussels Salon; soon after his return to Belgium, he became one of the founding members of Les Vingt. Formed shortly before the Société des Artistes Indépendants, this group of twenty avant-garde Belgian artists annually invited an equal number of artists from other countries to exhibit with them in Brussels. Van Rysselberghe later became a leader of the society that succeeded Les Vingt, La Libre Esthetique; in both groups, he was credited with introducing avant-garde French and English art to Belgium. When Seurat, Paul Signac, and Charles Angrand first exhibited pointillist paintings with Les Vingt, van Rysselberghe was greatly influenced by this new technique of painting in small dots of color. He began to frequent art circles in Paris and traveled throughout Europe, North Africa, and the Near East. In 1890 he participated in the Paris Salons of the Indépendants, and achieved fame in the French world of the avant-garde. His later life was spent between Paris and his home at St. Clair on the Mediterranean coast, where he and his wife lived near their friends Signac and Henri-Edmond Cross. Successful not only as a painter, he remained active as an illustrator of books and a designer of furniture, posters and catalogues. Though he lived in France, van Rysselberg maintained close ties with his native country, sending his most recent works to be exhibited in Belgium.

Jeune Femme Blonde au Chignon (Young Blonde Girl with Chignon) c. 1888
Oil on canvas on cardboard, 17³⁄₁₆ x 14 inches

PROVENANCE:

Alphouse Bellier, France; Private collection, France; Robert & Blanche, Nouveau Drouot, Paris, 1980; Private collection, U.S.A.; Mrs. Audrey Jones Beck, Houston, 1986

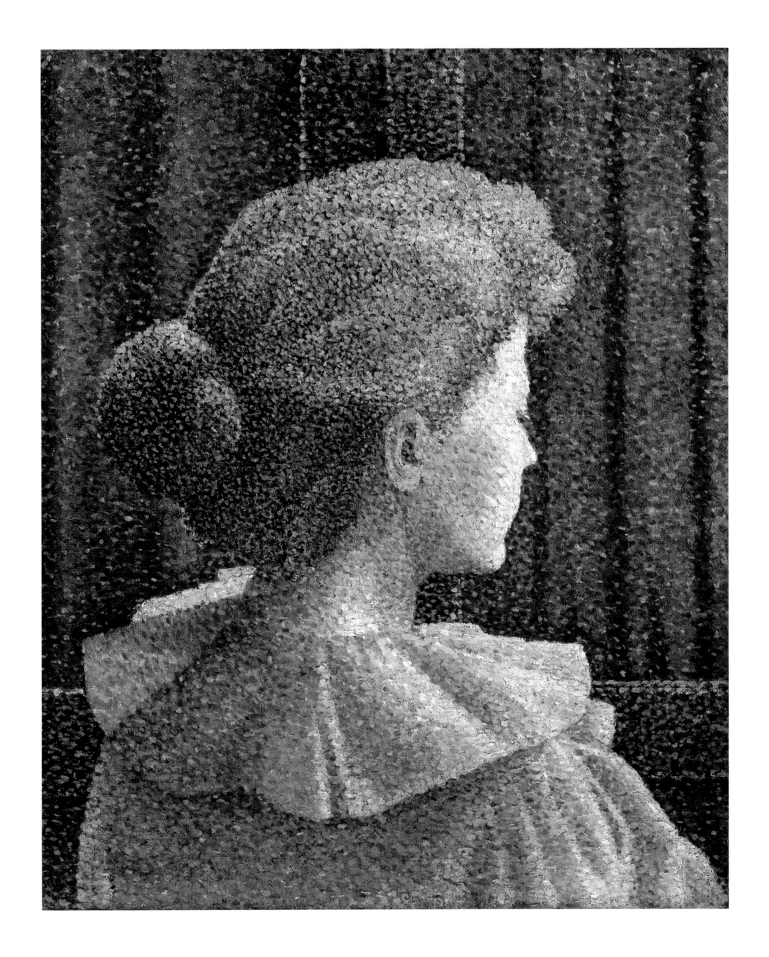

GEORGES-PIERRE SEURAT

Born 1859 Paris, France

Died 1891 Paris, France

JEUNE FEMME SE POUDRANT (YOUNG WOMAN POWDERING HERSELF) 1889

Young Woman Powdering Herself is a small version of a much larger
work of the same title, now in the collection of the Courtauld
Institute, London. This portrait of Madeleine Knobloch, Georges
Seurat's mistress, is an excellent example of the artist's evolved
method of painting with tiny dots or points of color which blend
with each other when viewed from a distance. The technique,
which he called divisionism, since colors were divided into their
scientific components, has popularly become called pointillism,
a term that Seurat abhorred. Although color and the pursuit
of light are the most obvious elements of his art, Seurat was also
interested in the meaning of shapes and lines. His compositions,
like this portrait, are built on complex relations of geometric
forms, placed in particular orders to achieve predetermined
emotional effects. For example, the red V-shapes in the back-
ground wallpaper of this painting, according to Seurat, were
symbolic of happy emotions.

Seurat's professional career spanned little more than a
decade, and yet he is acknowledged as one of the greatest mas-
ters of the nineteenth century. At the age of fifteen, his parents
enrolled him in a specialized drawing school. Later he studied
at the Ecole des Beaux-Arts with the classical teacher Henri
Lehmann. In 1883 Seurat received the honor of being included
in the Salon. Despite such a distinction for a young artist, Seurat
was angered because many of his entries were refused. He joined
the avant-garde group, the Société des Artistes Indépendants,
and exhibited with them for the next decade. Searching for a way
to render in oil paint the effects of light on human vision, he
ultimately rejected the experiments of the impressionists. From
Eugène Delacroix's diaries and murals at the church of Sainte
Sulpice he gained a deeper understanding of color, and from
scientific research he developed a theoretical basis for his tech-
nique. Seurat's new paintings interested other artists working in
Paris, and when he exhibited at the Salon des Vingt in Brussels,
artists such as Theo van Rysselberghe became instant converts to
pointillism. Seurat participated in weekly gatherings of poets,
writers, and artists at the home of the journalist Robert Cage.
These discussions often served as a catalyst for new artistic ideas.
Quiet and reserved, Seurat tended to regard his painting tech-
nique as a secret held within a small circle of friends. His per-
sonal reticence caused him also to keep secret from friends and
family his relationship with Madeleine Knobloch and the birth
of their son. He finally introduced his mother to them only days
before he died of diphtheria.

Jeune femme se poudrant (Young Woman Powdering Herself) 1889
Oil on panel, 10⅛ x 6⅝ inches

PROVENANCE:

Salomon Collection, Nancy; Wildenstein and Co., New York; Mr. and
Mrs. Leigh B. Block, Chicago, 1958; Wildenstein and Co., New York,
1973; Mr. and Mrs. John A. Beck, Houston, 1973

BIBLIOGRAPHY:

Henri Dorra and John Rewald, *Seurat,* Paris, 1959, p. 246, no. 194.
C.M. de Hauke, *Seurat et son oeuvre,* Paris, 1961, vol. 1, p. 176 (cited
 under no. 200).
André Chastel, *L'Opera completa di Seurat,* Milan, 1972, no. 198, ill.
 p. 108.
Louis Hautecoeur, *Seurat,* Milan, 1972, ill. p. 63, fig. 2.
George T. M. Shackelford and Mary Tavener Holmes, *A Magic Mirror:
 The Portrait in France 1700-1900,* Houston, 1986, no. 42,
 pp. 116, 117, 138.

EXHIBITIONS:

New York, Wildenstein and Co., *Masterpieces: A Memorial Exhibition for
 Adele R. Levy,* 1961, no. 46, ill.
Washington, D.C., National Gallery of Art, *One Hundred European
 Paintings and Drawings from the Collection of Mr. and Mrs. Leigh B.
 Block,* 1968, no. 23, ill.
Houston, The Museum of Fine Arts, Houston, *The Collection of John A.
 and Audrey Jones Beck,* 1974, pp. 84-85.
Houston, The Museum of Fine Arts, Houston, *A Magic Mirror, The
 Portrait in France 1700-1900,* 1986-87, no. 42.

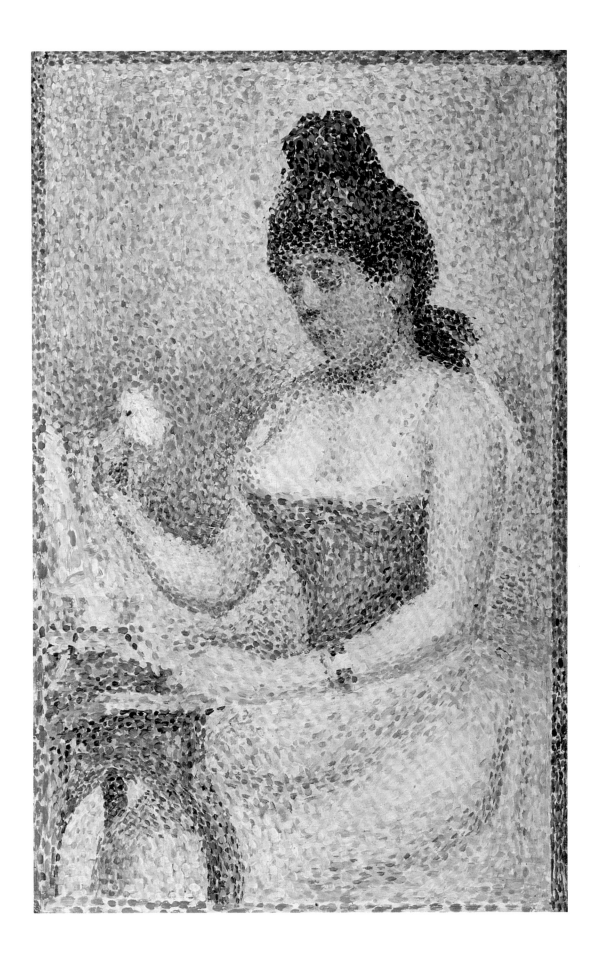

PAUL SIGNAC

Born 1863 Paris, France

Died 1934 Saint-Tropez, France

LE PIN DE BONAVENTURE À SAINT-TROPEZ
(THE BONAVENTURE PINE IN SAINT-TROPEZ) 1892

Paul Signac abandoned Paris for Saint-Tropez a year after the death of his close friend Georges Seurat in 1891. Shortly after he arrived in the south of France, Signac painted this picture of a giant umbrella pine tree overlooking a bay surrounded by mountains. Using the pointillist technique developed first by Seurat, in which small dots of paint are applied in close juxtaposition, Signac captured the Bonaventure pine, a native tree of the area, as an image of shelter and strength. For Signac, the sunlight and coast line of the Mediterranean made southern France a painter's paradise. His villa, La Hune, attracted numerous artists, including Henri Matisse, Louis Valtat, Albert Marquet, and André Dunoyer de Segonzac. These visitors, together with Signac and his neighbor, Henri-Edmond Cross, later transformed the pointillist style of painting from tiny dots into broader dashes of vivid color.

Born into an affluent Parisian family, Signac was financially independent throughout his life. At the founding of the Société des Artistes Indépendants in 1884, the twenty-one-year-old artist met Seurat, and the two men became close friends. Although Signac associated with Charles Angrand, Camille Pissarro, and Cross and painted along the banks of the Seine with Claude Monet and Armand Guillaumin, it was with Seurat that a link was forged in developing together the color theory of pointillism. This style made Signac and Seurat the leaders of the neo-impressionist artists who advanced avant-garde theories in the late 1880s. As an adolescent, Signac had been greatly impressed by the impressionists. According to popular tradition, he was asked by Paul Gauguin to leave an exhibition in which Signac was avidly copying the works on view. The young artist continued to study and eventually became president of the Société des Artistes Indépendants from 1909 until his death in 1934. Signac is generally credited with saving the Society and helping it to prosper during this period. He traveled widely, maintained a studio in Paris, and exhibited at the salons there as well as in Brussels, Berlin, London, and Amsterdam. He wrote articles on neo-impressionism and was the author of the book *De Delacroix au Néo-Impressionisme,* a history of nineteenth-century French painting. He was energetic up until his death, balancing a strenuous work schedule with travel and an active social life.

Le pin de Bonaventure à Saint-Tropez
(The Bonaventure Pine in Saint-Tropez) 1892
Oil on canvas, 25 x 32 inches, signed lower right: P. *Signac 93*
and inscribed lower left: *Op 239*

PROVENANCE:

Theo van Rysselberghe, Paris; Dr. Jacques Caroli, Paris, 1964; Phillip Reichenback, Paris, 1964; Mr. and Mrs. John A. Beck, Houston, 1964; The Museum of Fine Arts, Houston, The John A. and Audrey Jones Beck Collection, 1974

BIBLIOGRAPHY:

Arsène Alexandre, *Paris,* January 1, 1894
Françoise Cachin, *Paul Signac,* New York, 1971 (trans. by Michael Bullock), p. 65, no. 50, ill. (as *The Umbrella Pine* and erroneously as private collection, New York).
John Minor Wisdom, in William C. Agee, ed., *The Museum of Fine Arts, Houston: A Guide to the Collection,* Houston, 1981, pp. 118-19, no. 203 and pl. 28.
Diane Kelder, *The Great Book of Post-Impressionism,* New York, 1986, pp. 102-103, no. 96, ill.

EXHIBITIONS:

Paris, 20 rue Lafitte, *Groupe des peintres néo-impressionistes,* December 1893—January 1894, no. 2.
Brussels, *Première exposition de la Libre Esthétique,* 1894, no. 397.
Paris, *Onzième exposition des Artistes Indépendants,* 1895, no. 1403.
Paris, Musée du Louvre, *Signac,* 1963-64, no. 47.
Washington, D.C., National Gallery of Art, *U.S. Loan Exhibition,* 1971-73.
Houston, The Museum of Fine Arts, Houston, *The Collection of John A. and Audrey Jones Beck,* 1974, pp. 86-87.

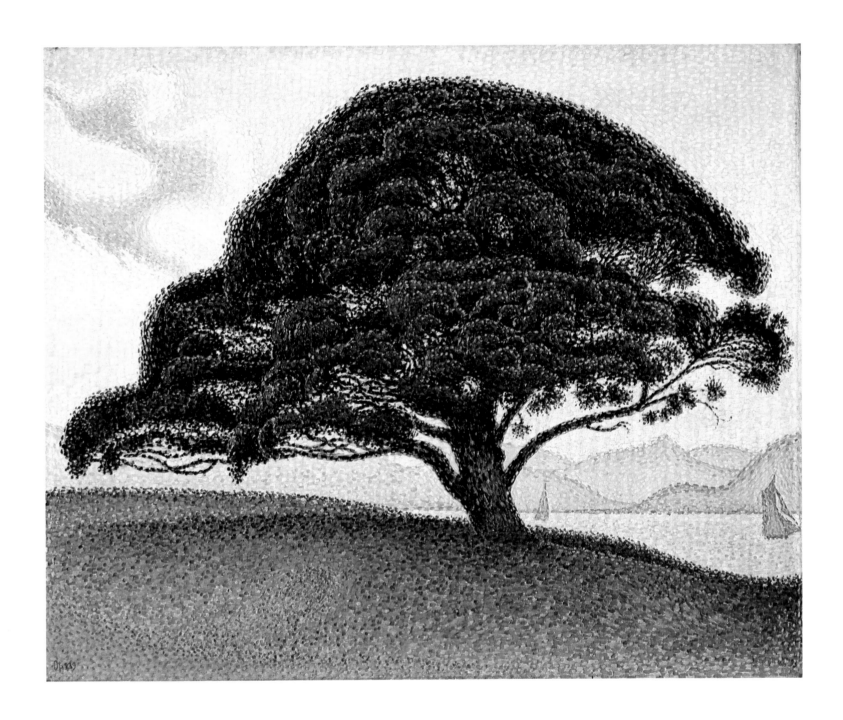

ALFRED SISLEY

Born 1839 Paris, France

Died 1899 Moret-sur-Loing, France

L'INONDATION—ROUTE DE SAINT-GERMAIN
(THE FLOOD ON THE ROAD TO SAINT-GERMAIN) 1876

Alfred Sisley was an impressionist who devoted himself almost exclusively to landscapes. A master at depicting water, Sisley painted some of his most important pictures in the winter of 1876 during the flooding of Port Marly, a small village on the Seine northwest of Paris. Sisley's *L'Inondation* is not a report of disaster but a luminous view of a transformed landscape. When Sisley painted the work, the waters had begun to recede, leaving the road, which is visible at the extreme left, once more passable. He has shown the flat-bottomed punts that were the principal means of transportation during the flood. Sisley generally painted pure landscapes devoid of figures, and when figures do appear, as in this work, he defines them as an unobtrusive part of the composition.

Sisley was born in Paris to English parents who sent him to London at the age of eighteen to train for a business career. During his four years there, he visited museums regularly and developed a strong interest in art. When he returned to Paris he entered the studio of Charles Gleyre, where he met Pierre-Auguste Renoir and Claude Monet, with whom he was to forge a new landscape style. In the early 1870s, the artists worked together in the small villages of Louveciennes, Marly, Bougival, and Argenteuil near Paris. Sisley's landscapes of this period, under Monet's influence, are among his finest works. While his contact with Monet was crucial to the development of Sisley's broad shorthand manner of rendering the effects of light, the example of the older artist Camille Corot was evident in his work throughout his career. Sisley exhibited at a number of the Salons between 1866 and 1870 and in four of the impressionist group exhibitions. Durand-Ruel was Sisley's dealer from 1872 and presented a one-man exhibition in 1883. Unfortunately, Sisley's paintings did not sell. To earn a living, he experimented with painting ladies' hand fans, which were then in vogue. Although Sisley exhibited annually until shortly before his death and his work was highly regarded for its sensitivity and lyricism, he did not achieve widespread acclaim and died in poverty in 1899 at the age of sixty.

L'Inondation—Route de Saint-Germain
(The Flood on the Road to Saint-Germain) 1876
Oil on canvas, 17½ x 23½ inches, signed and dated lower left: *Sisley 76*

PROVENANCE:

Galerie Durand-Ruel, Paris, purchased from the artist, 1880; Helen H. Pidge, Boston, 1886-1930; Durand-Ruel Gallery, New York, 1930-37; Carroll Carstairs Gallery, New York, 1937; Mrs. Murray Danforth; Paul Rosenberg and Co., New York; Madame Jacques Balsan, New York, 1944; Private collection, kept at Lefevre Gallery, London, 1969; Sale, London, Christie's, *Impressionist Paintings*, July 1, 1974, lot 12; The Museum of Fine Arts, Houston, The John A. and Audrey Jones Beck Collection, 1974

BIBLIOGRAPHY:

François Daulte, *Alfred Sisley, catalogue raisonné de l'oeuvre peint*, Lausanne, 1959, no. 238.
François Daulte, *Alfred Sisley*, Milan, 1972, p. 44, no. 3, ill.
Linda Dalrymple Henderson, "Alfred Sisley's 'The Flood on the Road to Saint-Germain,'" *Bulletin*, The Museum of Fine Arts, Houston, Summer 1975-Winter 1976, pp. 20-28, fig. 21.
John Minor Wisdom, in William C. Agee, ed., *The Museum of Fine Arts, Houston: A Guide to the Collection*, Houston, 1981, pp. 109-10, no. 189, ill.

EXHIBITIONS:

Boston, Museum of Fine Arts, *Paintings, Drawings and Prints from Private Collections in New England*, 1939, no. 125, pl. 62.
London, The Lefevre Gallery, *XIX and XX Century French Paintings*, 1969, no. 12.

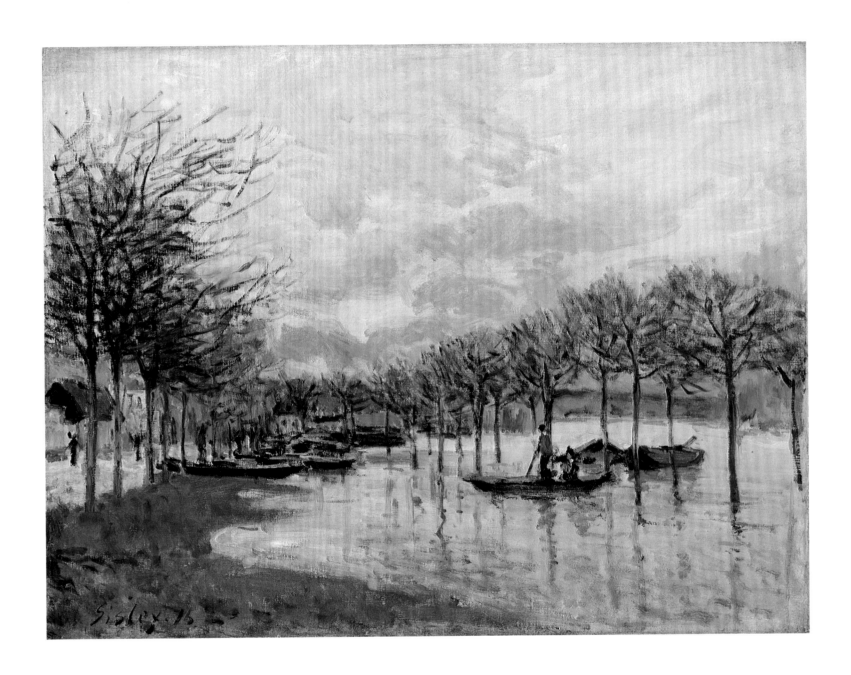

CHAIM SOUTINE

Born 1893 Smilovitchi, Lithuania

Died 1943 Paris, France

LE POULET (THE CHICKEN) c.1926

As early as the sixteenth century, dead fowl in full plumage were pictured as hunting trophies or in combination with other objects in still lifes. For Chaim Soutine, these subjects seemed to convey mystical significance, the dead fowl being symbolic victims and reminders of mortality. Soutine's Jewish heritage may account for this conception. In the kapparah ceremony, which took place on the eve of Yom Kippur, family members were required to swing a fowl in three circles above their heads and recite: "This is my substitute, my vicarious offering, my atonement. This cock (or hen) shall meet death, but I shall find a long and pleasant life of peace." Soutine's fascination with death was neither sadistic nor cruel, but simply his desire to explore the mechanism of the natural world. He often purchased at a local market the birds he used as models. Léopold Zborowski, Soutine's dealer, related that Soutine would fast with one of his models before him, and as his hunger mounted, would paint the bird with vibrant colors and vigorous brush strokes, instilling the force of life into the painting. His favorite subject became splayed animal carcasses—beef, fish, or fowl—which he painted with remarkable intensity of expression.

Chaim Soutine was the tenth of eleven children born to a poverty-stricken Jewish mender. At an early age, he immigrated to Minsk to study art, supporting himself working as a photographic retoucher. Upon selling several of his paintings in 1913, he was able to go to Paris and briefly study with Fernand Cormon at the Ecole des Beaux-Arts. Living in extreme poverty, he became severely undernourished but was too introverted or perhaps too independent to seek help from his friends, Marc Chagall, Jacques Lipchitz, or Amedeo Modigliani. Modigliani's death in 1920 devastated Soutine who was working in Ceret, where his dealer Zborowski had urged him to move. In 1923 the American collector Dr. Albert Barnes of Philadelphia purchased close to a hundred of his paintings; and in Paris Soutine's work began to attract a few collectors who acquired his works in large numbers. Despite his perilous position in Europe during the German occupation, Soutine refused an invitation in 1940 to go to America. Soutine died in Paris four years later, still in hiding. Pablo Picasso and Jean Cocteau were among the few who marched in his funeral cortège.

Le Poulet (The Chicken) c. 1926
Oil on canvas, 40 x 29⅞ inches, signed lower right: *Soutine*

PROVENANCE:

Baron de Rothschild, Paris; Cordier and Ekstrom, New York; Mr. and Mrs. George R. Brown, Houston; The Museum of Fine Arts, Houston, Gift of Mr. and Mrs. George R. Brown in honor of John A. and Audrey Jones Beck, 1976

BIBLIOGRAPHY:

Pierre Courthion, *Soutine, Peintre du Déchirant*, Lausanne, 1972, pp. 246-47, ill. 247.

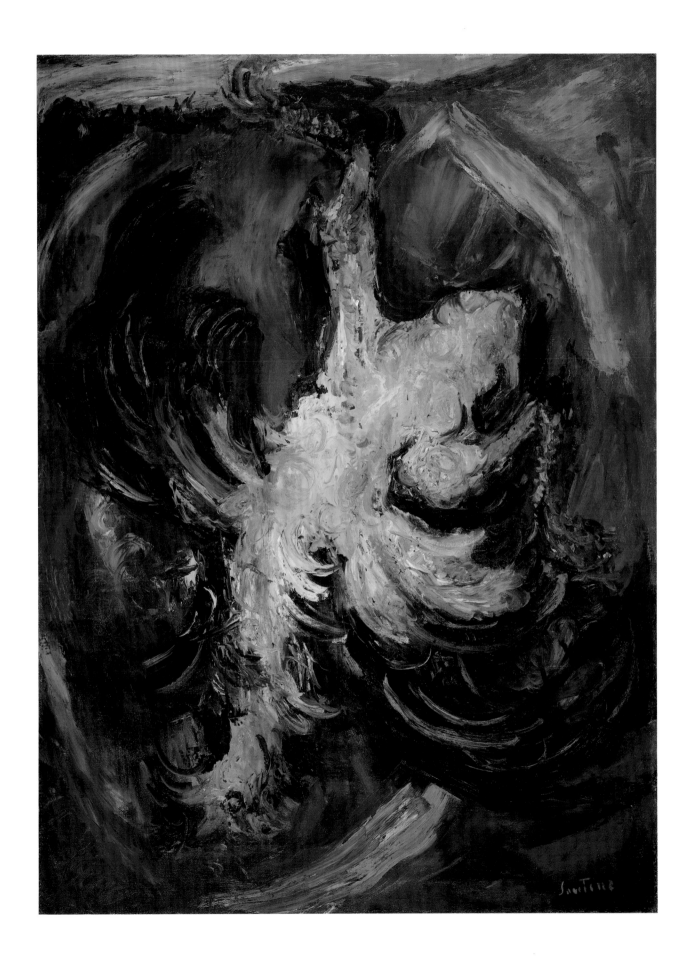

CHAIM SOUTINE

Born 1893 Smilovitchi, Lithuania

Died 1943 Paris, France

JEUNE FILLE À LA POUPÉE (YOUNG GIRL WITH A DOLL) 1926-27

Chaim Soutine approached painting with fury. Witnesses describe how he attacked the naked canvas with a paintbrush, often completing the picture in a single sitting. Soutine sometimes felt that the violence and spontaneity of his painting ruined the picture and would destroy the result himself. *Young Girl with a Doll* reveals the artist's constructive force and vigor. The child's figure is almost slashed onto the canvas in his favorite colors, bright red over a dark green background. In spite of the raw emotional quality of the painting style, the little girl retains a sense of charm. Soutine's ability to paint with both ferocity and tenderness is evident. Although the artist never married or had children, his affection for them is revealed in works like this. The artist Willem de Kooning, an admirer, said that Soutine distorted his paintings but not the people in them.

Soutine arrived in Paris at the age of twenty, a cynical, antisocial Lithuanian immigrant, whose first ten years were spent in desperate poverty. He studied at the Ecole des Beaux-Arts with the history painter Fernand Cormon and became friends with the sculptor Jacques Lipschitz and the painter Amedeo Modigliani. Modigliani thought Soutine was one of the greatest artists of the time, and brought his work to the attention of his dealer Léopold Zborowski. In 1923 Soutine's difficult and unhappy situation was reversed when the American collector Dr. Albert Barnes purchased an enormous number of his works. For the next twenty years Soutine's work grew in popularity and was eagerly sought after by a number of European collectors.

Jeune Fille à la Poupée (Young Girl with a Doll) 1926-27
Oil on canvas, 25½ x 19⅝ inches, signed lower right: *Soutine*

PROVENANCE:

Nemont Collection, Lugano; Mr. and Mrs. Bernard Kreiler, Greenwich, Connecticut; Marlborough Gallery, London, 1966; Mr. and Mrs. John A. Beck, Houston, 1966

BIBLIOGRAPHY:

Pierre Courthion, *Soutine, Peintre du Déchirant*, Lausanne, 1972, pp. 78, 88, ill., p. 260.
Raymond Cogniat, *Soutine*, New York, 1973, p. 64, ill.

EXHIBITIONS:

Houston, The Museum of Fine Arts, Houston, *The Collection of John A. and Audrey Jones Beck*, 1974, pp. 88-89.

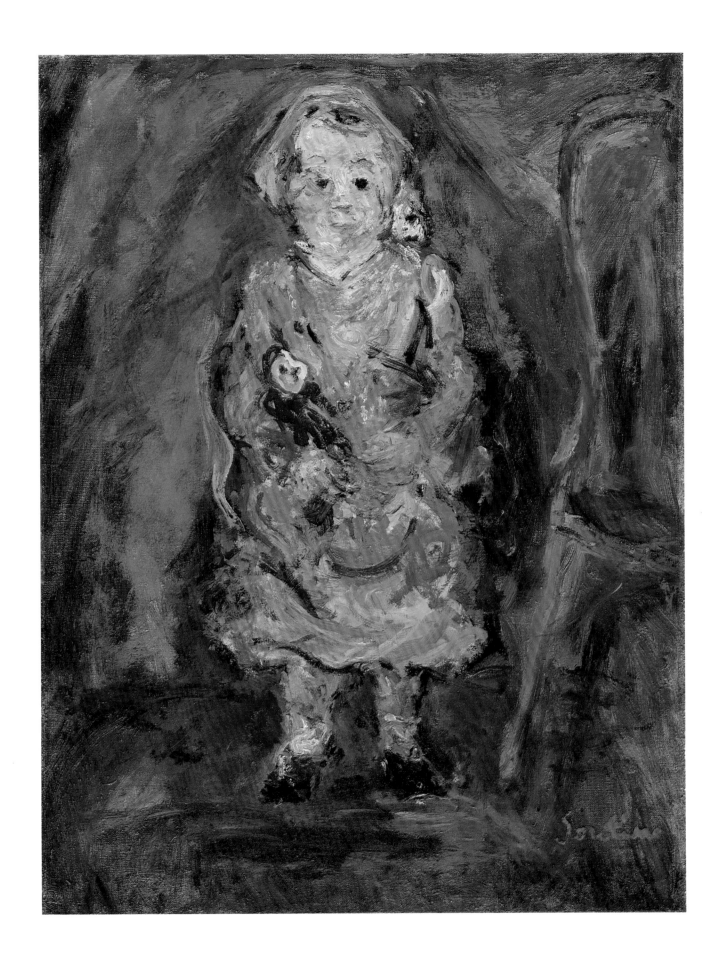

JOAQUIN SUNYER Y MIRÓ

Born 1875 Vilanova y Geltru, Spain

Died 1956 Sitges, Spain

LA TOILETTE (WOMAN AT HER TOILET) c.1900

Woman at Her Toilet was in the Benet Collection, Barcelona, when the art photographer Serra was commissioned to photograph it in 1930. At this time the pastel was signed Sunyer. Some time later in the presence of Jaime Sabartés, Joaquin Sunyer y Miró replaced his name with that of Picasso, to whom the picture was attributed until 1979, when the original Sunyer signature was discovered during cleaning. A friend of Picasso, Sunyer was a recognized Spanish artist at this time. In 1927 he had exhibited thirty of his paintings and numerous etchings at the Museo Español de Arte Contemporáneo in Madrid. He had worked for many years in Paris at the turn of the century and was associated with the avant-garde artists of that era. The influence of Edgar Degas, Pierre Bonnard, and Henri de Toulouse-Lautrec is evident in *Woman at Her Toilet*. The bather was a popular subject for both Degas and Bonnard, and here Sunyer used Degas' favorite pastel medium. A sketch in the manner of Toulouse-Lautrec appears on the reverse side of the work.

When Sunyer was fourteen, his family moved from Vilanova y Geltru to Barcelona, where he attended art classes at La Llotja. A dedicated painter, Sunyer left for Paris in 1894 where he discovered new painting theories and techniques. In Montmartre, Sunyer lived in the Bateau Lavoir, a run-down building which served as residence for many struggling young artists, including Picasso. During this period Sunyer exhibited at the Palais des Beaux Arts, the Circle de L'Oeuvre des Artistes in Liège, Belgium, the Baks Moderne Kunsthandlung in Munich, and the Salon d'Automne where he also served as a juror. Although Sunyer was popular in the Parisian art community and successful in having his lithographs published, he returned to Spain in 1911, settling in Sitges, a village on the Mediterranean famous for its festivals which included opera, dance, theater, and art exhibits. Sunyer became the master of Catalán painting, developing a style termed "Mediterraneanism." In 1931 his work was selected for the 13th Annual International Exhibition of Painting at the Carnegie Institute, Pittsburgh, and the following year shown at the Brooklyn Museum in the exhibition *Modern Catalán Painting*. At the outbreak of the Spanish Civil War in 1937, Sunyer fled to Paris where he lived in exile, returning to Sitges in 1942. The Barcelona Museum has the largest collection of his works, and he is also represented in the museums of Madrid and Bilbao as

well as many private collections. After Sunyer's death, a major retrospective of his work was held in 1959 at the Palacio de la Virreina in Barcelona and in 1974 a centenary exhibition opened in Madrid.

La Toilette (Woman at Her Toilet) c. 1900
Pastel, pencil, and wash on cardboard, 10½ x 11 inches, signed upper middle left: *Sunyer* (signed middle left: *Picasso*)

PROVENANCE:

Benet Collection, Barcelona (as Sunyer); Mr. and Mrs. Herbert L. Mathews, New York, 1964 (as Picasso); Sotheby and Co., London, 1964 (as Picasso); Mr. and Mrs. John A. Beck, Houston, 1964; The Museum of Fine Arts, Houston, The John A. and Audrey Jones Beck Collection, 1979

BIBLIOGRAPHY:

(as Picasso) Zervos VI, 397; Daix IV.17; Houston, *The Collection of John A. and Audrey Jones Beck, Impressionist and Post-Impressionist Paintings*, 1974, p. 72.

EXHIBITIONS:

Houston, The Museum of Fine Arts, Houston, 1973, *Pablo Picasso, 1881-1973: A Memorial Exhibition*, No. 1 (as Picasso)

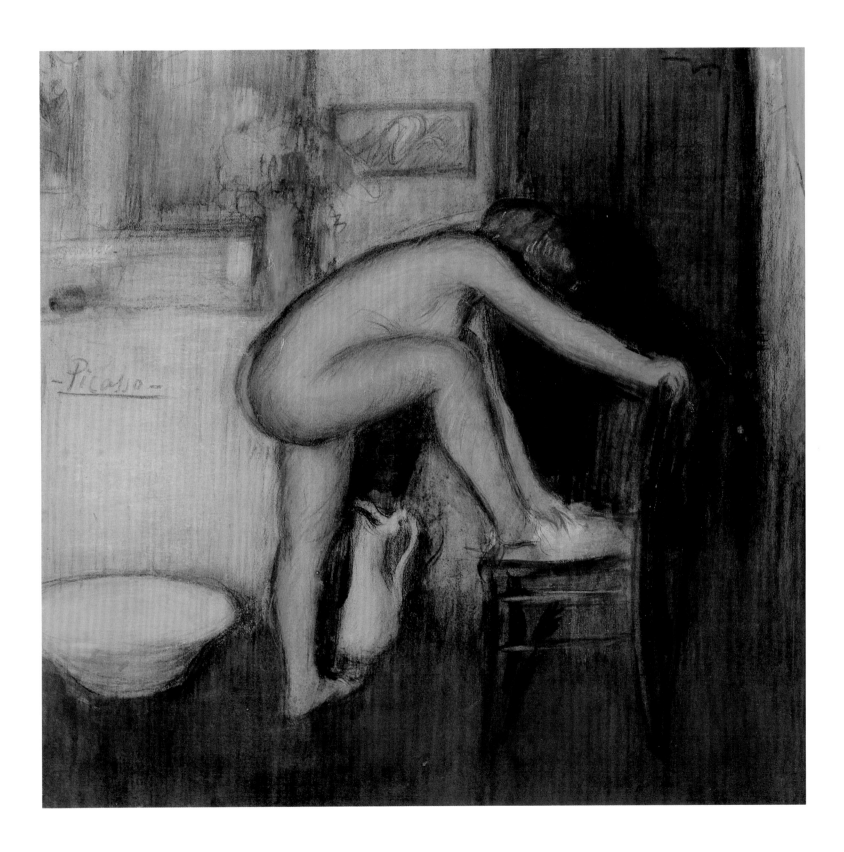

COUNT HENRI RAYMOND DE TOULOUSE-LAUTREC

Born 1864 Albi, France

Died 1901 Château de Malromé, near Langon, France

MOULIN ROUGE 1891

Moulin Rouge posters appeared throughout Paris in 1891, on the walls of public buildings, in the windows of commercial shops, and at the entrances to cafés. This poster was Count Henri Raymond de Toulouse-Lautrec's first lithograph, and it enjoyed immense popularity, making the artist immediately famous and sought after. Moulin Rouge was a popular cabaret in Montmartre. Although many artists tried to capture its glittering ambience, it was Toulouse-Lautrec who made the place his own. As a regular patron, he studied the movements of the famous cabaret dancers La Goulue and Valentin-le-Désossé. This was no small task, for Valentin, dressed in a shiny, dented top hat, stovepipe trousers, and a knee-length, double-breasted coat, moved his inordinately long legs and arms in a clumsy, tripping manner, inspiring his nickname *Le Désossé,* "Boneless." Louise Weber, a washerwoman from Alsace, starred in the cabaret under the name of *La Goulue,* "The Glutton." For Toulouse-Lautrec the poster is a picture of action. The central figure, La Goulue, is a swirl of white petticoats in contrast to the dark figures of the audience. The large image of Valentin is set in the foreground. This close-up technique would later become more common in prints, photographs, and motion pictures. Toulouse-Lautrec was only twenty-seven years old when *Moulin Rouge* was printed, but he presented the subjects with an authority and reality which no artist-lithographer would surpass.

From his earliest childhood, Toulouse-Lautrec sketched scenes of everyday life with precocious humor and scrupulous exactitude to mannerisms. Raised in an aristocratic family, Toulouse-Lautrec was encouraged to emulate his father in horsemanship, falconry, and supervision of the family estate. However, as the young artist matured, his growth was stunted, the result of a childhood accident in which he broke both his legs. As an aristocrat, he had not considered earning a living as an artist, but when he arrived in Paris at the age of eighteen to study, he met other artists who hoped to make a life of painting. He studied first under René Princeteau, the academic painter of horses, who introduced Toulouse-Lautrec to the demi-monde of Paris. Princetau's influence on Toulouse-Lautrec's art was minor, but he did shape the student's lifestyle. Toulouse-Lautrec's great passion became life in the streets, brothels, bars, circus, and music halls. A regular client of the Moulin Rouge, he was asked by the manager to design a poster. The result was a graphic masterpiece, the first in a series of more than thirty advertisements which reflected the artist's ingenious versatility. These posterprints, produced for commercial purposes, remain great landmarks in the art of lithography.

Moulin Rouge 1891
Lithographic poster printed in color on paper (first state of two)
66 x 46 inches, signed lower left: *T. Lautrec*

PROVENANCE:

Pierre Janlet, Brussels; George Cleary, New York; Sale, New York, Sotheby Parke Bernet, *Important Graphics,* April 15, 1964, lot 166; Mr. and Mrs. John A. Beck, 1964

BIBLIOGRAPHY:

Loys Delteil, *Le Peintre-Graveur Illustré,* vol. 1, *Henri de Toulouse-Lautrec,* Paris, 1920, no. 339, ill.
Merete Bodelsen, *Toulouse-Lautrec's Posters, Catalogue & Comments,* Copenhagen, 1964, p. 7.
P. Huisman and M. G. Dortu, *Lautrec by Lautrec,* New York, 1964, pp. 67, 89-92, 253, ill.
Jean Adhémar, *Toulouse-Lautrec, Lithographies—Pointes sèches, oeuvre complet,* Paris, 1965, no. 1.
Fritz Novotny, *Toulouse-Lautrec,* translation from German by Michael Glenney, London, 1969, pp. 22, 24, 185, no. 23, pl. 23.
Wolfgang Wittrock, *Toulouse-Lautrec, The complete prints,* edited and translated by Catherine E. Kuehn, London, 1985, vol. 2, pp. 756, 757, no. P1/B, ill.
Riva Castleman and Wolfgang Wittrock, eds., *Henri de Toulouse-Lautrec, Images of the 1890s,* New York, 1985, pp. 63, 64, 226, 247, no. 247, ill.

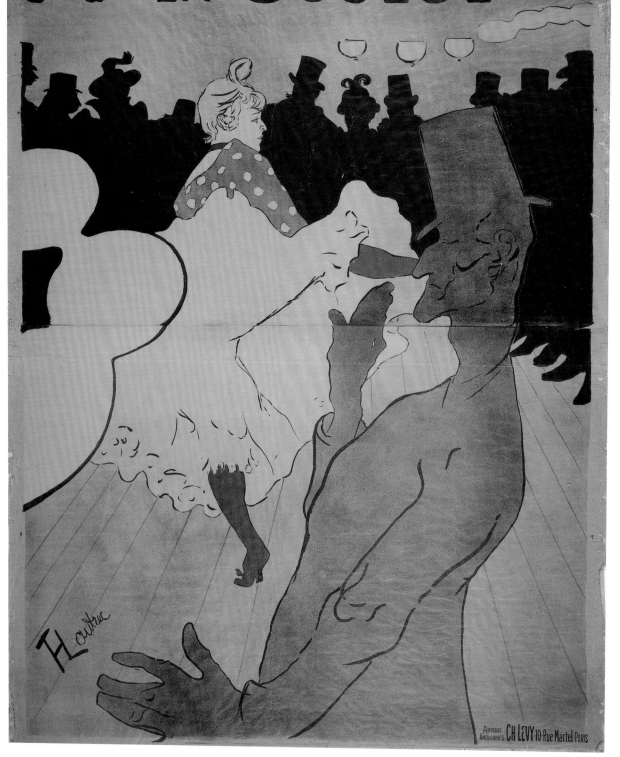

COUNT HENRI RAYMOND DE TOULOUSE-LAUTREC

Born 1864 Albi, France

Died 1901 Château de Malromé, near Langon, France

À TABLE CHEZ M. ET MME. NATANSON
(DINNER AT THE HOME OF M. AND MME. NATANSON) 1898

Henri de Toulouse-Lautrec frequented the salons of intellectuals as well as the night clubs and brothels of Montmartre. This painting records a dinner in Paris at the home of Thadée and Misia Natanson. Thadée was cofounder and editor of the magazine *La Revue Blanche;* Misia was a well-known concert pianist. The Natanson home was famous as a gathering place for writers and artists, and Toulouse-Lautrec was a frequent guest. Shown from left to right are the artist Edouard Vuillard, Misia Natanson, artist Félix Vallotton, and Thadée Natanson. Referring to this picture in her memoirs, *Two or Three Muses, the Life of Misia Sert,* Mme. Natanson, a celebrated beauty, explained she had so irritated the artist during past sittings for portraits that "he took his revenge by making an incredible caricature of a dinner party at my house in which I was presented as a procuress."

Toulouse-Lautrec was born to an aristocratic family whose lineage dated to the time of Charlemagne. At an early age, his life was programmed for the occupation of supervising the family estate. Because his legs never mended properly after being broken in a childhood accident, his growth was stunted. His disabled and disfigured condition made impossible the life he had envisioned as a sportsman and horseman. He escaped through his drawing. When he arrived in Paris in 1882, his love for horses prompted him to study under René Princeteau, who also introduced him to the theater, circus, and music halls. In painting these subjects, Toulouse-Lautrec began to crystallize his personal style. He frequented the ateliers of Léon Bonnat and Fernand Cormon, where he met Vincent van Gogh and Emile Bernard. He profoundly admired Edgar Degas, studying his pictorial style and sharing the older artist's taste for the themes of Paris nightlife. Toulouse-Lautrec became a Parisian celebrity and one of the most respected painters of his generation. A habitué of the music halls of Montmartre, he found refuge and artistic inspiration there.

À table chez M. et Mme. Natanson (Dinner at the home of M. and Mme. Natanson) 1898
Oil, gouache, and pastel on board, 22½ x 30¾ inches
stamped lower right: *TL*

PROVENANCE:

Joseph Hessel, Paris; R.A. Peto, London; Arthur Tooth & Sons, London, 1967; Mr. and Mrs. John A. Beck, Houston, 1967

BIBLIOGRAPHY:

Maurice Joyant, *Henri de Toulouse-Lautrec 1864-1901, Peintre,* Paris, 1926, pp. 183, 287.
Bernard Tristan, "Jos. Hessel," *La Renaissance,* Paris, 1930, p. 35, ill.
Gerstle Mack, *Toulouse-Lautrec,* New York, 1938, p. 266.
Henri Perruchot, *La Vie de Toulouse-Lautrec,* Paris, 1958, p. 244.
Edouard Julien, *Lautrec,* New York, 1959, p. 42.
M.G. Dortu, *Toulouse-Lautrec et Son Oeuvre,* New York, 1971, vol. 3, no. P 567.
Arthur Gold and Robert Fizdale, *The Life of Misia Sert,* New York, 1980, p. 67 and ill.
George T. M. Shackelford and Mary Tavener Holmes, *A Magic Mirror: The Portrait in France 1700-1900,* Houston, 1986, no. 45, pp. 122, 123, 139, ill.

EXHIBITIONS:

Paris, Galerie Rosenberg, 1914, no. 27.
Paris, Galerie Manzi-Joyant, *Toulouse-Lautrec,* 1914, no. 6.
Paris, Salon des Indépendants, *Trente ans d'art Indépendant,* 1926, no. 3250.
Paris, Musée des Arts Décoratifs, *Toulouse-Lautrec, trentenaire,* 1931, no. 136.
London, Lefevre Gallery, *Delacroix to Dufy,* 1946, no. 26.
London and extensive tour, Arts Council of Great Britain, *Paintings from Mr. Peto's Collection,* 1947-48, no. 13.
London, Matthiesen Gallery, *Toulouse-Lautrec,* 1951, no. 22.
Exeter and extensive tour, Arts Council of Great Britain, *French Paintings: A Second Selection from Mr. Peto's Collection,* 1951-52, no. 13.
Plymouth, City Art Gallery, *French Impressionists from the Peto Collection,* 1960, no. 43.
London, Wildenstein and Co., *The French Impressionists and Some of Their Contemporaries,* 1963, no. 82.
Houston, The Museum of Fine Arts, Houston, *The Collection of John A. and Audrey Jones Beck,* 1974, pp. 90-91.
Chicago, The Art Institute of Chicago, *Toulouse-Lautrec: Paintings,* 1979, no. 94, pp. 286-87.
Houston, The Museum of Fine Arts, Houston, *A Magic Mirror: The Portrait in France 1700-1900,* 1986-87, no. 45.

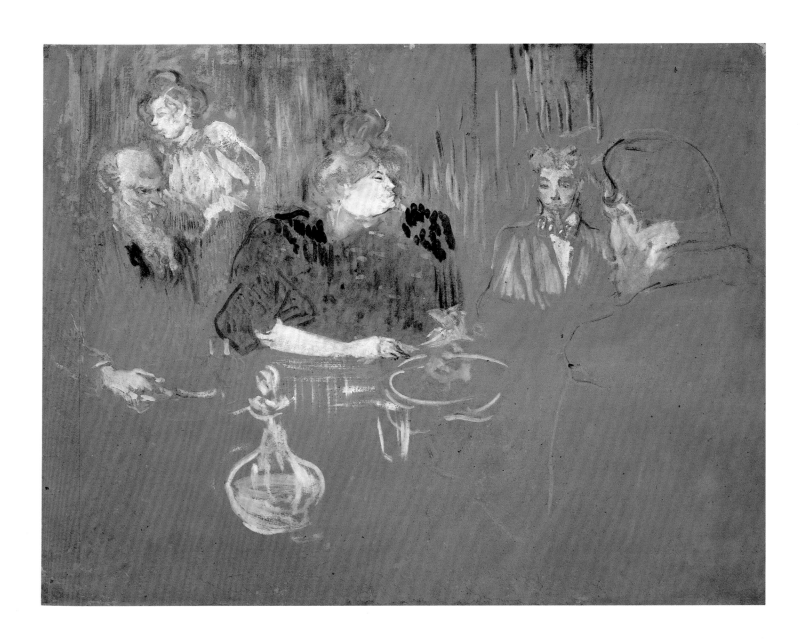

MAURICE UTRILLO

Born 1883 Paris, France

Died 1955 Dax, France

LA MAISON DE MIMI PINSON—MONTMARTRE
(THE HOUSE OF MIMI PINSON IN MONTMARTRE) c.1914

Maurice Utrillo's paintings convey the nostalgic appeal of Montmartre, with its picturesque cobblestone streets, modest bistros, and houses with old, aging facades. Because he knew and loved this neighborhood, he painted its streets and houses his entire life. During the years 1909 to 1914, his so-called white period, Utrillo produced some of his finest works. To heighten the texture of the paint and achieve more realistic effects, Utrillo mixed plaster, which was used on walls and buildings in Montmartre, with his zinc-white pigment. The result is a canvas of great surface richness. This innovative attempt to introduce new materials to the canvas parallels in time the work in collage by Georges Braque and Pablo Picasso, but with dramatically different results. The central house in this painting on rue Mont-Cenis is the home of Mimi Pinson, a bohemian celebrated in many literary and musical works. Just beyond, at the corner of rue Saint Vincent, is the home of composer Hector Berlioz. Across the street was the tavern La Belle Gabrielle, and around the corner was Lapin Agile, a famous gathering place for artists and poets.

The Spanish writer and art critic Miguel Utrillo, in an act of kindness, bestowed his name on the illegitimate son of his artist-friend Suzanne Valadon. At that time, Valadon was only eighteen years old; her son's paternity was uncertain, since she claimed that his father could have been one of several prominent artists. The boy Maurice was a student of limited promise, a failure as a bank clerk, and at the age of eighteen was committed temporarily to an asylum for alcoholism. On a doctor's advice, Suzanne Valadon urged her son to take up painting as a form of therapy and as an occupation. Utrillo haunted the streets of Montmartre, much as Toulouse-Lautrec had roamed there a generation before. This ordinary street artist had an international reputation by 1920, and in 1928 the French Republic awarded him the Cross of the Legion of Honor.

La Maison de Mimi Pinson—Montmartre
(The House of Mimi Pinson in Montmartre) c. 1914
Oil on canvas, 20 x 31⅞ inches, signed lower right: *Maurice Utrillo. V.*

PROVENANCE:

Private collection, Paris; Sale, Paris, Hôtel Drouot, *Tableaux Modernes composant la collection de Mme X...*, March 12, 1928, no. 94, as *La Maison de Berlioz*; Galerie Paul Pétridès/Galerie Philippe Reichenbach, Paris; Mr. and Mrs. John A. Beck, Houston, 1963

BIBLIOGRAPHY:

Paul Pétridès, *L'oeuvre complet de Maurice Utrillo*, Paris, 1962, vol. 2, p. 524, no. 1244.

EXHIBITIONS:

Houston, The Museum of Fine Arts, Houston, *The Collection of John A. and Audrey Jones Beck*, 1974, pp. 92-93.

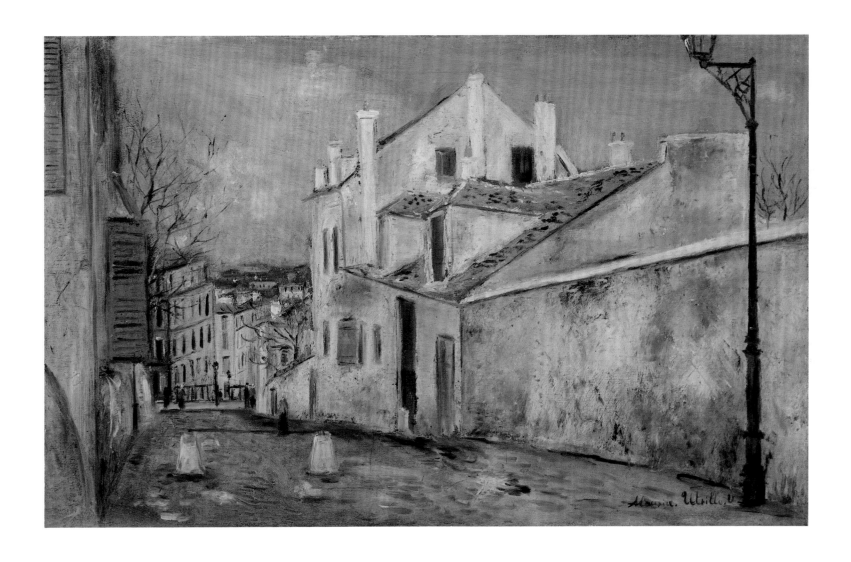

SUZANNE VALADON

Born 1867 Bessines, France

Died 1938 Paris, France

AUTOPORTRAIT (SELF-PORTRAIT) 1898

Suzanne Valadon was not known for pretty pictures. Her art expressed a sharpness of observation, forms vigorously rendered in bold outlines and vivid coloration. This portrait was purportedly a gift to her lover, the composer Erik Satie, who kept the work (along with a Valadon portrait of himself) until his death in 1925. Nothing of Valadon's striking and youthful appearance at age thirty-one is evident. Rather, the self-portrait is painted with a kind of brutality that leaves her image uncompromisingly exposed, revealing little of what lies behind the artist's cold, ironic stare.

The illegitimate daughter of a laundress, Valadon grew up in the Montmartre quarter of Paris in extreme poverty. After a brief and unsuccessful career as an acrobat, she began posing as a model for a number of artists, including Pierre-Auguste Renoir, Pierre Puvis de Chavannes, and Henri de Toulouse-Lautrec. Beautiful and lively, she was a popular model and frequenter of Montmartre cabarets. Valadon became a serious painter after the birth of her son Maurice Utrillo in 1883. Encouraged by Edgar Degas, who became her friend and critic, Valadon exhibited with the impressionists and at Ambroise Vollard's gallery. Her marriage to Paul Mousis in 1896 provided her with a more comfortable life and the ability to protect her son from alcoholism and suicidal tendencies. Valadon later separated from Mousis and married the painter André Utter in 1909. He introduced her to the circle of avant-garde artists and writers that included André Derain and Max Jacob.

Autoportrait (Self-Portrait) 1898
Oil on canvas, 15¾ x 10½ inches, signed lower left: *Suzanne Valadon 1898*

PROVENANCE:

Erik Satie, Paris; Georges and Norma Kars, Paris, 1966; Sale, Paris, Palais Galliera, *Tableaux Modernes,* June 17, 1966, no. 49; Mr. and Mrs. John A. Beck, Houston, 1966.

BIBLIOGRAPHY:

Paul Pétridès, *L'oeuvre complet de Suzanne Valadon*, Paris, 1971, P 1, p. 281, ill.

EXHIBITIONS:

Paris, Musée de l'Orangerie, *Exposition Suzanne Valadon*, 1923, no. 2.
Arnhem, Gemeente Museum, *Charley Toorop, Suzanne Valadon,* 1955, no. 15.
Paris, Musée Galliera, *Marie-Anne Camax-Zoegger, Louise Hervieux, Suzanne Valadon*, 1961, no. 51.
Houston, The Museum of Fine Arts, Houston, *The Collection of John A. and Audrey Jones Beck,* 1974, pp. 94-95.

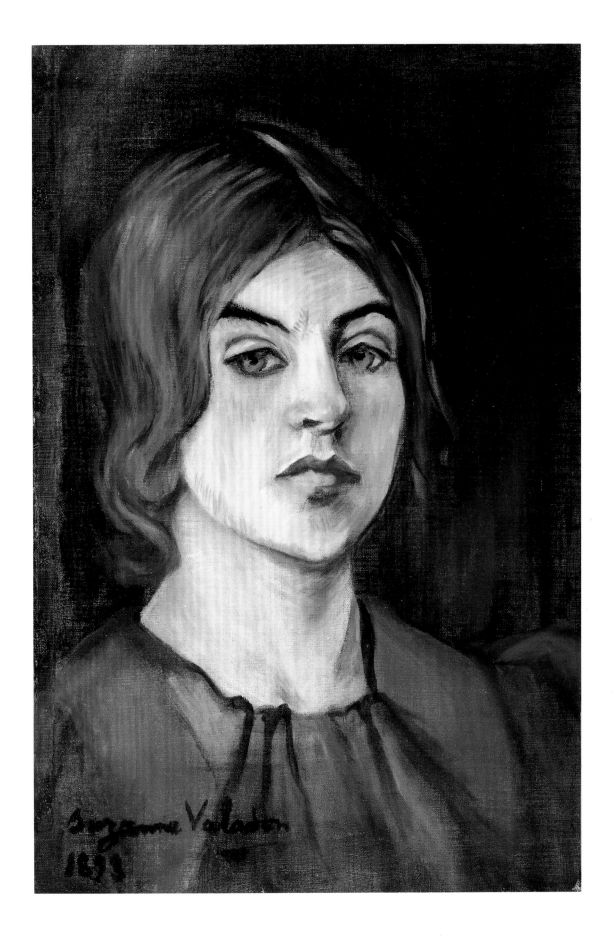

LOUIS VALTAT

Born 1869 Dieppe, France

Died 1952 Paris, France

LE PORTRAIT DE MADAME VALTAT (PORTRAIT OF MADAME VALTAT) 1906

Louis Valtat worked in the nineteenth-century tradition of figure painters who depicted female models posed in quiet introspection or seeming reverie. In this portrait of the artist's wife absorbed in reading as she sits in the Bois de Boulogne, Valtat has caught the charming mood of the moment. In painting the portrait, Valtat literally drew with the brush in long lines of color, akin to the style of Vincent van Gogh. Yet in its contemplative pose, filtered light, and luminous beauty, the work is associated with the manner of the impressionist painter Pierre-Auguste Renoir. Valtat, who also painted in the fauves' vivid palette, was represented by the influential dealer and connoisseur Ambroise Vollard.

Valtat's parents provided their son with a classical education at Versailles. After graduation he attended the Académie Julian with his friends Pierre Bonnard, Edouard Vuillard, Maurice Denis, and Félix Vallotton. Later at the Ecole des Beaux-Arts, while studying with Gustave Moreau, he met Henri Matisse and Albert Marquet. At the age of twenty-four, Valtat exhibited at the Salon des Indépendants, and in the following year he set up his own studio. His travels to southern France, Spain, Italy, and Algeria encouraged his preference for bright colors and led him to exploit brilliant chroma before his fellow fauves. Valtat was not tempted to alter his manner of painting in later years but maintained his own course of development, expressing his joyous view of life and nature. Tragically, he spent the last four years of his life in blindness. While his art had attracted the attention of connoisseurs and earned him numerous exhibitions, his name did not become part of the lexicon of popular painters of his day.

Le Portrait de Madame Valtat (Portrait of Madame Valtat) 1906
Oil on canvas, 28 x 22¾ inches, signed lower left: *L. Valtat.*

PROVENANCE:

Ambroise Vollard, Paris; Conte d'Oria, Paris, 1967; Galerie Philippe Reichenbach, Paris, 1967; Mr. and Mrs. John A. Beck, Houston, 1967

BIBLIOGRAPHY:

Jean Valtat, *Louis Valtat, catalogue de l'oeuvre peint*, Neuchâtel, 1977, vol. 1, p. 67, no. 597, as *Jeune Femme Blonde Lisant.*

EXHIBITIONS:

Austin, The University of Texas Art Museum, *Fauve-Color*, 1972, no. 19.

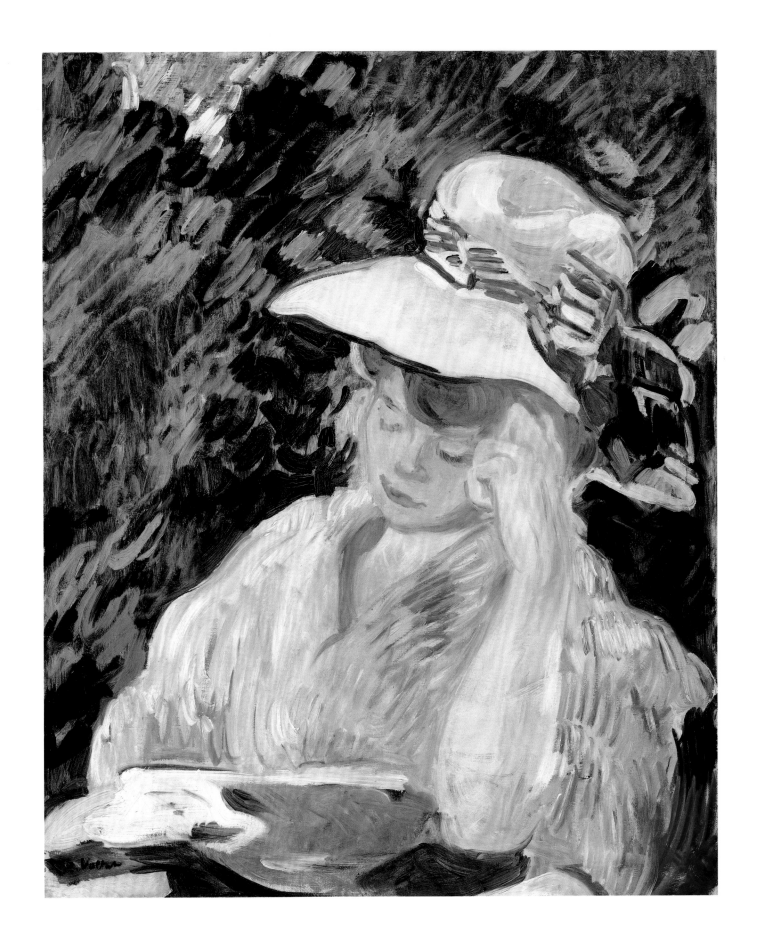

MAURICE DE VLAMINCK

Born 1876 Paris, France

Died 1958 Rueil-la-Gadelière, France

GRAND NU AU DIVAN (RECLINING NUDE) 1905

Maurice de Vlaminck created pictures of such explosive color and style during the fauve era that his audience was shocked and overwhelmed. He exhibited his paintings with Henri Matisse, André Derain, and the other fauves at the Salon d'Automne of 1905, christened the gallery of the "wild beasts." *Reclining Nude,* painted that year, reveals in its dashing reds, blues, and greens the orgiastic colorism of Vlaminck's fauve canvases. The reclining nude, or odalisque, is a subject with a long tradition in the history of art. The most important immediate precedent for this picture was the *Olympia* of Edouard Manet, a frankly provocative depiction of a Parisian courtesan based on images of Renaissance goddesses reclining on divans. Vlaminck's nude, brutally flaunting her nakedness, is truly a goddess of the flesh.

Vlaminck was born in Paris near the old Les Halles market. His Belgian parents were musicians and led a bohemian life, leaving their son to his own self-education. High-spirited and rebellious, Vlaminck established his independence at the age of sixteen, settling in Châtou, near Versailles. There he made his living as a racing cyclist and by playing the violin in cafés. By the age of twenty-four, he was the father of two children and had been recently discharged from the army. He met André Derain, and they immediately became friends. In 1900 the two artists shared a studio on the island of Châtou in the Seine, where Pierre-Auguste Renoir had painted his *Luncheon of the Boating Party* in 1881. Enthusiastic in their artistic collaboration, Vlaminck and Derain spent the days painting side by side and the evenings discussing their artistic endeavors. Vlaminck was greatly influenced by the Vincent van Gogh exhibition of 1901, as were all of the artists who were developing the fauve style. There Derain introduced Vlaminck to Henri Matisse, who joined them in Châtou in 1905. One year later, the dealer Ambroise Vollard became the exclusive representative of Vlaminck's paintings. Although Vlaminck associated with artists at the Bateau Lavoir in Montmartre and had the financial resources to establish himself in Paris, he preferred to live and work in the small villages surrounding the city.

Grand Nu au Divan (Reclining Nude) 1905
Oil on canvas, 27½ x 37¾ inches, signed lower left: *Vlaminck*

PROVENANCE:

Ambroise Vollard, Paris; Christian de Galéa, Paris; Perls Gallery, New York; Sale, New York, Sotheby Parke-Bernet, *Impressionist and Modern Paintings and Sculpture,* November 16, 1983, lot 43; Mrs. John A. Beck, Houston, 1983

BIBLIOGRAPHY:

Florent Fels, *Vlaminck,* 1928, p. 16, ill.
Marcel Sauvage, *Vlaminck: Sa Vie et Son Message,* Paris, 1956, p. 110, pl. 17.

EXHIBITIONS:

Paris, Galerie Charpentier, *L'Oeuvre de Vlaminck,* 1956, no. 15.
Paris, Galerie Charpentier, *Les Fauves,* 1962.
New York, Perls Gallery, *Vlaminck: His Fauve Period,* 1968, no. 5, ill.

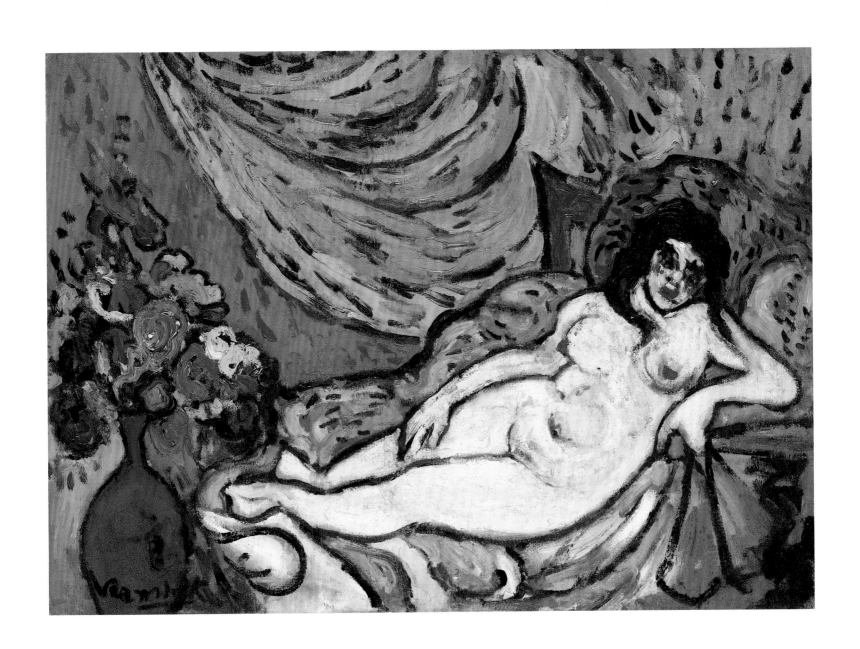

MAURICE DE VLAMINCK

Born 1876 Paris, France

Died 1958 Rueil-la-Gadelière, France

PAYSAGE DE VALMONDOIS (LANDSCAPE OF VALMONDOIS) c. 1912

In the years following the height of the fauve movement, Maurice de Vlaminck's canvases changed. Bright tones gave way to darker and more brooding compositions in which color was applied in great sweeps of paint. Vlaminck's admiration for the work of Paul Cézanne led him to turn from vivid color in favor of a technique based on Cézanne's geometrical compositions. *Landscape of Valmondois* reflects this post-fauve development. Vlaminck painted the houses and barns of the small hamlet of Valmondois in a somber palette applied in broad blocks of color, the hallmarks of his new style.

Vlaminck was a large, jovial, energetic man with flaming red hair and beard. To support his family, he worked as a racing cyclist, violin teacher, café entertainer, essayist, and journalist writing in support of anarchism. He was editor of the radical journal *La Libertaire,* a noted illustrator of books, and author of romantic erotic novels. Despite his innate artistic talent, Vlaminck never intended to become a professional painter, an occupation which he saw as trivial compared to farming. He boasted that he never entered museums or academies, decadent institutions which he rejected as products of urban life. In 1901, however, Vlaminck saw the Vincent van Gogh exhibition in Paris and was deeply moved. The self-taught rebel decided then to pursue a career in art. He exhibited at the Salon des Indépendants and with the fauves at the 1905 Salon d'Automne. When Ambroise Vollard, the Paris art dealer, signed a contract with Vlaminck in 1906 and purchased all of his paintings, the artist was at last able to live and work in the small villages near Paris that he loved. In 1925 he purchased the country home La Trouvillière near Rueil-la-Gadelière, where he continued to paint for the rest of his life.

Paysage de Valmondois (Landscape of Valmondois) c. 1912
Oil on canvas, 31¾ x 45½ inches, signed lower right: *Vlaminck.*

PROVENANCE:

Tenoudji collection, Paris, 1963; Galerie Philippe Reichenbach, Paris, 1963; Mr. and Mrs. John A. Beck, Houston, 1963

EXHIBITIONS:

Paris, Galerie Charpentier, *Chefs d'oeuvres des collections françaises,* 1962, no. 107.
Houston, The Museum of Fine Arts, Houston, *The Collection of John A. and Audrey Jones Beck,* 1974, pp. 98-99.

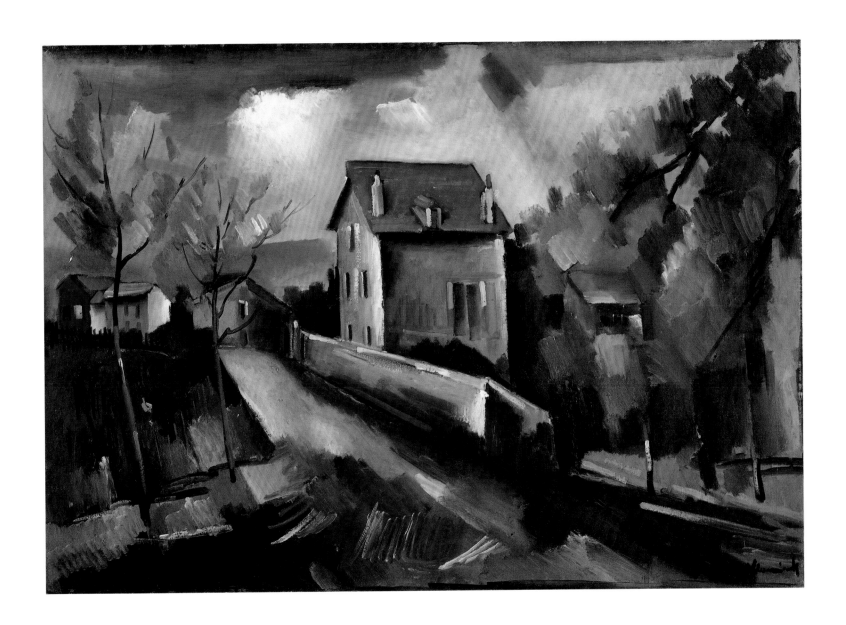

EDOUARD VUILLARD

Born 1868 Cuiseaux, France

Died 1940 La Baule, France

MADAME HESSEL CHEZ ELLE (MADAME HESSEL AT HOME) c. 1908

Women exerted a strong influence on Edouard Vuillard's art and life. He was devoted to his mother, a source of inspiration to his work, and his friends Misia Natanson, Mme. Joseph Hessel, and the famous writer Anna de Noaïlles were favorite subjects. He painted them in the intimacy of their homes with an eye to the surrounding details. Mme. Joseph Hessel, the wife of an art dealer, became not only his model but also a dominant force in his life for forty years. This picture portrays Mme. Hessel in her lavish Parisian home on the rue de Rivoli. She sits silhouetted against the colorful pattern of wallpaper and a mantelpiece cluttered with ornaments and pictures. No detail escaped the scrutinizing eye of Vuillard. Stéphane Mallarmé, the symbolist poet, was a great influence on Vuillard, and a parallel can be drawn between this painting and the theme of the lamp and shadow in Mallarmé's verse.

As a child, Vuillard seemed destined to emulate his father and become a military officer. However, in 1884 at the Lycée Condorcet, Vuillard was urged to continue art lessons by Ker-Xavier Roussel, a fellow student. Together they attended the Ecole des Beaux-Arts in 1886 and the Académie Julian in 1888. The two artists banded together with a group of painters they had met at the Académie Julian, including Pierre Bonnard, Paul Sérusier, Maurice Denis, and Félix Vallotton, to form the group known as the nabis. Vuillard, like Bonnard and Henri de Toulouse-Lautrec, was part of the most advanced literary circles in Paris, notably that of Misia and Thadée Natanson and of the poet Mallarmé. Vuillard exhibited from 1891 through 1938 and was one of the founders of the Salon d'Automne. He created theatrical sets and received a number of major mural commissions, such as the Comédie des Champs Elysées, the Palais de Chaillot, and the Palace of the League of Nations in Geneva. Despite his success, Vuillard frequently questioned the legitimacy of art as a profession. His first sales terrified him, and he needed the constant support and encouragement of his friends.

Madame Hessel chez elle (Madame Hessel at home) c. 1908
Oil on cardboard, 28 x 27 inches, signed upper right: *Vuillard*

PROVENANCE:

Hillman Periodicals, New York; Alex Hillman Family Foundation, New York; Sale, London, Sotheby's, April 29, 1964; Mr. and Mrs. John A. Beck, Houston, 1964

BIBLIOGRAPHY:

André Chastel, *Edouard Vuillard,* Paris, 1948, pl. 10.

EXHIBITIONS:

New York/Cleveland, The Museum of Modern Art/The Cleveland Museum of Art, *Edouard Vuillard,* 1954, p. 62.
Houston, The Museum of Fine Arts, Houston, *The Collection of John A. and Audrey Jones Beck,* 1974, pp. 100-101.

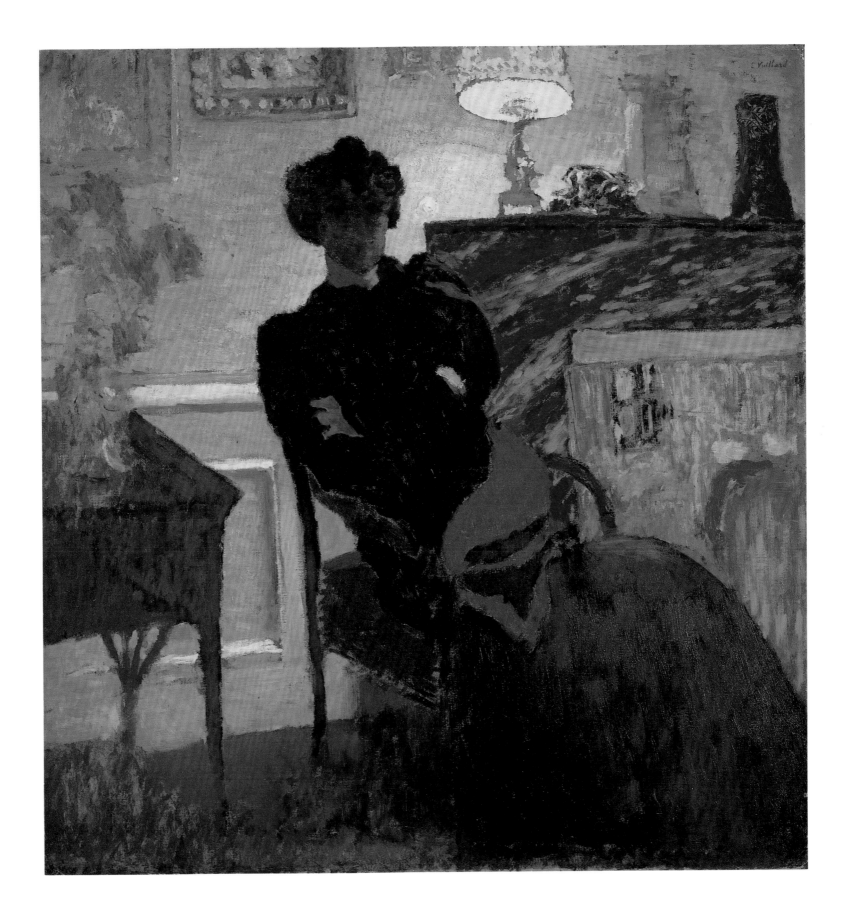

ARTIST INDEX